PHOTOGRAPHICALLY **SPEAKING**

A DEEPER LOOK AT CREATING STRONGER IMAGES

David duChemin

Photographically Speaking: A Deeper Look at Creating Stronger Images
David duChemin

New Riders
1249 Eighth Street
Berkeley, CA 94710
510/524-2178
510/524-2221 (fax)
Find us on the Web at www.newriders.com
To report errors, please send a note to errata@peachpit.com
New Riders is an imprint of Peachpit, a division of Pearson Education

Editor: Ted Waitt
Production Editor: Lisa Brazieal
Cover and Interior Design: Charlene Charles-Will
Layout and Composition: Kim Scott, Bumpy Design
Indexer: James Minkin
Cover Image: David duChemin
Back Cover Author Image: Gary Dowd

ISBN-13 978-0-321-75044-0
ISBN-10 0-321-75044-6

9 8 7 6 5 4 3 2 1

Printed and bound in the United States of America

In Memory of Barbara Brown, 1976–2011

To my dear friends Barbara and Daniel, who spent the last 18 months fighting cancer together with courage and grace. Barbara passed away on July 24, 2011, leaving an inexpressible absence in our hearts.

It is to Barbara's beautiful memory, and to Daniel's astonishing strength and love, that this book is dedicated.

Acknowledgments

Like the three books that preceded this one, *Photographically Speaking* didn't write itself. I'm grateful beyond words to the people who had my back, held my hand, pointed out my blind spots, and polished my words. So while no one except the people in these acknowledgments reads this part, I want to thank and share the credit with the following. Of course, if the book falls on its face, then these people also share the blame.

My editor, Ted Waitt, has become both my partner in crime and my close friend. People assume that I keep writing books because of the fame and riches. (These are also the ones against whom I have restraining orders.) Others think— and they're partly right—that I just can't shut up. But mostly it's because I enjoy working with Ted so much that I consider it worth the blood, sweat, and carpal tunnel that comes of writing, just to work with him again.

My publisher, Nancy Aldrich-Ruenzel, who continues to take chances on me and publish my stuff against all reason. One day she'll realize she's made a horrible error. Until then, I'm grateful for the chance to get my words and photographs out to the broader world and to do so as part of the fantastic family of book-loving Berkeley neo-hippies at Peachpit.

Charlene Charles-Will, my designer. This is the fourth book she's made with me and I'm not even sure there's a good reason for me to keep looking at the layout proofs; they're just always so beautiful. I'm unreasonably proud of how good these books look, and I'm not sure why as I've got so little to do with it.

Hilal Sala and Lisa Brazieal, the production editors who keep this whole thing on track and makes sure it gets printed and out the door. We've not missed a deadline yet!

And then there are all the other people. The ones who live and love and work with me without any contractual obligation to do so. The ones who have influenced this book in ways both profound and diverse, though probably still not enough to be listed in a class-action suit.

My manager and best friend, Corwin, who literally holds my world together, and has been a tireless and faithful friend to me in some tough times over the last year and a half.

My friends who I am blessed to say are too numerous for me to mention without getting in trouble for missing one. Over the last handful of years I've been particularly grateful for the support of Troy, Erick, Jeffery, Reid, Matt, Gavin, Gary, Reid, The Legendary H, Erin, Daniela, KF, Sabrina, Dave Delnea, Kevin and Trish Clark, and my dear friends Daniel and Barbara, to whom this book is dedicated.

Cynthia Brooke, who abandoned Venice to get me through the longest four days and nights of my life after the accident in Pisa. I am so, so grateful.

My colleagues in the world of photographic education. I'm humbled and grateful to be counted among them. Joe McNally, Chris Orwig, Vincent Versace, Scott Kelby, Matt Brandon, Gavin Gough, Jeffrey Chapman. All of these have either written books or taught alongside me in ways that have enriched my own life and craft.

My sponsors—companies who've been generous to me and my community— Sigma Canada, SanDisk, Gitzo, Artistic Photo Canvas, LiveBooks, Think Tank Photo, and Singh Ray Filters.

My readers and the photographic community at large. I am an unabashed fan of the amateur, the ones who do this for the love of it, whether or not they ever make a buck. You folks keep me sharp and honest and as free from pretense as possible. If you've ever read my blog, left a comment, or asked a question, I'm grateful. If you've ever shelled out for one of my books, ebooks, or workshops, I'm equally grateful. Puzzled, but grateful. On top of all that, you saw me through months of recovery and rehab after a fall in Italy on April 23, and your endless comments, emails, card, flowers and assorted expressions of support meant more to me than you can know. Thank you!

My mother, Heather, and my stepfather, Paul, who have always managed with such grace to be both my parents and my best friends. And to my father, Dick, who gave me my first camera, a little Black's 110, with which I acquired my life-long habit of making far too many horrific photographs in search of the beautiful ones.

And finally God, from whom this passion comes. Be Thou my Vision, oh Lord of my heart.

(Way Too Much) About the Author

David duChemin is a humanitarian and world photographer, previously based in Vancouver, Canada. He wrote this book in airports around the world in a jet-lagged stupor, and while living in his 1983 Land Rover Defender, Jessie, while traveling a long slow circle around the North American continent and trying hard not to think of himself as homeless. He did this until he fell off a wall while teaching in Pisa, Italy. The rest of the book was written while he rehabilitated and learned to walk again, so there was a great deal of pain meds involved. When you get to the fuzzy bits, that's why.

David is a formally trained photographer, though that formal training was not actually in photography, but theology, in which he graduated with a four-year degree (which took five years) in order to pursue a twelve-year career in comedy before stepping off the stage, to the relief of his audiences, to return to his cameras and begin photographing vocationally and leaving pieces of his heart on seven continents.

David likes single malt whisky from Islay, hammocks, and also long walks on the beach. Sometimes he pretends he has a Golden Labrador called Kodak because it seems authors should have a dog, and also because he always wanted his own Kodak lab (how long will that joke mean anything?). He is also a best-selling author, which means he will one day inherit the basement full of his books that his mother has been furiously ordering. The three books preceding this one are *Within the Frame: The Journey of Photographic Vision*; *VisionMongers: Making a Life and a Living in Photography*; and *Vision & Voice: Refining Your Vision in Adobe Photoshop Lightroom*. He's also the author and publisher of a growing library of ludicrously inexpensive ebooks, which can be found at CraftAndVision.com.

David's work can be found at DavidDuChemin.com, as can his blog and the growing community of kind and talented people who read it.

Contents

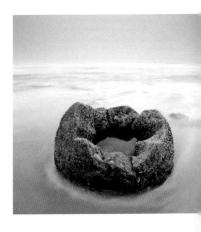

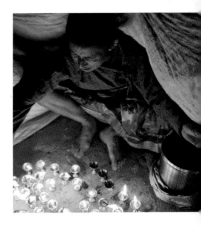

CHAPTER THREE

Decisions .88

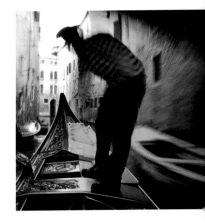

Introduction

FOR THE LAST FEW YEARS, I've been a little hung up on the role of intent or vision in the making of photographs. I've written thousands upon thousands of words about what vision is, why it matters, and how we identify it, tap into it to guide our process, and create images that have, at the heart of their creation, a thought or feeling around which they are built. Those people who have my previous books will be surprised not to see the word *vision* in the title or subtitle of this one. For some, that's a welcome relief, for others a cause for concern. For those for whom that causes concern: this is not a departure from my teaching about vision-driven photography; it's a progression. Don't panic; I'm still drinking the KoolAid. For those of you who bought the book because I

▶ Canon EOS 5D Mk II, 24mm (TS-E24mm f/3.5L II), 1/400
@ f/5.6, ISO 100

Dave Delnea, Iceland, 2010.

finally gave up on the whole "vision thing," you're going to be disappointed, because not only am I still drinking the KoolAid, I'm still serving it.

Ultimately, this book is about what makes a good photograph—if we can agree on a common definition—and we'll discuss that at greater length in the coming chapter. But that's the extent to which we'll talk in those terms. For the most part, we'll look at what photographs say, and how they say those things. Whether it is good, or even art, is for the critics to discuss; that's a discussion I'm not sure I have much interest in, given how vague, subjective, and ever-changing the criteria are. Instead, we'll talk more in terms of successful images.

This book assumes that a significant part of what makes a photograph successful is the communication of some key thought or feeling, whether that's something deep and ponderous and meaning-of-lifeish, or a simple statement about the laughter of a child (which I would argue is still pretty close to being meaning-of-lifeish).

The notions of communication and expression are key to this book. If in the past I've overused the word *vision*, this book might, I think, run the risk of overusing the word *expression*. As important as our intent for a photograph is, it remains only inside, unrealized, until it is externalized. Poets, songwriters, painters, dancers, jazz pianists, comics, and countless others all have their own ways of getting the inner stuff out. We have the photograph. Not the camera. The photograph. The camera is merely the tool. The photograph is the very expression of that inner thing bursting to get out. How we make that photograph with the tools at our disposal, and how close it comes to expressing what we hope, determines how successful that image is. To do that well, we turn to the language spoken by the photograph.

It's like this with all art. The cellist uses the cello, but it's only her tool. Her language is music, with which she expresses herself, through the skilled use of the instrument. The mournful adagio echoes in our soul and brings us to tears because she knows the language of music so well that she can wield it with the nuance and subtlety needed to strike our deepest parts. She knows what she wants to say (vision/intent) and the music lets her do that right up to the limits of her own ability to wield her tool. The poet uses language in the same way; the broader his vocabulary, the greater command he has over grammar, and the more creative he is in arranging one word with another to create new meanings and implications, the more clearly he can express himself.

Photographers, too, have a language. It is awareness and use of that language that allows us to move on from merely having vision to being able to express it. That language is unique to us alone, though not unconnected to the language employed by painters and graphic artists. What we share is the frame and the constraint of two-dimensionality. The better we know the language, the greater our expression. It is in this sense that this book is called *Photographically Speaking*.

But there's another sense, too, and that sense is what first suggested this book. I often teach photography in the context of workshop tours in places like India, Nepal, or Kenya. I don't usually lecture or even hold formal classroom sessions during these times because I mostly assume that anyone coming that far already knows the basics of their craft. If you show up for a workshop with a musician you respect and want to learn from, they aren't likely to have you doing scales all week. You can do that on your own time. What we do instead, aside from spending hours making photographs, is talk about photographs. Almost every day I ask my students to each submit one image that we can talk about. We have certain rules, but mostly it's a free-for-all with the goal of learning to speak about what we see within the frame, what elements are there, and what decisions the photographer made that led to this particular photograph, and what it says.

What first surprised me when I started teaching this way is how universally hard it is for photographers to talk about photographs. To some degree, I get it. If we were all good with words, we wouldn't likely have turned to the camera to interpret for us. We don't always have the words. However, I think the situation is more dire than a lack of words; it's a lack of understanding. We simply don't know how to think—and therefore to speak—about photographs.

It is always amazing to watch my students become comfortable with this process, begin to work through this stuff, and become able to think about photographs. Without exception, this process helps them create stronger photographs that more closely align with their vision, their original intent. So that's the second meaning of the title, *Photographically Speaking*: greater awareness of the language leads to an expanded and refined ability to use that language to express ourselves. We'll use the process of speaking about photographs to teach us about the language of the photograph, and in turn to make us stronger photographers. In part this book is an effort to recreate those teaching

"This book assumes that a significant part of what makes a photograph successful is the communication of some key thought or feeling."

times that I've seen so often in places like Venice or Kathmandu, opening the eyes of students to the power of a photograph when the visual language is wielded well.

> "Vision isn't the goal. Expression is the goal. That's where the visual language comes in."

In a sense, this book is the logical follow-up to *Within the Frame*, and the one out of which *Vision & Voice* would have more naturally flowed. Both books are different conversations about similar things, all of them connected by the idea that a mindful approach to our photographic process—being conscious of what we want to say and how we want to say it—leads to images that are more able to express that unique inner voice, which seems to prefer the camera as a means of getting those words out and onto paper. In our case, the "words" are the elements around us, and the paper is the print. We're left with arranging those elements within the frame. Vision isn't the goal. Expression is the goal. That's where the visual language comes in.

The scope of this book is limited mostly to the in-camera act of creating the negative. Relating photography to music, Ansel Adams said that the negative was the score and the print was the performance of that score. In the same way, the post-capture manipulation of the negative and the resulting output—whether that's in a traditional wet darkroom or the digital darkroom—is a part of our expression. It matters a great deal. I've seen negatives of beautiful photographs printed so poorly you'd never give them a second look. For that matter, I've heard cover bands play pieces of music that are so good they make me want never to hear the original again. But while the performance isn't within the scope of this book, separating the camera work from the darkroom work is a bit of an unfortunate divorce, as both work in tandem to bring the final photograph into line with our intention. If that part interests you, *Vision & Voice: Refining Your Vision in Adobe Photoshop Lightroom* should have followed this one, and would make a great next step in the journey of learning to refine your expression. I look at *Photographically Speaking* and *Vision & Voice* as the Siamese twins of the *Vision* trilogy—which is also the only way I can squeak in on a technicality and still call what is now a series of four books a trilogy.

What this book is not meant to be is a complete treatise on theory, criticism, or what does or doesn't make art. There is a difference between artists and art critics—and both are needed—but in this book I'm more interested in speaking to the artists and would-be artists than I am interested in pleasing

the critics with perfect definitions and big words. This book is meant to simply introduce some key concepts in language in a way that is as accessible as I can make it. It's not meant to be a substitute for more academic books about composition and visual literacy, if your interests eventually run in that direction. I do, however, believe that you can understand visual language and create expressive and compelling photographs without diving into academics and big hundred-dollar words. I believe that a grasp of what's going on within the frame, and a mindful approach to creating photographs that speak this language, are enough to create powerful photographs that express or communicate something within us that is bursting to get out.

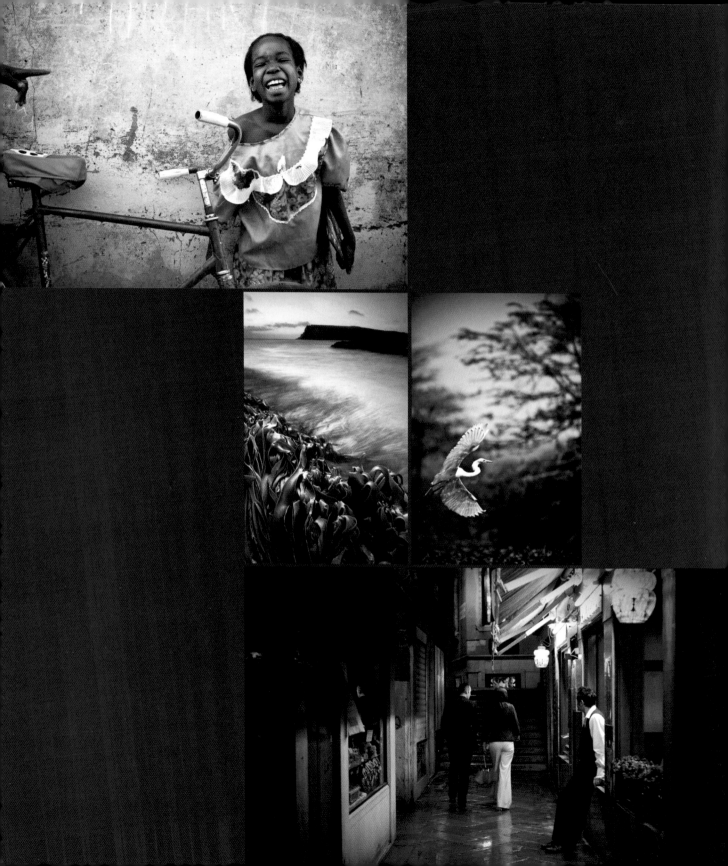

THE PHOTOGRAPHER'S **INTENT**

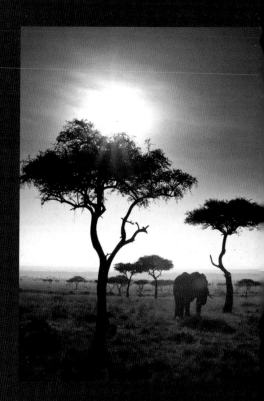

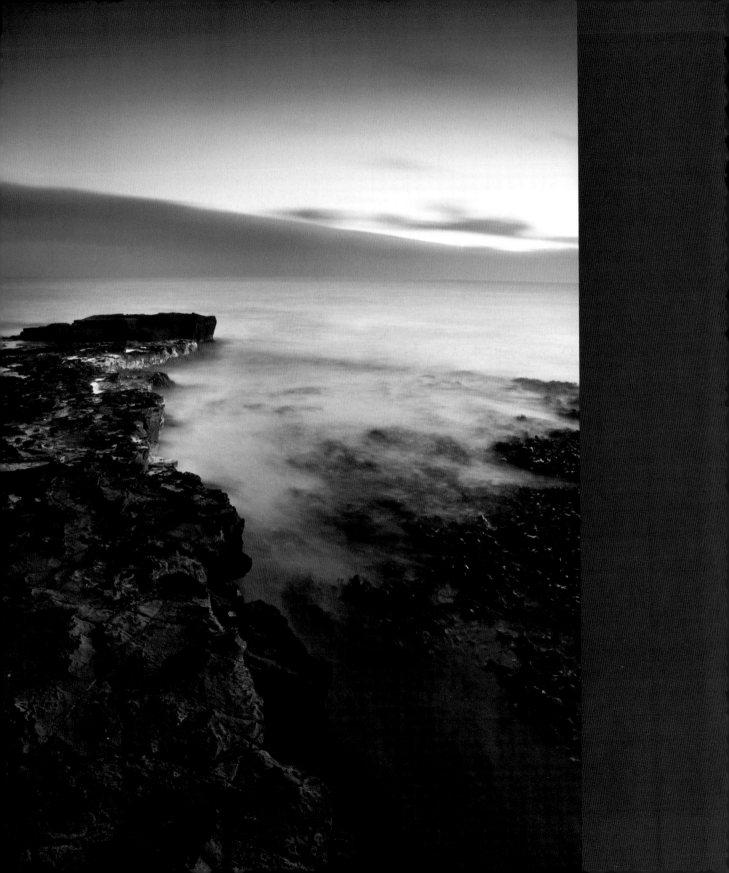

Introduction

THE SUBJECT OF THIS BOOK IS THE EXPRESSION OF VISION OR INTENT—and not vision itself—so I'm inclined to keep my talk of vision short. However, I've never been accused of brevity or of saying my piece only once, so if you've read anything else I've written, this will be familiar territory. The subject of vision does need to be covered, though, because it's central to the notion of expression, and I've always hated it when an author forces me to read another of his books to cover material foundational to the one I'm currently reading. Bit of a balancing act.

There can be no discussion of expression without at some point touching on that thing which we intend to express. I've been confused for years about the photography world's odd backward approach, so often focusing on gear, technique, and craft without ever talking about intent or vision. I'll use these words interchangeably because I see them as one and the same. The word *vision* is a tough one; we use it as a metaphor, but metaphors aren't helpful when the language starts getting fuzzy, as it does when we use the word vision to talk about our inner intent and to describe the things we see with our eyes. *Intent*, on the other hand, is much clearer. It's what you *mean to say*.

You might not always say something quite right; it comes out jumbled and muddled. Ambiguous. You clear it up with a mumbled apology and try again; "What I *meant to say* was..." You had intent, even though the way you used the language calls for a redo. On the other hand, there are times when that intent comes through loud and clear. When Martin Luther King Jr. stood up and began his "I have a dream" speech, his intent was unmistakable and he lit fires inside people that burn to this day. His passion was clear, his cause was just, and the time was right. But without a sense of his message, it might just as easily have come out with *ums*, and *uhs*, and "You know, uh, why can't we all just get along?" We'll come back to Dr. King in a moment, because it's a good analogy.

◀ Nikon D3s, 24mm, 30 seconds @ f/22, ISO 400
Curio Bay, New Zealand, 2010.

It Means Something

I BELIEVE THERE ARE TWO KINDS OF VISION separate from the ability to see with our eyes. There is *personal* vision, and there is *photographic* vision. Personal vision is the big picture; it's macro vision. It is your worldview and, to return to Dr. King, it was everything in his sizable heart and mind that led him to believe what he did, say what he did, and teach what he did. It's who you are. Photographic vision is vision as it pertains to an image, or a body of work. It is your intent for that one image. Two analogies come to mind. The first is Dr. King again;

▷ Nikon D3s, 24mm, 10 seconds @ f/22, ISO 200

Curio Bay, New Zealand, 2010.

I photographed this image, and the preceding one, in Curio Bay on New Zealand's South Island, within minutes and mere feet of each other. The elements and decisions that went into both differ and result in different moods. This particular scene was a fantastic kelp forest at low tide, the long tendrils of the kelp moving to and fro with the surge of the surf, which is here reduced to a blur and given a more peaceful feeling than a shorter shutter speed would have resulted in. Images like this, for all our good fortune in finding such a place and waiting out the light and the weather, are a result of our intention.

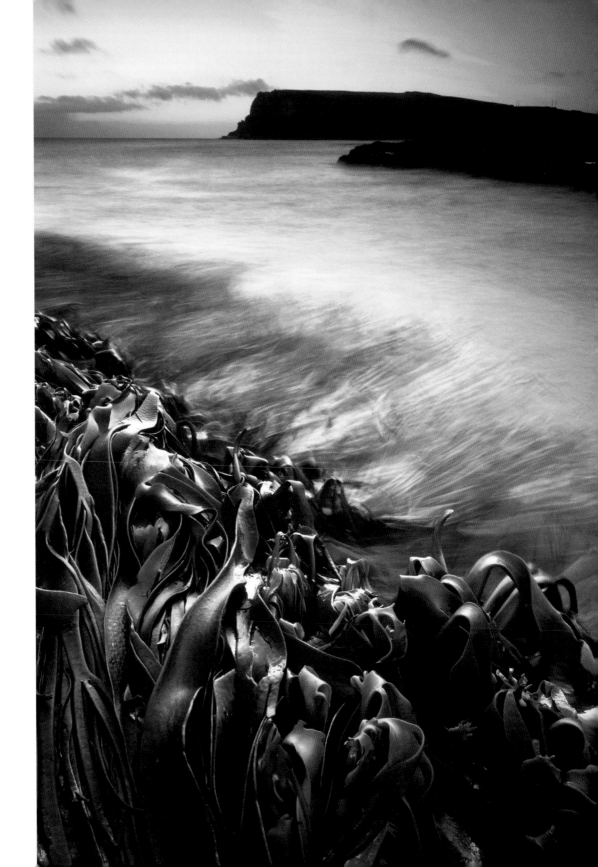

his larger personal vision—the dream he spoke of in his speech—fed his specific vision for the speech he gave that day. He knew what he wanted to say, and that led him to choose the words he did, to express both the larger and more specific visions.

The second analogy is the writer, though a musician would serve us well here, too. The writer's larger vision, her personal vision, determines the kind of books she writes, the kind of audience she envisions, and the way her stories end. Her more specific vision for a single book, however, needs to be narrower. What is she trying to say, and what is she not trying to say? What direction will the story take, and how will her characters speak? That intent drives her decisions to choose one word over another, one sentence over a different one.

The way we express ourselves first depends on our having intent. No author throws random words on the page in hopes that they will somehow make sense. (Okay, some seem to, but they aren't exactly selling box-loads of books.) Yet we photographers do it all the time. We make photographs without fully engaging in the process, without being mindful of our intent for that one image. But if you identify that intent, it narrows your gaze and helps you choose the best lens, the best shutter speed or aperture, or suggests you shoot from a different, better perspective. Intent matters. It is the prime mover. Without it, we are engaging in little more than accidentally exposing light to film or a sensor.

I once read a comment online that suggested a photographer's frustration with this idea. He said if he had to think about his intent every time he made a photograph, he'd put a fork in his eye. (Or something like that; I might have added the fork part.) But it was clear he wanted to avoid thinking too much about things. Can you imagine if your favorite author or songwriter felt that way? By all means, go out and shoot in whatever fashion you like, but if you ignore the role of intent or vision, there's a reason you're frustrated that your images don't say what you want them to or look how you want them to. It's because you really don't know what you want them to say—and therefore don't know how to make them look the way you want.

Become more mindful of what you want to say and then practice your craft relentlessly so that you have the growing means with which to say those things, and you'll be working in that beautiful space where vision and craft collide and, in that mash-up, create expression: art.

Is it simple? Far from it. It can be hard. It can be elusive. We grow and change, and as we do our personal vision changes, too—as it should—and that trickles down to our artistic, photographic vision. So just as we feel we've got a handle on this vision stuff, it vanishes and we're pushed to begin again. No wonder artists go insane. But what a journey. I won't discuss process here, because the ways in which we create are all different.

All I want to do is leave you with an introduction to the idea of intent, because it plays heavily in this book; without it, all discussion of expression, which *is* the subject of this book, is meaningless. If it's as simple as an inner dialogue and the question, "What am I trying to say?" then that's a good start. To put it another way, writer Anne Lamott says that "art, to be art, must point at something." Knowing what you are pointing at before you do so is not only helpful, it's necessary. Ever seen someone look at something in front of them, say, "Look at that!" and then point 90 degrees to the right of what they're looking at? Neither have I. But it would be genuinely surreal and confusing. What on earth do they want you to look at? Sure, their finger is pointing in one direction, but their eyes, by looking at something in another direction, are pointing elsewhere. It's unclear. The body language is confusing.

I'm writing this book to help us all point more clearly, to avoid confusing language in our photographs. Through it I am hoping to bring us all a little closer—myself included, because I learn most when I teach—to creating photographs that look the way we want them to, and therefore say the things we ask them to say.

> "The way we express ourselves first depends on our having intent."

"But I Shoot Intuitively"

The most common reaction I get when speaking about vision-driven photography is this: "I don't need to consider my intent or learn about visual language because I shoot intuitively."

I don't buy it. Yes, there are photographers who appear to shoot intuitively. Some of them seem so talented that I want to sell my gear and go back to juggling. But intent and the use of specific visual language to express ourselves are no less important. I suspect two things in these scenarios. The first is that the photographer really does shoot intuitively, and that this seemingly effortless

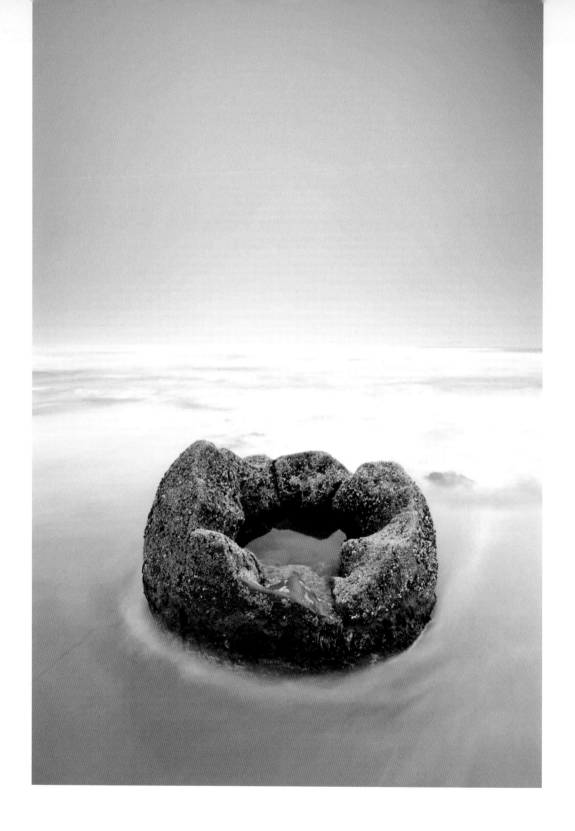

image-making is a result of years of internalizing—consciously or not—the visual language. You don't have to be able to write a textbook on English grammar to be a poet. This book is not for that person.

The second possibility is that "I just shoot intuitively" is artistic and technical laziness, and if that's the case I suspect the images would be much stronger if the photographer were a little more specific about what he wanted to say, and a little more intentional about the elements he included in the frame and the decisions he made in arranging them there. I suspect this book is not for that person either. Or, rather, it *is*, but it's unlikely he'll read it.

I believe in the power of shooting intuitively in much the same way that I believe a jazz musician (I'm listening to Miles Davis's *Kind of Blue* as I write) plays so much, develops the muscle memory required to play his instrument without thought, and internalizes the language of music so well that the path between his emotions (intent) and his expression seems uncluttered by so much as a single conscious thought. That's flow. It's a magical place to be, but it doesn't happen because of your genetics or talent or because your mother dropped a Leica on your head as an infant (though it might explain the weird scar). It comes from putting in the time. Most of us are not prodigies, and the best photographers I know, while they're undoubtedly naturally creative, seem to have that flow because of the hours—many and long—put into understanding and practicing their craft.

If you want your photographs to have meaning, you have to put it there. One day it might look effortless, almost intuitive, to others, but there's no short path to getting there. The best photographers are the ones with both a clear intent—even when that intent is just a feeling—and the practiced visual language skills of the craft.

All Content Has Meaning

The readers of your photograph make an assumption. They assume that you know what you are doing, that you meant to say the things you did by including or excluding elements and making certain decisions, whether technical—that is, optics, shutter speed, and aperture—or artistic—that is, your point of view and

◀ Nikon D3s, 20mm, 6 seconds @ f/14, ISO 400

Moeraki Boulders, New Zealand, 2010.

▶ Nikon D3s, 70mm, 1/2000
@ f/22, ISO 200

Masai Mara, Kenya, 2011.

use of perspective, or your framing. The reader believes you meant to do it. So whether or not the idea of intent works for you, it is assumed by your readers. And because they believe this, all content—whether we intend it or not—has meaning.

Because of this fundamental assumption on the part of the reader, every element implies something. Every decision we make that forms the image, whether in-camera or in the darkroom, implies something. Any meaning that comes from our photographs comes because we allowed it to be there.

I guess it's fair to ask if the reader's assumption is a fair one. I think it is. It would be a rare novelist who just threw a bunch of extra words into her novel for no reason at all. Rarer still is that this novelist could then blame the reader for thinking the author knew what she was doing and meant something by these words. "Don't read into it, for crying out loud, I just threw a bunch of random words on the page!" But it's this kind of thinking I hear time and time again from students when I ask why they've left this or that in the frame, or why they excluded something else, and they stare at me like I'm an idiot before replying, "Well, because it was in the shot." No it wasn't. It was there, no doubt. But if it's in the photograph it's because you *allowed* it to be there. As craftsmen we have many ways of including or excluding elements at will. We have optics with different angles of view, we have apertures capable of creating various depths of field that include or exclude elements within the plane of focus. We can move around a subject, sometimes in every possible direction. We can expose in such a way that we plunge things into shadow and hide them from view. And to be honest, if we're going to avoid sloppy photography and blaming the universe for failing to align to our wishes, we can choose not to press the shutter button and make the image in the first place. We can choose to come back later, try again, scrape the paint from the canvas over and over until we get it right. Neither blaming the reader for an unfair assumption nor blaming the scene for being as it was will result in meaningful images.

Our best chance at being understood, once we've identified our intent, comes before the image is created. That's when we make the biggest decisions and include the elements we need to create the meaning in our images. Meaning in a photograph, at least where we have anything to do with it, comes at the place where Subject, Subject Matter, and Composition overlap. I think of them as Message, Elements, and Decisions, because it makes more sense to me, but I'll

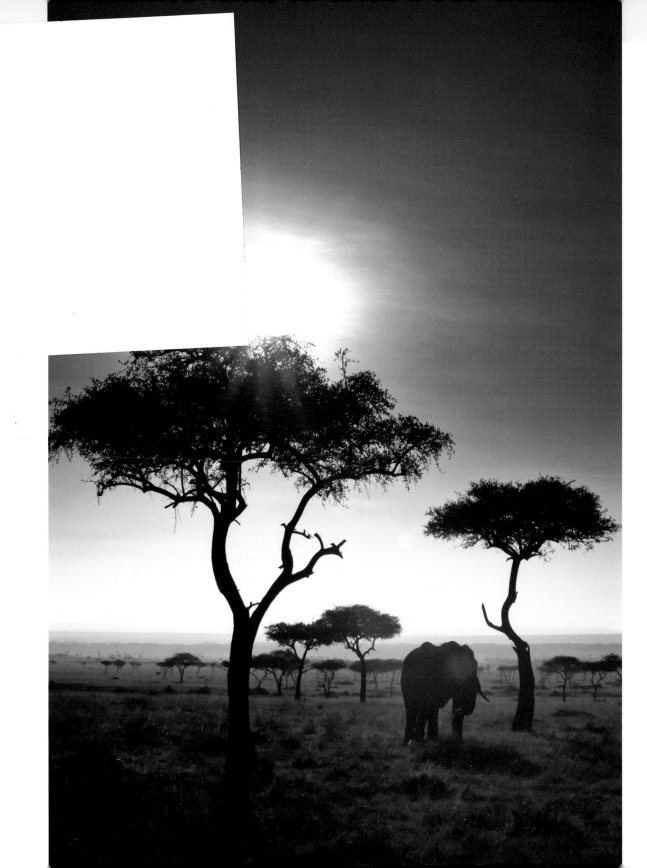

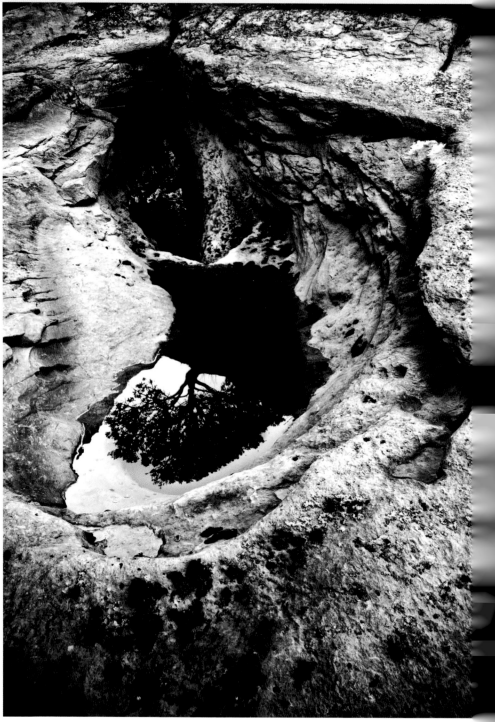

explain that as I discuss the difference between the three and why I think meaning is found at their intersection.

The Subject is the message or theme of the photograph, and it differs from Subject Matter in the same way in which the moral of a story is not the story itself. Let's use the fable as an example; the fable and the moral are two different things. The Tortoise and the Hare is a fable about the value of pacing and persistence. In this story the subject is not the race between the tortoise and the hare; the subject of the fable is patience.

Subject Matter is the thing through which the story is told—in this case, a race between a turtle and a rabbit. Aesop could have chosen to communicate the same subject or moral using very different subject matter. The two are connected but not the same, and the difference is important because one is about meaning itself, and the other is about how we communicate that meaning. But they are connected. As I said, Aesop could have chosen to tell the story differently—for example, with an elephant and an ant—but that wouldn't have communicated the moral as clearly. Why? The contrast between a turtle and a rabbit is one of slow versus fast, and the impact of the fable comes from the surprise ending when slow wins the day. Elephants and ants are about large versus small. Is there a fable in there somewhere? Sure. It just won't be one about our subject: patience and perseverance.

Composition is the way in which the story is told. It's in the structure. The words are chosen, arranged, and rearranged in such a way that the story is true to the author's desire to express himself in his own way, in a way that he feels is clearest to the reader. It is composition that makes a story engaging, creates tension, builds to climax, then resolves. Or it doesn't. There are plenty of stories out there that have a great subject and clear subject matter but are so poorly composed the story just never makes it off the ground.

All three combined give the story its meaning. The missing piece, of course, is the reader. Once she begins to read, a new element is introduced: the act of interpretation. That interpretation is entirely out of our hands. The best we can hope for is to craft our stories with universal and powerful appeal, and be unambiguous in our language. The same is true of photographs, and so it's important that we understand how people read a photograph in order to create one that has a chance of being understood.

◀ Nikon D3s, 27mm, 1 second @ f/22, ISO 200

Tree of Life, New Zealand, 2010.

I made this photograph while exploring the caves and arches at Cape Foulwind. The subject is life itself, more specifically the reproductive self-perpetuating nature of it. The subject matter is the tree mirrored in the tidal pool sitting in a rock formation that itself suggests female reproductivity. The angle of view, choice of lens, and the decision to crop out the form of the tree looming in the rocks above this scene allows this photograph to be as intentionally suggestive as it is. The final photograph is the intersection of the subject, subject matter, and composition. This is the sum total of what I have at my disposal to express my intended meaning, my wonder at life. I tried other angles and other crops, including the wider, more inclusive image inset here, but none of them carried the meaning I wanted to express the way this one did. Meaning is carried not only in what we say but how we say it.

As I said, I look at these factors as Message, Elements, and Decisions. The Message is what I want to say, or point at. It's what I want to show. The Elements are those things I include in or exclude from the frame. The Decisions are the choices I make in arranging those elements in a way that best communicates my message clearly. This is the paradigm through which I create my photographs. A writer would boil it down in simpler language, to: What do I want to say, what plots and conflicts are at my disposal, and how will I arrange the words to tell this story? Similarly, the playwright might ask: What is the theme of this play, who are my characters, and how do I place them on the stage? The photographer asks what he's pointing at, what he should include in and exclude from the image, and how he should arrange the elements within the frame.

Knowing what we want to say (vision, intent, message) allows us to make the best selection of subject matter (elements) and the best choices about arranging those elements (decisions, composition). How we make those three choices is what makes our photographs what they are, and it's because we're assumed to have made these choices intentionally, and not just accidentally, that the image will be read and interpreted.

The Frame

While painters can put to canvas nearly anything their mind conjures, the photographer is limited, to a greater or lesser degree, to what exists already. Our art is not the *creation* of things so much as the selection of them (and by that to create a new thing). That's not to say that our art is not creative; of course it is. But photography is an art that finds its materials in what is there already, and it's the frame that allows us to include things while excluding others. By the act of putting certain things within the frame and leaving others without, we are saying of those things in the frame, "Look at *these* things. *These* things are important." We are not saying things outside the frame are unimportant because, in fact, they don't exist. Nothing exists beyond the edges of the frame. We can hint at things by having the frame bisect certain elements, leaving the implication that the rest of those elements are in a world not shown. We can even suggest a porousness or permeability to the frame by using creative photo borders or messy carrier edges when we print. But the frame is essentially a tool of selection.

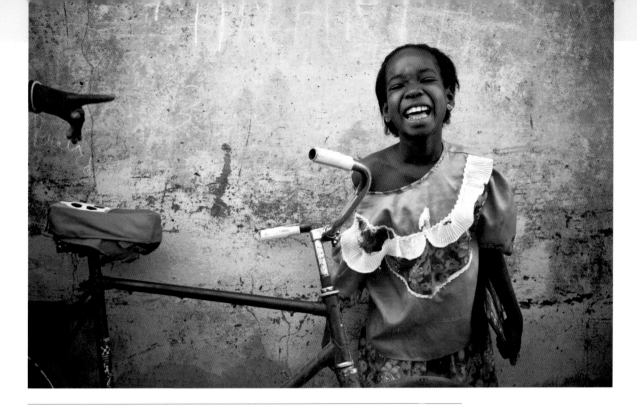

▲ Canon EOS 5D MkII, 32mm, 1/125 @ f/5, ISO 200

Senegal, 2009.

The frame creates a world of its own. Here it excludes the schoolmates of this Senegalese girl heading home from class, and it also forces a relationship between her and the bike, and most noticeably between her and the disembodied hand. Placing certain things within the frame is both an act of inclusion and an act of exclusion, forcing relationships and juxtapositions where otherwise they'd not have been perceived or connected.

When you include it within the frame—whatever *it* is—you are saying it matters. It's part of the story. It may not be a big part of the story. Its only role, like a piece of trash on the ground, may be to decorate the set and provide context or setting. But it matters. The frame isolates and gives the photograph its power to make significant the seemingly unimportant, to make visible the previously unseen, to imply relationships we'd never notice in real life, pulled from their context and presented as juxtaposition.

I am not yet speaking of *framing*. Framing is *how* we place our frame around the elements. How we do that is important, but that we do it at all is what makes

photographs, in their brief history, as powerful as they are. Millions and millions of photographs are created every year, and all of them—for better or worse—place certain things into a world of their own. They call attention to aspects of life we might never have noticed. In the same way we love to quote a line or two from Shakespeare, a photograph quotes life. The whole play is important, but the well-chosen quote distills something within the play in a more powerful and enduring way than the whole play itself might. I can't quote all of *King Lear*, but those pieces that I know mean something to me because they've been pulled from their context and pointed out to me. I won't mull over the whole story of Lear as often as I will think about the next-to-final words in the tragedy:

> *The weight of this sad time we must obey,*
> *Speak what we feel, not what we ought to say.*

It is for this reason that the notion that the camera never lies is absurd. The camera quotes life out of context. We create, with the frame, bite-sized pieces and implied relationships we'd never have seen. By excluding the world around something, we allow our undiluted attention to settle only on what is within the frame. We show more by showing less. That's the power of the frame. It is our job to choose where we place that frame.

I've often heard defensive cries from students when I suggest they've included too much—or not enough—in their photographs. When I've questioned their framing and asked whether it might be more powerful had different choices been made, I've heard over and over again, "But that's how it was!" Agreed. I said the same thing to my own photography teachers. But I was wrong. The role of the photographer is to make choices. The frame forces us to choose. And if you are going to choose, then it's best that you choose while keeping in mind that the reader will make that primary assumption: that you included everything on purpose, that it means something. "But," they protest, "I couldn't possibly arrange things to exclude what I wanted to! I just couldn't do it!" And that brings us to a truth about our craft that is a hard pill to swallow.

Not every scene at every moment makes a good photograph. Even the photographer who specializes in seeing the extraordinary in the mundane, or the photographer who might want to show that the mundane is, in fact, just mundane and not extraordinary at all, must use the frame to make a choice of what is in and what is out. We do it with moments as well. Some moments are less

visually compelling than others. The key word there is *visually*. When discussing moments it's easy to jump to Cartier-Bresson's idea about the so-called decisive moment, but he's misunderstood more often than not. Cartier-Bresson was not referring to a dramatic moment—he was referring to a visual one. He was talking about the look of a photograph, not the climax of a story. The decisive moment is when the apex of the action in any given scene coincides with whatever else is going on in the frame, and the frame itself. It's about composition. It's about geometry. The decisive moment, as Cartier-Bresson talked about it, is meaningless without the frame. Some moments, well chosen and well framed, make photographs that resonate. Some do not. Which moments those are...I can't tell you. That depends on your intent, and only you can decide that.

My encouragement to students, and my own challenge, is to be relentlessly aware of the frame. Not everyone makes photographs the same way or for the same reasons; some prefer to make images that are about simplicity, or vastness of open spaces, whereas some prefer images that are chaotic. Even the most chaotic image, to best convey that chaos, must be a conscious act of inclusion and exclusion. To convey chaos you'd have to exclude elements that are orderly, and that's as much of an intentional act as excluding chaotic elements might be for another photographer.

> "Perhaps the steepest learning curve in photography is learning to see as the camera sees."

The Flattening

Perhaps the steepest learning curve in photography is learning to see as the camera sees. The moment photographers understand that the camera sees profoundly differently than we do is a crucial moment. It's the moment an individual with a camera becomes a photographer. I'm not being prescriptive about that; it's just the way I think about it. Before we learn to see like the camera and understand that the camera is a tool that flattens the world from three dimensions to two, we are just people with cameras. The moment we start to see the world as the camera does, we begin to anticipate the way the camera will translate that world, and we become able to use that translator to communicate meaningfully, though even the word *translate* isn't quite accurate.

The difficulty is this: the camera is an idiot. For all the intelligence built into it by its makers, the camera was born capable of transliterating but not translating or interpreting. We're starting to talk about language now, and we'll get deeper

later, but if you took a paragraph from a selection of Japanese literature and transliterated it word for word into English, you'd have a choppy piece of writing with the words in all the wrong places. You'd be lucky if it made any sense at all. Add to that the fact that all languages have particular words that have no equivalent in another, and you'll see why what is needed is not transliteration but translation. Add cultural differences and what we *mean* by those words, and it gets even harder. Implicit in translation is some degree of interpretation. The translator's question is not only, "What does the text say?" but to some degree, "What do the words of the text mean?" Without considering both languages and the unique character of each, you get meaningless transliteration. Transliteration is helpful for scholars, but rarely serves the need to actually communicate.

That's a long way of saying that the camera is a profoundly simple—and under-qualified—transliterator. The camera will take the three-dimensional reality from which you want to pluck a rectangular scene, and it will flatten it into two dimensions. It will not ask you what you mean to say, it will not alert you to the way that flattening will push the foreground against the background and in so doing put a telephone pole through someone's head. It won't add depth. It will only flatten. It will take the language of reality as we usually see—in three dimensions—and translate it word for word into the language of two dimensions. Much gets lost in translation if we do not intentionally guide our translator. It is not an interpreter. That is our job.

Being conscious of this flattening allows us to use it to our advantage, or to compensate for it and reintroduce the illusion of depth. It allows us to begin to read an image as it really is—a flat image composed of lines and tones. I'm often amused by how unaware of this flattening we are. As photographers we deal in creating illusions, yet we're taken in by those illusions all the time. I hear my students talk about photographs as though they're little three-dimensional worlds. They say things like, "I like how that person is standing," as though the photograph is a little aquarium full of real, but smaller, people. I have to remind them there is no person in that photograph. There are only the lines and shapes that represent that person. If this sounds like pedantic hair-splitting, let me explain.

The ability to see the illusion for what it is allows us to more finely create it. If we stop seeing that shape in the photograph as a person and instead see it as lines and tones, we become aware of those basic building blocks. Seeing the person

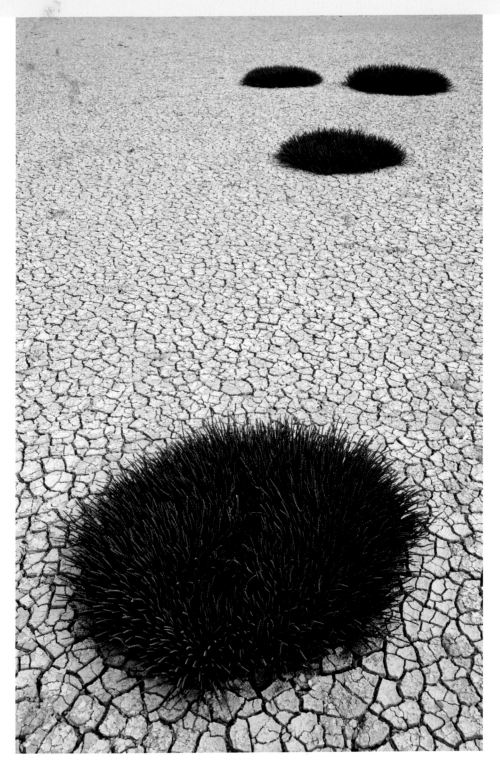

◀ Nikon D3s, 32mm, 1/80 @ f/18, ISO 800

New Zealand, 2010.

Learning to anticipate the translation of three-dimensional scenes into two-dimensional images begins with recognizing that each element gets flattened and becomes not, for example, a patch of vegetation in a sea of cracked earth, but a series of lines and tones that can be rearranged, balanced, and played against each other as we play with optics and angles. We arrange those lines and tones within the constraints of the frame.

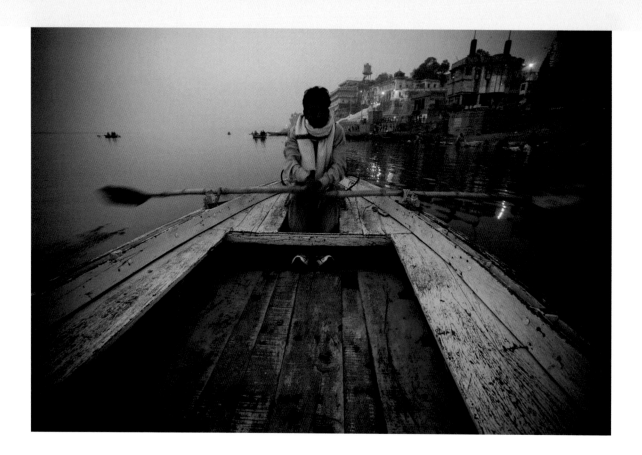

▲ Canon EOS 5D, 17mm, 1/13 @ f/5.6, ISO 800

Boat Walla, Varanasi, India, 2007.

When I refer to the flattening I do not mean the apparent
compression effect of a longer lens, but the way that
elements we normally perceive as moving from front to
back become lines that move within a frame that has no
front to back, only length and width. We can create the
illusion of depth, but in this photograph of a boat walla on
the Ganges, the lines of his boat are just that—lines—and
in order to manipulate them with lens choices and camera
angles you must first see them as flattened lines. Using
a wide angle and a low point of view here allowed me to
move the lines around in order to direct the eye and create
an immersive feeling. Other focal lengths and angles
would have placed the lines differently, resulting in a
different photograph. Same scene, different look entirely—
and therefore a different experience for the reader. The
perceived depth in this image comes from intentional
choices to reintroduce it through the manipulation of
the lines.

distracts us; it's a sleight of hand that keeps us from seeing what's really going on. It's pattern recognition, something Galen Rowell often wrote about. We see the shapes and recognize them as a person because we've seen people before. Additionally, we respond emotionally to people. So when we look at a photograph of a loved one, we find that our emotions for that person come flooding back. The emotional response created by the illusion of the photograph blinds us to anything but that emotion. But ask a photographer who doesn't know that person, who doesn't share the same memories, and they'll see things in that image you never did. They'll see sloppy framing and imbalance, harsh shadows, and distracting backgrounds. It's an extreme example, but learning to see images as they really are—being able to identify the building blocks—becomes an important way of seeing.

This is the reason I encourage people to *talk* about photographs. Really talk about them. It leads to better perception of the two-dimensional image, which leads to better collaboration with the camera as we create. But we're getting ahead of ourselves.

What is needed is a keen sense of what is within the frame of the photograph. Not people, trees, brides, grooms, or faraway places, but the result of the translation or flattening. The photograph is its own medium, its own reality, and it needs to be—it will be—read that way. When we are conscious of this and we force ourselves to predict the effects and the results, we stop being at the mercy of this peculiar quirk of our art. We become more able to control it. The camera will create an illusion the moment we release the shutter; if we want a hand in creating that illusion, we need to understand it.

That illusion is created by every element in the photograph and every decision made. Elements and Decisions: that's what we have. It's what you do with what you have, as it is with every art.

A Good Photograph?

When I returned to photography seriously after a 12-year detour in comedy, I came at it with a new perspective. As a comedian, I'd spent 12 years studying comedy. Comics, for all the laughter, can be a too-serious bunch. They pick things apart, record their sets, count LPM (laughs per minute), study what makes people laugh and why, and they write and rewrite, obsessing over each word, each beat. The best of them learn the language and work relentlessly to bring the audience to the most laughs with the least amount of words. Fewer words mean more time to laugh. It's economy. But for all the study, there's one goal: to have the best set possible. To do that you need to perform as many sets as possible, to get it out there on the stage, bring it to real audiences. And you need to understand what makes good comedy.

But that's where it gets tricky. What is *good* comedy? What makes one crowd laugh will make another angry. The word "good" is unhelpful; it's just a little too vague to be meaningful in our quest for, well, "good" photographs.

So perhaps we need to redefine the goal, be more specific about the target.

We all make photographs for different audiences, and for different reasons. What compels me to pick up my camera is different from what compels you, but I think we're all trying to point at something. Some of us are trying to communicate information, some are trying to elicit a raw emotional response, some want both. But we're all trying to show something; with the camera, we're saying, "Look at this." It is, to be pragmatic, about communication. It's about expression. Communication and Expression are two sides of a coin. The former places a priority on being understood; the latter's priority is simply to get it out there in the most authentic and powerful way. For most photographers, I suspect, the most desirable scenario is to create photographs that do both.

The trouble, of course, is that from the final moment of creation, when we wash the clay from our hands or put the paint brush down, we've said our last word. We have completed the expression, and whatever interpretations the audience brings to bear on the work is way out of our control. In other words, you can be sure of expression—when it happens, you know it. But communication is a trickier game. Fifty years ago, Ansel Adams expressed himself beautifully, but today, the notion that he is still *communicating* depends on whether the viewer

is listening. It takes two people to communicate, and only one to express. I think we can do both.

That's the stuff I think we need to understand as we look to define what it means for us to create a "good" photograph. I'm not sure it always helps our process or results in better photographs, but I do think it helps us identify the goal. For most of us, I suspect the goal is to express something of ourselves that communicates that something to others. Even when it's a wedding. You haven't been hired to "express something," right? But you have. No one simply records things as they are. The frame forbids it. The act of photographing requires that we make decisions about what we include, and which moment we select. As a wedding photographer you're hired to react to the emotions, moments, and relationships of the day and express that reaction through your images. It's the same with landscape photographers. Your first reaction may be, "But I don't want to *express* myself, I want to show people the beauty of the morning light on the land," but how do you do that if you're not expressing the way *you* see, the way *you* feel about that scene? It's expression. It always is. If you don't care about your subject or subject matter, if you don't have any reaction to it, if you've got *nothing to say*, why photograph it?

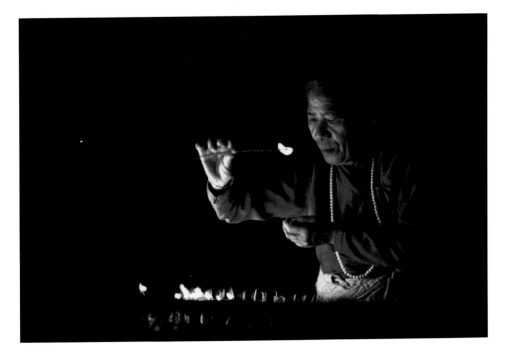

◀ Canon EOS 1Ds Mk III, 85mm, 1/100 @ f/1.2, ISO 800

Kathmandu, 2010.

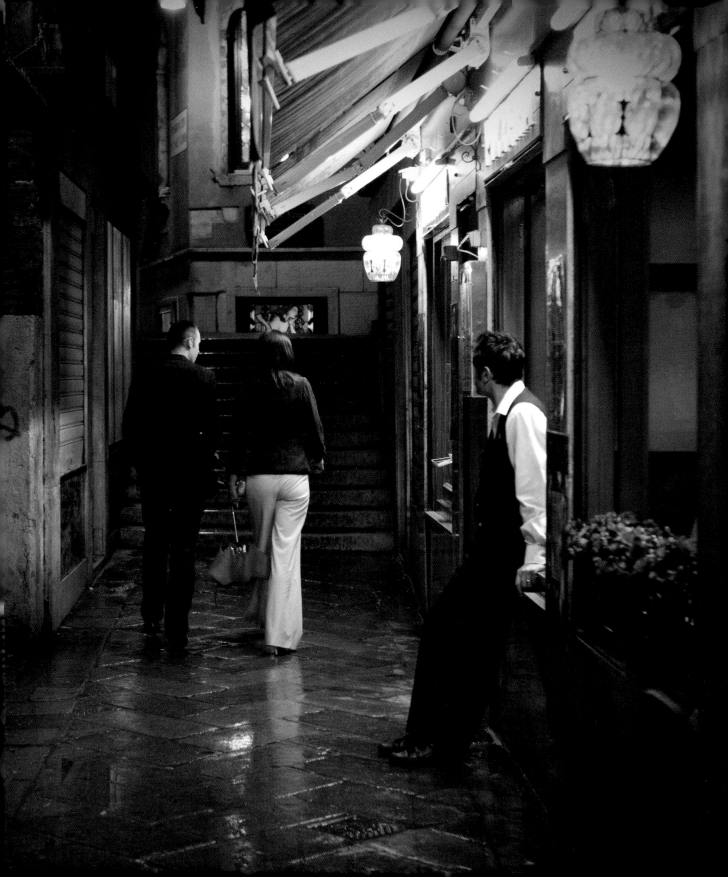

◀ Canon EOS 5D Mk II, 52mm, 1/40 @ f/2.8, ISO 1600

Venice, 2010.

For me, this photograph is about longing. For part of my Venice monograph, I was exploring the theme of loneliness. This man may not have been looking at this couple with anything more than curiosity, but I saw longing. Knowing what you are trying to say, even if all you have is a feeling, is a good place to start as you make decisions about what to include and how to arrange those elements. In this case, a longer focal length would have created a tighter implied relationship between the couple and the man watching them. If I'd been able to, I would have liked to have been a little closer so I could have used a slightly wider lens and increased the feeling of disparity between their world of companionship and his world of solitude.

If the goal, then, is to express ourselves in a way that communicates clearly to our intended audience, the most helpful questions are

- What am I trying to express? What's my vision or intent for this image?

- Who is my intended audience and how will they read this photograph?

- What elements can I include, what elements must I exclude, and what decisions can I make to both express my vision and communicate it in a way that elicits a response from my audience?

The photograph succeeds first when it expresses something for you. Commercial concerns aside, we make photographs first for ourselves. We all want people to love and understand our work, even when that is not remotely the principle goal. If not, why create it? Life is too short to create work that says nothing, means nothing. But art is not created in a vacuum, and while we create it first because we are compelled to, art is also a gift. It is the nature of art to be shared, to be a gift, and so the recipient of that gift must to some degree be considered.

Photography has its own language, and although the grammar and vocabulary of that language are still growing and evolving, it is still a language, and photographs will be read according to the conventions of that language. All the innovation in the world may make you feel very artistic and expressive, but if you hope to be understood—to communicate—you need to know the language in which the audience will read your work. In our case, it is the language of the photograph.

▶ Nikon D3s, 20mm, 1/125 @ f/22, ISO 200

Fig Tree, Kenya, 2011.

What we say is in both the words we use and the way we choose to use them. Together, the choices to include the sun and the fig tree (the words in this image) and to use a low point of view (POV), a wide angle lens, a tight aperture, even to use a lens I know to generate exaggerated lens flare (the grammar of this photograph) form the language of this image. It is the knowledge and use of this language that enables us to express ourselves, to say more than "I was here." It allows us to say, "It felt like this."

All art forms have their own language. The most universal and powerful of them, like music, are understood by the audience without, or with only a fraction of, the knowledge that is required to speak it. I can't play the cello, and I know next to nothing about music, but I know when I first heard Gorecki's Symphony No. 3, I wept. It's not the viewer's responsibility to learn the language, but ours to know it well enough that we can communicate powerfully and bring people to tears or laughter or wonder without demanding they first read a book to understand it.

For the sake of this book I'm going to steer a wide berth around the issues related to criticism and what makes art. I have my own opinions and they'll creep in here and there, but for the sake of this book, the "good" photograph is the one that expresses what you desire to express, and communicates to your audience in the strongest and clearest way possible. For that reason, perhaps substituting the word *successful* for the word *good* is more helpful and gives us something more tangible to aim for.

Visual Language

The notion of visual language is not new, and I am not going to discuss it in deep technical detail. I'm not drawing from formal study on this, and this book isn't meant to be a primer on what is probably a discipline people spend a great deal of money on in pursuit of a graduate degree. I want to talk about it as a metaphor, and hope that doing so affords me a certain freedom from the constraints and accountability of academia. All that to say: there are smart people out there who know much more about language than I do, and this is meant simply to help us get our minds around the idea of using our craft to better communicate our vision, and in so doing to create images that move people.

Before you get worried about being bogged down by all this, relax. I'm using language as a metaphor here, and the whole point of a metaphor is to describe complicated things in different, more familiar terms—ever simpler terms—in order to increase understanding. For the record I didn't do very well in school until my final years, and subjects like grammar took a long time to take root. Still, for all that, I think comparing a photograph to more conventional language is helpful, as language is the way we communicate every day.

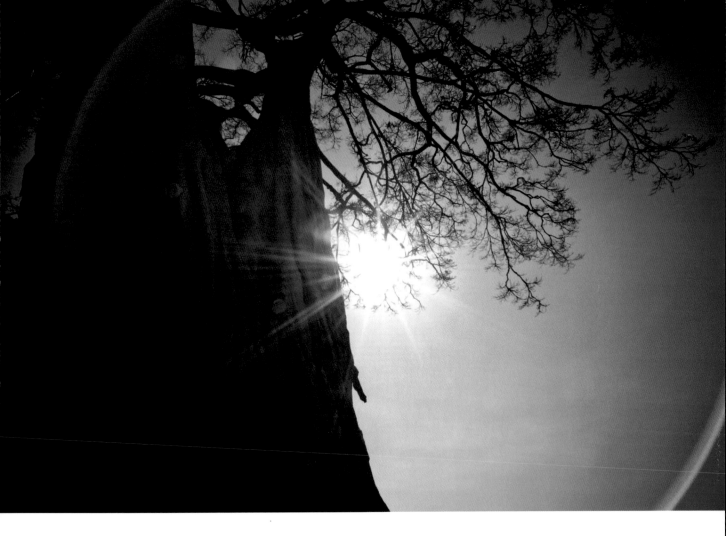

The most fundamental building blocks of language are simple. Words and Grammar. Words are the basic units of meaning, and Grammar is the way in which we assemble those words in meaningful ways. Both rest on a commonly accepted series of rules and principles, and that keeps us all in the same general ballpark when one person has something to say (I mean this...), then says or writes it, and another person hears or reads it, then interprets it (he must mean this...). It is the common acceptance of what words mean in their context, and in the way that they are assembled, that allows us to communicate at all.

This topic dovetails nicely with what we discussed earlier in saying that meaning is found in the intersection of Message, Elements, and Decisions. The message

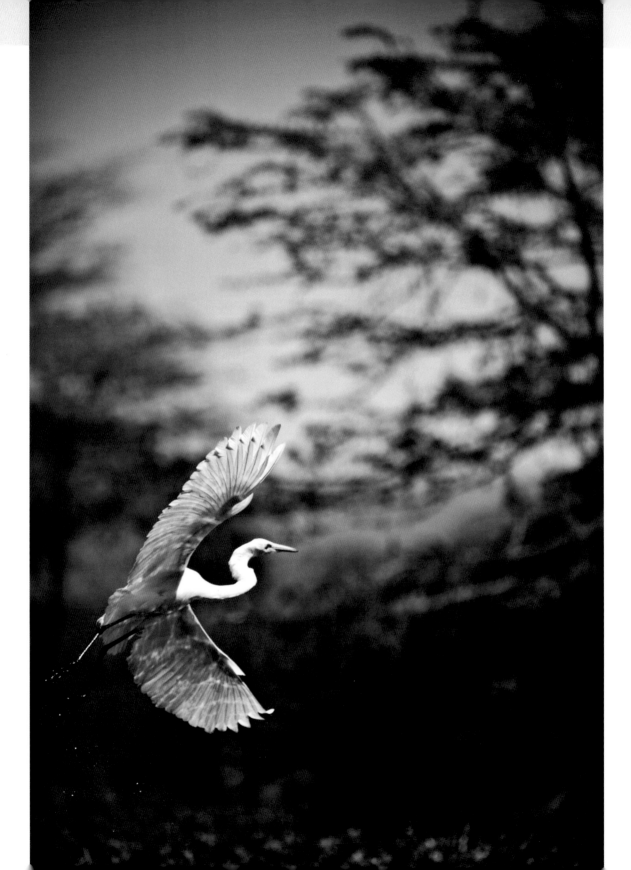

is still the intent of the communication. The elements of the photograph are the words. The decisions we make in assembling those elements within the frame are the grammar. Having an understanding of verbs, nouns, and adjectives doesn't matter for our purposes; knowing how people will read or respond to our photographs matters. They may not even be aware that they are reading your image, may not have a clue about visual language. But they'll respond all the same.

"I Like It"

When I conduct workshops, the most significant teaching times we share together are the image critique times. We gather where we can, with laptops or a projector, and each student shows a photograph. My directions are always the same: talk about the photograph itself. How do you react to it, and why? What does it tell you? And through all of this the photographer herself must remain silent. Why? Because we speak through our photographs, and if we have to add to it, we've not created a successful image. Once in a while, yes, we need context and captions, but what we try to do in these sessions is guess the intent of the photographer. If she's done it well, we all react similarly, though not identically. The photograph should be able to speak for itself, and when the photographer pipes up with the inevitable, "Yeah, but I..." we remind her that she has already spoken through her photograph. We don't do this to be rude. We do it because these gatherings are not normal; in most cases our photographs go into the world carrying within them the only words we will be able to say to the ones who will one day read those photographs. We rarely have the luxury of telling people how to interpret our images, so being reminded that the photograph is our *only* means of communicating meaning as a photographer is helpful. We also do it because the purpose is to learn, and if eight people tell you they read your image differently than you intended, it's a good sign you're not saying the things you thought you were.

Each presentation follows a predictable pattern in three phases. The first is awkward silence during which people look at the image and hope someone else starts talking before I pick on them and ask them to lead the charge. The second is reaction, the phase in which the first thing out of their mouths is "I like it" before I start thinking about throwing something at them to push them to the third phase. The third stage is evaluation, the dissection of *why* they like it,

◀ Nikon D3s, 300mm, 1/4000 @ f/2.8, ISO 200

Lake Naivasha, Kenya, 2011.

If this photograph moves you in some way, that pleases me, but as students of a craft it's important we are able to say *why* we are moved by a photograph. Is it the motion, the drops of water, the composition, the toning, the contrast, the lines of the bird's neck? Knowing what we respond to—and why—helps us build those elements more intentionally into our photographs.

are indifferent to it, or react in a certain way. Once that's out of the way it gets a little easier, but it's interesting to me that photographers wrestle with how to talk about photographs.

Why do I push students to move past the "I like it" stage? Because "I like it" is irrelevant to the learning process, and probably not very relevant even to the goal of the photographer who created the image. I don't create photographs so you can "like" them or find them "nice." Not once have I created a photograph with the first intention being that people like it. I hope for something more. I hope they will feel something, see the world differently, respond in some way more than simply liking it. If they like it, fine. But my interest in this conversation is in teaching photographers an awareness of visual language, not showing them photographs of kittens and rainbows. That people respond to a photograph is, of course, important, but if we want to improve our own ability to create photographs to which people respond, we need to look more mindfully at *why* people respond the way they do. If you like a photograph, the question relevant to this book is *why* do you like it? What is it that the photograph is saying to you that moves you?

Moving into the evaluation stage is when we talk about the photograph. What I ask students to do initially is tell me about every element and decision that has gone into the making of the image and what message those parts, and the sum of those parts, communicates. Although it sounds challenging, remember that we're talking about photographs. Nothing is hidden from view here. Everything is visible because that's all there is in a photograph—the frame, and the stuff you can see in the frame. So I ask them to *describe it all.* And we all feel a little silly pointing out the obvious, but I want to know *everything.* I want to be told it's a portrait of an antelope placed on the bottom right of a horizontal frame. I want to be told that the grass is backlit and that the warm light is responsible for the feeling of early morning and serenity. I want to be told about the moment the photographer chose—when the antelope is eating, therefore not at attention— further adding to the feeling of being part of a scene rather than an intruder. I want to know about the angle (low, almost from the animal's level), the depth of field (very low, resulting in a soft and serene background), the plane of focus (perpendicular), and the relationship of the foreground to the background, among other things. And *then* I want to know how they think and feel about the image and why.

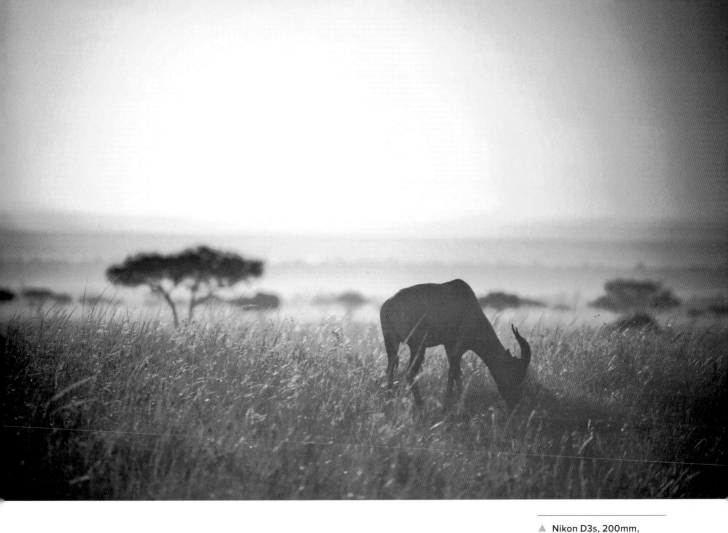

▲ Nikon D3s, 200mm,
1/6400 @ f/2.8, ISO 400

Masai Mara, Kenya, 2011.

It is so important that as photographers we learn to read, experience, and talk about photographs themselves. I'm not sure we need to pick images to pieces, and I'm pretty sure there's no need to systematize the whole thing. We do pick the images apart to learn, but it's learning that's the goal, not the awkward dissection of something beautiful. Often a thing is greater than the sum of its parts. You can kill a living thing and dissect it, looking for the life, but all you'll find is anatomy. Anatomy helps us understand how a living thing lives, but it doesn't replace the wonder of life itself. Having said that, I think you'll find it helpful to break this stuff down a little further. But first I want to talk about the cumulative effect of using the words and grammar of the visual language well.

Layers of Impact

Last year I was teaching in Kenya and playing around with an idea I was calling Layers of Awesome. It's become a pet concept of mine, but when I started teaching in front of larger groups I felt I owed the idea a more dignified name. So it became Layers of Impact.

The idea behind layers of impact is this: If you want to make a beautiful image, you have to put the beauty there. If you want to make—forgive the jargon—an *awesome* image, you have to put the awesome in there. How do you do that? Essentially, it's layers of elements and decisions. The image is nicely composed, but add the most appropriate light, choose the perfect moment, add some motion blur, expose to hide all but that one amazing detail, choose a wide-angle lens, shoot from an oblique angle to add depth to the photograph, and you've created a photograph with layers of impact that will provoke a stronger response and hold the attention of the reader longer. To go back to the language metaphor, you've created something more than a catchy limerick. You've created a poem with depth and insight, one that people will read again and again. A poem that expresses something human.

Familiarity with the visual language means you have the ability to create both short, concise sentences and complex and powerful ones, consciously adding layers of impact. As you study these visual words and grammar, consider how they're used together to create photographs, and ask yourself, "Is there another layer I can add that would give greater meaning or greater impact to this image?" Sometimes it's a layer that needs to be removed—like color—in order to retain greater power in other layers. Color is profoundly seductive, and if it doesn't move the photograph closer to your intent, try rendering the image in black and white, permitting the lines and tones and the moment itself to take center stage.

Where the idea of Layers of Impact has been most helpful to students is in reminding them to ask questions of their process like "How can I make this photograph stronger?" The Layers of Impact concept provides suggestions about how that might happen, by prompting us to consider the various layers possible. Could the light be better? Could the moment be stronger? Have I chosen the best angle? If the question is, "What are my Layers of Impact?" and you can't come up with anything, remember that great photographs work for a reason. You have to put that reason into the photograph.

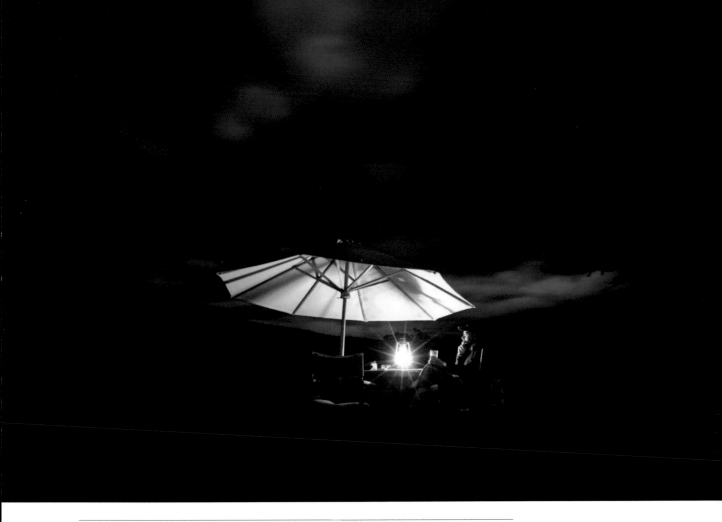

▲ Canon EOS 5D MkII, 16mm, 30 seconds @ f/5, ISO 800

Self-Portrait, Karen Blixen Camp, Kenya, 2010.

The photographer on the cover of this book is my friend Dave Delnea. He opened my eyes to the possibilities of shooting during the blue hour, that time of day between sunset and complete darkness. During the blue hour, long exposures give the sky more color than is visible to the naked eye. I set this shot up using the widest angle I could to enhance the line of the hills in the background and their convergence with the sweeping line of tree in the right foreground. The long exposure gave the image its great color and the softness to the clouds, which were moving quickly that night. The umbrella pushed the warm light of the lantern back down on me and the table, while pointing my lens directly at the lantern gave me the starburst usually only seen at tighter apertures. It is one thing to look at a photograph and say, "Nice image!" It's another thing entirely to be able to look at the layers of elements that go into making that image; doing so enables us to create stronger photographs that make use of these layers.

▶ Nikon D3s, 24mm, 1/125 @ f/9, ISO 400

Milford Sound, New Zealand, 2010.

The so-called Rule of Thirds is helpful only inasmuch as it helps you express your intent. Had I followed the rule to the letter, this photograph of Milford Sound would have had much less impact. Pushing the key elements closer to the edges of the frame gives a significantly increased feeling of vastness and scale that the Rule of Thirds would have forced me to lose.

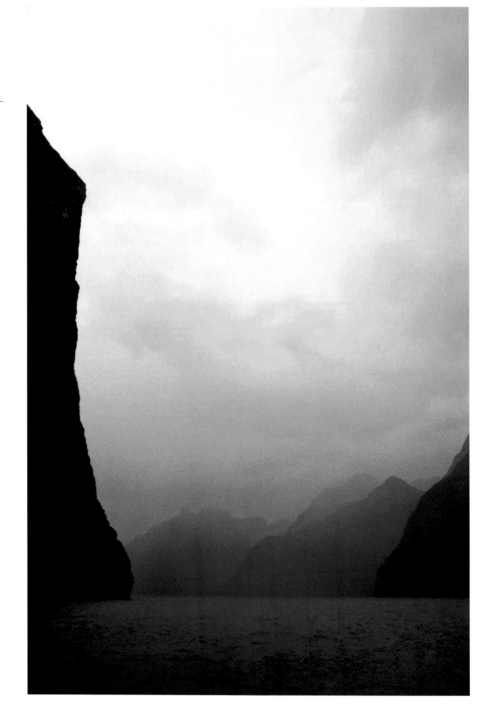

A Word about Rules

At some point while writing this book I threw a question out to many of my readers through my blog, Facebook, and Twitter: If I were writing a book that explored composition, what kinds of topics would you like to see discussed? What kinds of questions would you be reading this book for in hopes of finding answers? I got really good stuff—questions which, in some cases, pushed me harder to find clarity on topics that aren't always easy to discuss. But one of the questions that kept rearing its head had to do with rules and was expressed in a way I'm not sure I'll ever be able to give a satisfactory answer to. In its many forms, it went something like this: How do I know when to follow the rules and when to break them? After thinking about it for a while I started chuckling because what this question is asking is for another rule concerning when to break rules. So let's back up.

We've chosen the wrong word. There are no rules in art. There are none in composition, exposure, focus, or any other element of our technique. There are principles of good technique, and there are many so-called rules that once upon a time had a known rationale behind them. But as with so many things, those rules broke free of their rational moorings and started drifting. They come to us, washed up on the shores of our craft in so many well-intentioned books and magazines about photography, and it's high time we stopped following them. Art created in adherence to rules is art about rules, not about passion or beauty or any other thing about which humans have made honest art over the centuries.

That's not to say there aren't helpful principles. But they are only that. They're guides to help us make our decisions, but divorced from the Why, separated from the reason they became rules in the first place, they're more a shackle than a permission to experiment and express. I know the usual response to this discussion is that you have to know the rules first, then you can break them; I think that's baloney, too. Just knowing the rules is useless. We need to under-stand the principles of photographic expression, the reasons these rules came into play to begin with, and then feel free to use or ignore them in the service of our vision. Breaking rules for the sake of breaking rules isn't usually art; it's just anarchy. And following rules for the sake of following rules is just mindless con-formity. So by all means, keep the sun over your shoulder, your horizons level, and your center of interest on an imaginary line along the thirds of your frame,

but do it because those decisions get you closer to expressing your intent in this one photograph, not because you read it somewhere. Some of your best photographs will be made not in willful defiance of rules, but in understanding the principles and choosing to use those principles to go in a different direction. When it works, shoot straight into the sun, skew your horizon, and put your center of interest anywhere you please in the frame. There is no "should" in art.

So it's with a healthy suspicion of so-called rules and a desire to engage in some actual teaching that I'm going to avoid being prescriptive about what to do and what not to do. No literature professor worth her salt would tell you that you should always use certain words and sentence structures in certain situations. Nor would a serious literature student ask when he should use metaphors instead of similes. So much of this is about taste and unique expression, and no book in the world can teach that. It comes through trial and error. You play with the concepts, find where they work for you and where they don't. Like our spoken languages, you add to your vocabulary one word at a time, you learn to play with the order of words, and eventually to experiment with timing and juxtaposition as you tell, for example, your first jokes. Some jokes work because they're great jokes, but even they can be destroyed in the telling. And some people will never learn comic timing any more than photographic balance or the ability to predict a moment. There are no rules in comedy that result in perfect jokes. There are no rules in photography that lead to "perfect" photographs—if "perfect" photographs are even desirable. Some of this just simply can't be taught. It can be learned, certainly, but even then it comes by way of long days of experimentation and frequent failures, and for some it will always be a struggle. That's the hard face of it. It's what makes us sigh a little when we see the work of the masters—if it were within easy grasp for us all, we'd simply replicate it and move on. That we have masters and masterpieces at all is a witness to the fact that for most of us it'll be a hard-won battle to find our voice. And as most of us are all too familiar with the frustrations of that battle, that's good news. It puts us all in the same boat. Floating, but without a motor and having to figure out the damn oars all by ourselves.

On "Reading" and "Viewing"

In my eBook *A Deeper Frame*, I began to make the conscious choice to refer to those who look at our photographs as *readers* instead of *viewers*, and—though I will occasionally still talk about viewers, or viewing an image—that's a convention I am going to continue here in *Photographically Speaking*. This whole book loosely attaches itself to the metaphor of language, specifically written language. So in that sense, it's appropriate to refer to *readers*. However, I think it goes further than that.

I think the distinction forces a focus on the intentional and active interaction with a photograph, which is what I'm hoping a stronger, more intentional understanding of visual language will accomplish—that is, it will invite readers to engage. For the most part, to view something is a passive activity, really the opposite of participation or interaction. My hope in my own photography is that my photographs engage people, draw them in, make them more than viewers—make them *readers*. To return to the metaphor of language: in a good novel, the author provides the words and the grammar, which in turn build whole characters, settings, and plots. But it is the reader who provides the imagination and interpretation. It is the interaction between the words and the reader that brings the story to life, and I hope my photographs—and yours—will have the same chance at life in the eyes and imaginations of others. So it is for that reason—hair-splitting or not—that I use the word *reader*. And if it does nothing more than remind us that those readers will be assuming that we made intentional decisions about our photographs as they look for meaning, I think that will push our photographs forward immeasurably.

Introduction

ONCE WE'VE SEEN SOMETHING and raised the camera to our eye with the intent to create a photograph—that is, we've got something to say, and in our hands have the tools to say it—the rest boils down to words and grammar. Elements and decisions. That's about as tidily as I can break it down, and while there are times when it's obvious which are elements and which are decisions, they work in tandem.

It's a dance. We see our friend bathed in low evening light, and it's obvious that one of the elements in the photograph is that light. But have your friend turn in a circle with you and watch the light change upon her face from front-lit to side-lit to backlit, and back again. Your *decision* to work with the element of light, in one way over another, changes the look—and therefore the message—of the photograph. Backlit, the light forces you to make further choices about your exposure. Expose for her face and she's likely to take on an angelic look, the background blowing out and implying a more ethereal context. Expose for the brighter background and she becomes a silhouette, an abstract.

Which choice you make depends on what you want to say about this friend, but whatever your choices, it's undeniable that the resulting images would be very different from each other, and therefore be experienced differently by your readers. That's the dance between the available elements and our decisions, because once that photograph is made, the decision to backlight your friend becomes an unalterable element. Once the photograph is made, the element that you've chosen to present is strong, beautiful backlight. But in the moments before you pressed the shutter, it was your decision that made it so. It could just as easily have been front-lit had you made a different decision.

Similarly, our choice of framing imposes our will on the final image, and while one choice means the inclusion of certain elements, another choice would mean a simpler composition. To further complicate

◄ Nikon D3s, 35mm, 30 seconds @ f/16, ISO 800
Lake Tahoe, California, 2011.

it, the choices we make change the elements out there in the scene before us when they become part of the photograph. Let's go back to the backlit friend. She is in front of you, your eyes see her as perfectly focused in front of a forest of perfectly sharp trees. But raise the camera, focus on her, and open the aperture to f/1.2 to make the photograph, and by your choice of a wider aperture you'll have transformed those trees into a very different photographic element, a soft ribbon of orange and red bands. The combination of trees in autumn and your choice of aperture translate the scene into something much more than a documentary record; it's an impression of that moment and how you felt during it. Knowing that the aperture is capable of creating an effect like this is important. It's part of your visual grammar. But knowing the way viewers will read this image, how they will respond to the backlight, the ribbon of warm colors, that momentary downward glance—that's what allows us to take words and grammar and make poetry.

For the sake of the book we'll first explore what I've loosely grouped as Elements—what might otherwise be seen as the raw materials that make the image—then we'll look at Decisions, the technical issues related to organizing those Elements within the frame in a meaningful way. I urge you to see these categories only as an organizational decision to make this a little easier to talk about it, remembering that the elements and decisions that bring us to the final image are necessarily and inextricably connected. They work together in service of the greater thing. For the writer, that's the story. For us, it's the photograph.

Devices: Putting the Elements Together

Before we dive headfirst into all this talk of words and grammar, elements and decisions, I think it's helpful to briefly jump to the end of this process and look at where we're going with all this. It's important to remember that—and remember, we're talking in metaphors here—the words and grammar of the visual language of photography are not the point. The point is expression and communication.

In a written language, we use words and grammar as our basic building blocks, but we use those words and that grammar to construct certain devices, like metaphors, irony, foreshadowing, personification, and satire. An author uses these devices because they're known to capture our attention, hook our emotions, or make us better understand something. She uses action and suspense and love triangles and plot twists. She reveals some things and conceals others. If she's writing a mystery she might use red herrings, those seemingly important clues that lead us intentionally down the wrong

◀ Nikon D3s, 24mm tilt-shift, 6 seconds @ f/3.5, ISO 100
Bandon, Oregon, 2011.

Like the previous image, this one is a piece in a series I worked on while traveling across North America in the spring of 2011. Decisions were made to interact with the elements I had in order to create a certain mood. I was playing with an idea about dreamscapes, more impressionistic interpretations of the landscape forms I'd been playing with in the previous year, so long exposures and a wider tilt-shift lens were chosen specifically to string together the visual grammar of this series, to express and invoke specific feelings and moods.

▶ Nikon D3s, 20mm, 10 seconds @ f/6, ISO 400

Moeraki, New Zealand, 2010.

I photographed these boulders at Moeraki on New Zealand's South Island, and in playing with the geometry in my frame came up with a couple compositions I liked. Both gave a certain amount of perceived depth due to the wider focal length, but it's the photograph made from a more oblique angle that creates, along with the converging headland, the strong vanishing point, and therefore the greater perceived depth.

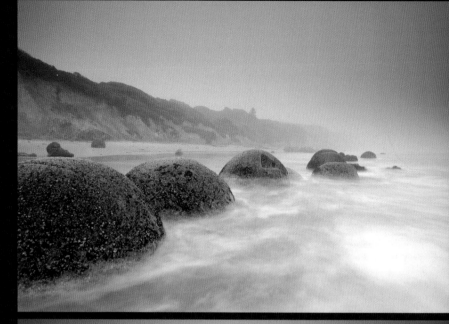

▶ Nikon D3s, 20mm, 10 seconds @ f/6, ISO 400

Moeraki, New Zealand, 2010.

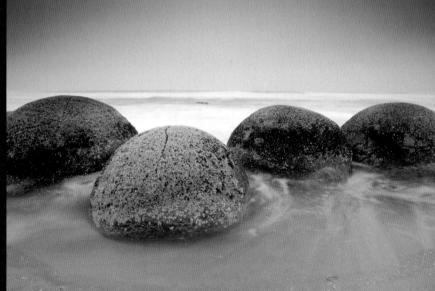

path and prevent us from solving the mystery too soon. She might tap into imagery or symbolism. She might draw on known narratives, but whatever she does she uses words and grammar to create these devices, which in turn capture our attention and give greater experience and meaning as we read.

To relate this to photography, a photographer first learns that a large aperture (f/1.4, for example) will result in a very shallow depth of field. At the beginning, that's all she needs to wrap her brain around. She sets out to practice and falls in love with the way that shallow depth of field softens a distracting background. As she gets more finessed in her use of this technique—the words and grammar—she begins to realize that it can be used to a very specific end: to isolate one element and draw attention to it. The device, in this case, is *isolation*, and it has a powerful and specific way of engaging the reader. The same aperture can accomplish other things as well, creating a specific mood. For example, that large aperture renders specular highlights into dreamy abstract points of light that would look and feel much different if the aperture were set to f/8 instead. Same technique, but different result in terms of the experience of the one looking at your photograph.

Here is another example. We've all heard that adding depth to a photograph can result in a "better" photograph, but behind well-meaning truisms like this always sits an unspoken assumption or two. In this case, what is unspoken is *why* adding depth is desirable in the first place. Depth, or more accurately *perceived depth*, in a photograph undoes some of what making the photograph did in the first place: the flattening. We live in a three-dimensional world and anything we can do in a photograph to return some sense of three-dimensionality makes the image a little more real, a little more engaging. Depth pulls us in, invites us to explore the image not just from top to bottom and side to side, but *into* the image from the foreground to the background. An image with greater perceived depth gives us a deeper stage with which to work, gives the reader the possibility of a more engaging experience. Take this discussion into another medium—film, for instance. If you watch a movie and feel like you are really there, is your experience not more memorable, your feelings more intense, your investment in the characters even greater? This is what we're trying to do when we make the decision to add greater depth

to the photograph. It can be accomplished in many ways, all of them tied in some way to technique, but what matters is the resulting engagement of the reader. Similarly, an intentional removal of depth can be used to create a different reading experience. One is neither better nor worse than the other; they are simply devices to be used at our discretion.

When you use lines to guide the eye into the frame, or make the decision to allow foreground elements to be close and out of focus, you give a sense of depth. Light too can be used, as we use the clues provided by shadows in real life to give us clues about dimension. Using wide-angle lenses can also exaggerate the feeling of depth. Whether you chose to re-introduce depth to your image through one or several of these, keeping depth in mind when you look at and create photographs is one way to increase reader engagement.

Asking ourselves *why* we are stringing certain elements and decisions together to make the photograph is important, but another question, perhaps more relevant is this: What do these decisions do for the reader? How will your decisions affect the experience of your eventual audience? Creating mood, isolating elements, increasing depth, adding mystery, choosing a particular moment to create comedy and therefore laughter: all of these are choices we make with the visual words and grammar at our disposal. They are the way we tell our one-frame story, and if we want our readers to experience any of these things, it falls to us to make it happen.

Spend an hour looking at the work of Elliott Erwitt and you'll have a sense of how he used juxtaposition to create comedy within his photographs. Comedy in photographs is no different than it is on a stage; it's created by the unexpected zigging where the obvious thing would be to zag. Erwitt used juxtaposition extremely well to create implied relationships between two unlikely elements. But the comedy in Erwitt's work doesn't come just from a keen eye for juxtapositions. It comes from his selection of great moments, because comedy is also about timing.

Laughter has long been used to hook audiences. Laughter is a break in tension and lets our walls down, allowing us to engage and remember with greater receptivity. Laughter may not always align with your goals for a photograph, but where it is elicited, it signals a powerful level of engagement. Yes, ultimately the moment is captured with a certain shutter speed, lens, and framing, but it is the choice of moment that is most key, and knowing why you are choosing one moment over another allows you to not only create a sharp photograph but one with a sense of humor. The timing is everything, and knowing you want a particular juxtaposition in order to create laughter or interest allows you to best choose that moment.

Elements

WHAT I AM CALLING ELEMENTS are the pieces of the photograph that are *out there*, the ones that will become the subject matter of the photograph. In our language metaphor, the elements are the words, the raw pieces we have to work with, to manipulate within the frame to create our photograph. It would be a mistake, however, to see elements that are "out there" as being beyond our control when we place them within the frame; this is why it's hard to strip out the elements from the decisions we make. Within the context of the frame, it is we, the photographers, who have the means—through perspective and angle and choice of optics—to rearrange those elements. We have the means to move those objects around, if not physically, then by the

▶ Nikon D3s, 24mm tilt-shift, 1/100 @ f/8, ISO 200
Monument Valley, Utah, 2011.

forced flattening that occurs when we make a photograph. We move around, change lenses, and make decisions that place elements into implied relationships with each other and the frame, and then press the shutter, make the photograph, forever lock down the perspective and the moment, making that scene unalterable. The elements themselves are important.

What's essential to remember is that I'm talking about graphic or photographic elements. The moment you press the shutter, the outside world you see through the lens becomes the flattened world of the photograph. The man you see in the middle of the street is no longer a man on the street. He's a collection of lines, tones, and colors. He's light and shadow. The photograph is made of these things—not flesh and blood, not concrete and diesel fumes. All we have is that which is visible.

Lines

Lines are among the most fundamental elements in a photograph. Together with tones and color, they are really all we have. What about the moment? It's only visible to us as it's portrayed to the eye, and that happens through line, tone, and color. Emotion? Same thing. Texture? Also the same. The reason I'm starting with the humble line is to launch our discussions by getting us all on the same page. The moment you can look at your photographs *first* as a collection of lines and tones and sometimes color, the sooner you'll begin to see photographs as they are and not as you hoped they would be. The portrait is not a smiling face but a series of lines and tones that reproduce, in two dimensions, the face of our model. If we want emotion or depth or the texture of their skin, it can only come across in the lines and tones. We have to put it there. That means choosing the best optics, the best angle, and the best light to create those lines.

A line can be made with a lick of light that outlines a bride's figure, the shadow of a lamp, or a crack in the concrete. But don't fall for the illusion as you create it; it's still a line, and it's vital. Seeing the line allows you to make decisions about that line and its placement within the frame, which in turn will be read in a particular way.

▲ iPhone 4

Valley of Fire, Nevada, 2011.

These two images were taken with the camera on my iPhone 4. Essentially the same scene, the lines in the frame are created by a combination of the elements present (i.e., the rocks and jet trail) and the decisions made (i.e., choice of framing and crop). The diagonal line of the jet trail is significantly increased in impact by its placement in a vertical frame, giving it more room to draw our eye. The power of the rocks—and the feeling of the photographs—change from looming and powerful to solid and balanced as the frame changes from vertical to horizontal. The choice to frame horizontally or vertically is inseparably connected to the direction and power of line elements in a photograph.

Lines, of course, can take many shapes and directions. At their most basic, straight lines move in the frame in three orientations—vertically, horizontally, and diagonally. Other lines are as important and they too can lead the eye around the frame, like the classic S-curve. Less obviously, there are lines that aren't really there but are implied. I'm including them in this discussion because, although they aren't visible, they still get read. What I am not including here, in any depth, are the myriad lines that don't fit into easy categories—lines like an arc that can function as a diagonal in some circumstances and implied circles in others, for example—mostly because there are just so many of them, and their shape and purpose depends entirely on the photograph they create. What is important is the ability to 1) recognize lines separate from the shapes they create and 2) identify the way they move the eye around the frame, and therefore change the reader's experience.

Horizontal Lines

All lines are read and perceived a little differently from each other. Lines lead the eye along their length. How we feel about those lines depends in large part on their orientation. Horizontal lines speak of solidity and solid ground. Placed low in the frame they anchor it, and when that line is thick or dark, like a horizon, that line gives weight to the bottom of the image, as it does in real life. But put that horizontal line toward the top of the frame and it feels looming. We read an image in much the same way that we respond to real life. In fact, the only reason we recognize things within photographs is because we've seen them in real life; it's called pattern recognition. It works powerfully to allow us to feel anything at all about photographs because we feel something about the scenes they represent in real life. So we bring to a photograph the same reactions we have to a world outside the photograph, one where our day-to-day experience of gravity has caused us to feel a certain way about solid ground or things looming overhead. We sense, even in the photograph, that there's a chance that looming thing may fall, so our reaction to it is much more dynamic than our reaction to the solid horizontal line at the bottom of the frame.

◀ Canon 5D MkII, 24mm tilt-shift, 1/800 @ f/4, ISO 400

Iceland, 2010.

At its simplest, the horizontal line in this image splits the photograph into two bands of color, with the darker band giving weight and solidity to the ground. The eye follows the line and meets only one solitary element near the middle of it, giving the image a sense of starkness and exaggerating the aloneness of the trailer.

Vertical Lines

Vertical lines encourage the eye to move up and down and explore the height of an image. As with other lines, they exert a pull on the eye, so if what you intend to do is draw the attention of the eye either up or down, the vertical line is a great tool for this, especially when used within a vertical frame. While the movement encouraged by lines seems profoundly obvious, I'm constantly amused by even my obliviousness to them, still falling for the illusion that the objects I see through my viewfinder are real things and not lines, and often only after I've made the photograph do I recognize the lines that comprise it.

Although lines, as simple as they are, don't seem to warrant all this discussion, it's lines that form so much of our photographs. Designers and painters pay a great deal of attention to a single line, knowing a slight difference in its angle or shape can alter the entire aesthetic or balance of the work. Furthermore, lines collaborate with each other, and they often make something new when combined. I'm writing this book over several journeys, one of them in New Zealand. While photographing the vertical fence posts of a summer pasture I was struck by the way the repeated pattern of the vertical lines created a long horizontal line across the meadow, or diagonally up the hill. In this case, the lines form a pattern and create something new, making a long diagonal line that has more interest as one single sloping line than a series of vertical lines—so we read these lines not as vertical, but as one solitary diagonal.

Diagonal Lines

Diagonal lines lend energy to an image. Placed at an angle through the frame, they pull the eye down and across the frame toward the bottom. Because we read from left to right, the diagonal from top left to bottom right is the most powerful diagonal, and is often called the *primary diagonal*. The *secondary diagonal* moves in the opposite direction and is often read less as a line that starts at the top and goes down—giving it momentum and energy—but as one that begins at the bottom and goes up. It still leads the eye through the frame and is more dynamic than other straight lines in the frame, but less so than the primary diagonal, which has implied gravity on its side as it pulls the eye across and down instead of across and upward. This is neither good nor bad, nor even really about which line is stronger than the other. They are simply different. And while there are plenty of exceptions, the primary diagonal seems best at leading

◀ Canon 5D, 125mm, 1/1600 @ f/4, ISO 400

Sapa, Vietnam, 2009.

▼ Nikon D3s, 29mm, 10 seconds @ f/22, ISO 100

Glenorchy, New Zealand, 2010.

In an otherwise peaceful and natural setting, the strong diagonal lines here do two things: they lead us visually from the foreground into the image, giving it much more depth than it would have without the dock at all; and, like the S-curve in the image that follows (page 60), they give us a contrast with the natural world. I waited for a couple of hours at this dock, hoping that when dusk came the light would give me another contrast: the warmth of the ambient, man-made lamp and the cool of the coming night.

the eye in a downward and into-the-image kind of way whereas the secondary diagonal seems best at leading the eye upward and out of the image. So were I wanting to photograph a kid flying off a ramp on a skateboard, I would orient myself so that the implied line of his flight moved along the secondary diagonal. Were I photographing a skier on a slope moving straight down, I would consider orienting myself so that the line of the hill and the implied line of the direction they were skiing took the primary diagonal. Mathematical precision is unimportant; simply understand that the primary diagonal does some things better while the secondary diagonal does other things better. They imply different things because of how we interpret photographs in response to our cultural left-to-right way of reading, and our normal response to gravity.

▲ Nikon D3s, 24mm tilt-shift, 1/400 @ f/4.5, ISO 200

Death Valley, California, 2011.

In addition to my thoughts on the orientation of diagonal lines, other factors change the dynamic of the image. Consider these two photographs of the same rock in Death Valley, taken from different angles. In one the diagonal line plays along the primary diagonal of the frame; in the other, the opposite. More important, however, is the placement of the rock. In one, the rock is at the bottom of the frame, coming toward the viewer, as it were. This is clearly a rock that is *coming from somewhere*. The other image places the rock at the top of the frame, the rock clearly leading away from the viewer, implying a rock that is *going somewhere*. The difference, aside from the visual balance of the image, is in the message of the photograph. Is the rock coming or going? How you tell that story depends on what you imply through the placement of elements.

The S-Curve

Lines take forms other than straight—among them, the classic S-curve. When I first began studying composition, it drove me crazy that teachers, writers, and other photographers would talk about these S-curves and all I could think was, "So what?" Being told to put S-curves into your images is a little like being told to add red. What I wanted to know was why.

The S-curve, and other kinds of lines—like the spiral—are interesting to us for the same reason we sometimes take the scenic route. A straight line takes you through an image with economy; the S-curve does so slowly, encouraging exploration through the image. Where a straight line is severe, the curved line is graceful, and—neither static nor extremely dynamic—it is an invitation to take your time. Any line or compositional device that encourages exploration means we spend more time within an image, see hidden surprises, and do so without haste. Straight lines often lead the eye to something. The curved line makes us feel we're being lead *through* something.

▶ Canon 5D MkII, 24mm tilt-shift, 1/6400 @ f/8, ISO 400

Iceland, 2010.

The curving shoreline in this image takes the eye up the middle of the frame where it meets the line of the horizon and the receding power lines. This point of intersection is also where the subject and subject matter of the photograph collide; it's partly where the implied meaning of the photograph comes from—the contrast of mechanical and man-made with the organic and the natural. Without the curved line of the shore, the organic-versus-mechanical contrast of the image would be less pronounced and communicate less clearly the impact of man on the land.

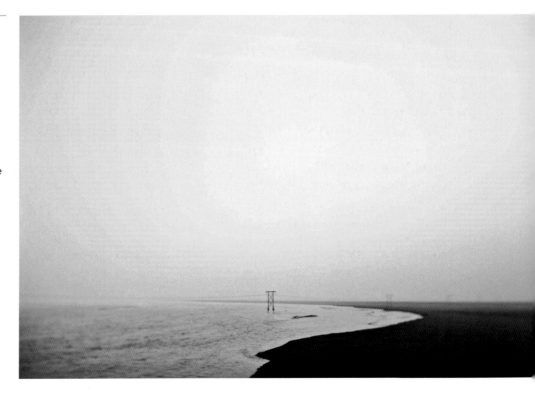

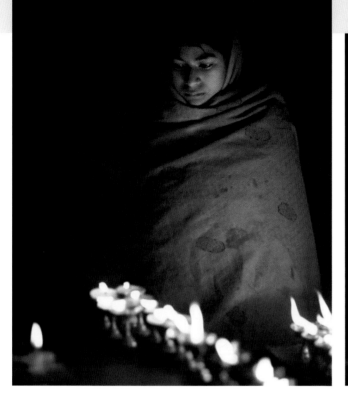
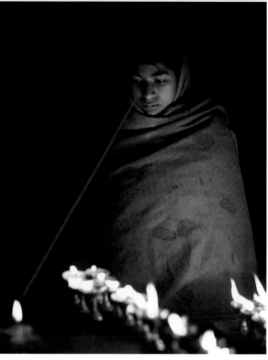

Implied Lines

▲ Canon 5D, 85mm, 1/125
@ f/1.2, ISO 400

Kathmandu, Nepal, 2009.

Implied lines are lines that aren't really there but are read as though they were. The gaze of a woman across the frame to someone or something just outside the frame creates a line because, while it's not actually visible, our own eye follows the direction of the gaze in a straight line until it meets either the thing she was looking at or bumps into the frame itself. If that same woman was looking down at something in the other corner of the image, that gaze creates an implied line that follows the primary diagonal and creates the same tension and dynamism that would be present with a real line. Implied lines matter for that reason: they aren't visible, but they pull the eye and accomplish the same function in the photograph as visible lines.

Remember, too, that in the three-dimensional world some lines, because they are a distance apart, never intersect. But flatten them within a photograph and those same lines now bisect each other, connect, and make new lines. The three-dimensional world allows lines a freedom that the two-dimensional world doesn't, and that requires us to think two-dimensionally as we press those lines together in the making of our images. Seeing two-dimensionally and anticipating the flattening will allow us to use those intersections and new lines to create photographs that work with the flattening instead of fighting against it.

Other Lines

▶ Canon 5D, 40mm, 1/50 @ f/5.6, ISO 640

Hanoi, Vietnam, 2009.

This bicycle is no more than a series of shapes, triangles, and partial circles, but even these shapes are merely derivations, or interactions, of lines. We follow the lines of geometrical shapes in the same way we follow simpler lines, though shapes too can have emotional significance as symbols, increasing their pull on our emotions and therefore on our eyes.

Lines can take many more forms, all of them more complex. They form other powerful elements, each with its own draw upon the eye. The triangle and the circle are both powerful photographic elements, but I've chosen not to focus on them because—aside from their function as symbols—they are just lines or collections of lines. Triangles are powerful compositional devices but for no different reason than a diagonal line is powerful. The triangle just has more lines, and while those lines can be treated as a whole, the eye only sees and follows one line at a time. These shapes—and others formed by lines—are not insignificant, but they're no more than lines. Their significance is in how they lead or prevent the movement of the eye around the frame, and how they either create or short-circuit the visual exploration of the reader.

Creative Exercise

As you look through the viewfinder, ask yourself, Where are the lines in this image? Where do they intersect the frame? Where do they lead? Do they trap the eye? Do they lead toward or away from the place in the image I most want viewers to look? Are they static or dynamic? How would that line make me feel if I moved my position and forced that line to move from a horizontal line to one that bisects the frame diagonally?

Pull out a magazine and, with a bright red Sharpie marker, trace the lines and ask yourself how the image would be different without them. Where do they lead the eye? How do they make you feel about the image? Do some lines make you feel the image is more grounded whereas others elicit a more dynamic feeling?

▶ Nikon D3s, 40mm, 0.8 seconds @ f/22, ISO 200

Farewell Spit, New Zealand, 2010.

This photograph is a good illustration of the difficulty of easy categorization of elements. The posts of the fence form vertical lines, but together as repeated elements they form a curving horizontal line. Individually they lead the eye up and down but taken together as a pattern they lead the eye across the frame, as well as dividing the frame into contrasting zones—separating the tamed land from the encroaching wild.

Repetition

The repetition of elements is as powerful in a photograph as it is in graphic design, teaching, or literature. It's a visual echo, even in some senses, a rhyme. What we may not notice at first we will notice when seen a second or third time. Recurring forms abound in art—visual or otherwise. There's a reason much of the music we listen to has a repeating chorus or refrain, and why filmmakers often use a recurring visual theme to tie a movie together. For the photographer, visual repetition provides a cohesiveness.

Repetition of key elements also communicates (or implies) a connectedness between elements, a relationship between them. It's a visual clue. For a less-than-subtle example, imagine a photograph of a woman in a red dress sitting on the gray steps of an old museum in Paris. She's sitting on the top left. On the bottom right of the image is a little girl in a red raincoat. The fact that the woman and child are both females, both wearing red, connects them. Red is the repeating element. It may imply they belong to the other, perhaps family. It may imply something more, even suggest—if the woman is looking at the child—that the woman is thinking about herself as a child. Further, if other clues are there to support it, it could even be stretched to say that the photograph implies that the child is simply a projection of that woman, that she's just a memory. Not all photographs will be

interpreted as fantasy, but they can be if we're conscious of using the visual language to provide the clues. This brings me to a tangent.

I had an English literature professor in high school who could read unbelievable things into novels, things I'm not sure the author ever intended. But that's the beauty of art. The role of the author's intent is significant in the creation of a work, and we do all we can to create something that communicates meaningfully because most of us want to express something or be understood. But the

▲ Nikon D3s, 56mm, 1/30 @ f/9, ISO 400

Masai Mara, Kenya, 2011.

Acacia trees have their own symbolism and association with the savannah of East Africa. Here, they repeat as they diminish in a line from foreground to far midground, guiding the eye through the frame toward the promontory in the background, which leads us up to the clouds, and then the sun before bringing us full circle around to the prominent tree. In my own work in Africa, these trees don't mean anything significant as symbols—sometimes a tree is just a tree—but they are uniquely African and in some ways become, therefore, symbols of Africa throughout my work. They are a visual clue, a hook, and for those who have spent time in Africa, a powerful one.

photograph, like all art, gets born and sent out into the word to be interpreted, and we can do nothing once it's out there to coerce our audience to read it the way we intended.

As readers of photographs, we read into them our own stories and history, our own memories, and a way of recognizing and responding to symbols that the photographer could only have guessed at. What is amazing about this is the vast latitude of experiences we are making possible. It could be that Joseph Conrad wasn't at all saying the things my English literature professor said he was, but what does it matter? If I put down the book having had a new experience, having learned something, I'm still better for it. Conrad had his chance to be clear and unambiguous, but he could never have predicted the years and miles of cultural differences between us that would shape my own reading of *Heart of Darkness*. At the moment we create our photographs, we too have our chance. Then we let it go. Understanding the power of the visual language and elements and decisions—like the conscious repetition of visuals such as lines, shapes, colors, symbols—can give our photographs the best chance of being understood, and if not understood then experienced, long after we're here to explain ourselves. And if we know our work will one day be understood separately from our intent, then perhaps the best thing we can do is create images with enough depth to engage people, draw them in to experience the images in their own ways, and to find meanings that are relevant to themselves, even if those meanings were never part of our conscious creation. That would elevate what we do, turn our photographs into something enduring beyond the here and now. A little ambiguity is okay; art created with a heavy hand tends to be read as propaganda and dismissed easily.

Back to the subject at hand: repetition. When an element is repeated with enough consistency in an image, it becomes a pattern. A couple of black squares is a repetition; after that, it gets closer to being a checkerboard. And while the eye is drawn to pattern and repetition, it is also drawn to the breaking of that pattern. This is contrast. Replace one black square on a checkerboard with a yellow one, and the eye will go to that square before the others. It says to the reader, "This square is important; look here." And the contrast between them says something. Imagine a frame filled with green trees, except for one of them, which is dead and barren of leaves. That's a pattern broken, and the resulting contrast engages readers, makes us curious. We ask questions of exceptions. Why is this one different?

"A little ambiguity is okay; art created with a heavy hand tends to be read as propaganda and dismissed easily."

Repetition is equally powerful when creating a body of work. If enough repeated elements in one image become a pattern, then an element repeated throughout a body of work becomes a symbol. By the context of the photographs we give meaning to those symbols, and when using symbols that have a generally accepted meaning, we can harness them or present a new meaning—perhaps something jarring. The Christian symbol of the cross is a good example of this, though there are many others. The cross means something, it signifies something, but *what* that symbol means differs from one person to another. There's a broad acceptance of it as a symbol of the historic Christian faith, but it will be read very differently by the orphan raised in love by a Christian nun and the ghosts of anyone killed under that same symbol in a so-called Holy War. I'm not looking to comment on these issues, simply to point out the power of symbol to be read through the filter of memories and experiences. The swastika is another such symbol. Walk through India and you'll see this symbol everywhere as a symbol of luck and peace. But my experience of stories heard and films watched—and being only one generation away from the horrors of the Third Reich—make me cringe every time I see it. I could buy countless souvenirs with this symbol on it, but I could never wear it. What I'm getting at is this: we create, harness, or reassign the meaning of symbols in our work because they are powerful. We do this for the same reason companies use logos. Logos are no more than corporate symbols. But where these symbols elicit strong emotional responses, we need to use them intentionally. Even small elements, repeated, become symbols and give us a chance to use the power of repetition to create themes and meanings.

Creative Exercise

Experiment with repetition within your compositions. If you've got one fence post in the frame, move around, find a wider lens, and include a few more, or find some trees that repeat the vertical line of the post. It need not be obvious; circles within your image can be subtly repeated by including blurred specular highlights, bright circles of out-of-focus light in the background. Repeated elements can include color or shape or lines. Any element that repeats itself can create an echo or a rhyme within the frame of the photograph, form visual interest, and imply meaning.

▲ Canon 1Ds MkIII, 80mm,
1/30 @ f/9, ISO 200

Ladakh, India, 2010.

Contrast and Juxtaposition

Stories move forward through conflict, but photographs—limited to one frame, one moment in time, and no possibility of a character arc—move forward and imply story through contrast. Contrast in photographs occurs in two significantly different ways. The first is visual contrast. A high-contrast black and white image is one in which the extremes—the blacks and whites—are strong and prominent, and what lies in between—the midtones—are fewer. With color images, that contrast occurs between colors at opposite ends of the color wheel—blue and yellow, for example. Similarly, conceptual contrast is about the extremes of ideas, and the point at which they clash. Both can be called

contrast, but to distinguish them I will call the difference in tones and colors *contrast* and the difference in concepts *juxtaposition*.

Contrast, a strong difference in tones or colors, is what pulls the eye. Our eyes function on contrast and look for areas where those contrasts are the strongest. Even perceived sharpness in images is a function of stronger contrast. Where there is a slower gradation of contrast, i.e., blacks slowly turn to gray and then white, the eye sees it, in a photograph, as less sharp. In color, as in black and white, contrast pulls the eye, and that pull will be read as intentional. In other words, the reader will assume you meant to include areas of strong contrast and will expect it to be there for a reason. Pragmatically, this means areas of contrast should be where you intend your readers to look. Where contrast between colors occurs, the eye seems to register warmer colors closer than cooler colors, creating a perceived depth that also draws the eye. Awareness of the visual pull of contrast allows us to orchestrate the image in the most intentional way possible, pulling the eye to key areas with greater contrast and pushing the eye away from areas with lower contrast. This attention management can occur in-camera, as well as later in the darkroom, but it is key to moving the eye around the frame.

Juxtaposition also draws the eye, but it has more to do with engaging the mind as it's less a contrast of visual elements and more a contrast of concepts. Where tonal contrast is about the difference between blacks and white, juxtaposition—or conceptual contrast—is about the differences between ideas. It could be as simple as small versus large, what we usually call scale, or it could be any set of paired opposites: wet versus dry, rich versus poor, alive versus dead, moving versus stationary. Why this matters is the same reason tonal contrast matters: we pay attention to it. Take the contrast between comedy and tragedy. Shakespeare said that if we wanted something to be comic, we should precede it by something tragic; if we want something to seem tragic, precede it by something comic. Why? The contrast draws our attention. What is already funny is made even more so when preceded by tragedy because we see, by contrast, how much more comic it truly is. So it is with ideas in our photographs. If you want to draw someone's attention to sadness, contrast it with something happy, even happier colors, and that sadness leaps out of the image. If you want to point to man's harmful presence in the environment, place the gray cooling towers and

◀ Canon 1Ds Mk III, 34mm, 1/25 @ f/8, ISO 200

Iceland, 2010.

These small green buds growing out of dark black volcanic sand suggest a conflict or contrast of organic versus inorganic. There's a contrast in tones that is visually interesting to us, but it's the contrast in ideas—that living matter can grow in such inhospitable conditions—that contains the suggestion of a story.

surrounding dead trees in a surrounding wilderness. If you want to illustrate age—either old age or youth—place an infant in the aging hands of his grand-mother. The contrast makes us more keenly aware of both.

As readers of photographs we see these contrasts, and because we assume the photographer made her photograph intentionally, we infer meaning. The greater the contrast, the greater the impact and the more powerfully we feel that inference.

Creative Exercise

I've often asked students to complete these two exercises. The first is simpler than the second. Go out and photograph both tonal and color contrasts. You aren't looking for big ideas, themes, moments, or exquisite lighting—just contrasts of tone (black and white) or color. The stronger the contrast, the better. Photograph 12 great contrasts.

The second exercise is a little harder. Make 12 photographs that are driven by juxtaposition, or conceptual contrast. When you are done, you should be able to identify the contrasting pairs. Make at least a dozen of these, where the subject is the conflict between two opposing ideas, expressed through contrasting subject matter.

If you want one more exercise, go back through your existing images and look for contrasts and juxtapositions. I suspect the strongest of those images contain these contrasts, whereas the weaker ones do not, or contain contrasts that are less obvious or a bit of a stretch. Contrast, either tonal or conceptual, moves a photograph forward, and where there is a lack of contrast, that too should be done intentionally and with a mind to point the reader toward the sameness or lack of that contrast. Lack of contrast indicates homogeny, uniformity, and boredom, and can be used as effectively as contrast. But both can be used more powerfully when used intentionally.

The Seduction of Color

Color deserves a book of its own, and probably a book written by someone else. Michael Freeman discusses color in *The Photographer's Eye* with more depth than I am prepared to do here, and because there are better voices to address the real intricacies of color, I'm only going to touch on it before discussing its seductive nature and how that relates to the language of the photograph.

Where color matters as an element of language is in what it communicates. Color is highly expressive and is by no means a neutral element in the frame. We are profoundly affected by color on an emotional and psychological level. There's a reason there are whole books about color psychology. It matters to us because we have to learn to actively include, adjust, or exclude color based on how we read it.

Colors have strong associations for us. Blues and greens are calming; both of them are organic colors that have natural or earthy associations. Reds excite us visually, and they have strong associations with blood, love, and passion. Yellows and oranges are warming. With all these associations and emotional

effects, we'd be foolish to pretend that their presence in a photograph doesn't powerfully alter or impact the way others will react to our images.

There is a great deal more to color theory, but barely touching on it is probably worse than not covering it at all, so I'm going to leave it to other teachers to thoroughly cover it. I'll simply remind you that all of this stuff is visual, and because it's not hiding under the hood—it's in plain sight in the photograph—much of it can be learned simply through observation. Look at a handful of photographs and ask yourself how you respond to the colors and the way the colors interact. Do they draw your eye or repel it? Do they feel peaceful or jolt your eye? Do they play well together as a palette or are they dissonant and chaotic? All of these reactions are keys to how we use color. Unlike painters—who choose whatever hues they like, while we are more often reacting to existing colors and color combinations—we still have the ability to include or exclude them, wait for different light (and color is a function of light, so different light will often result in different colors), or even play with the balance of colors in the darkroom.

What I want most to discuss is the *seduction* of color.

One of the questions I continually ask my students is, "Have you tried it in black and white?" It's become a running joke. My belief that every element in an image means something—and will be read by the viewer of the image—extends to the inclusion or exclusion of color. If the element doesn't add to the image, it detracts from the image, and no element does this more so than color.

Color is powerfully seductive and affects us not only visually but emotionally. There are whole conversations to be had about color psychology; we are drawn to certain colors before others—red is among the most seductive. Even subtle colors present in an image can give those elements more visual mass than we want or create a clash of colors that distracts. But create a great black and white conversion, rendering those same colors as tones, and you allow the lines, tones, textures, and gesture of the image to speak more loudly because the color has been silenced. The question becomes, "What is this image about?" If color is part of that for you, then keep it. If it's not, consider pulling it.

Look at the two images here of the hillside in New Zealand's North Island. It's not a question of one being better than the other; it's a question of which

▲ Nikon D3s, 48mm, 1/125 @ f/10, ISO 200

New Zealand, 2010.

elements I want to be center stage. In the color version, there's no question the colors are a significant part of the subject—a bright pastoral summer. In the black and white version, the subject—and the place to which my eye is drawn—is much more about the lines, the textures, and the meeting of land and sky. Both evoke different emotional responses, and the only difference between the two is the presence of color.

It often comes as a surprise to students when, after we've looked at an image together and I've asked them to try it in black and white, the whole image seems to change. Sometimes it completely loses its soul, and that's a sign that the color matters greatly in that image. But often the image suddenly gains greater impact for having lost the distraction and seduction of the color elements. Being conscious of what makes the image work, and being willing to create the final print as a black and white photograph, can make the difference between a good photograph and one cluttered and diluted with just one too many elements.

Given the seduction of color, it makes sense that toned, duo-toned, or even tri-toned images create a different emotional response than a neutral black and white. It's this emotional connection to color cues that makes many people respond to a sepia-toned print with nostalgia; the yellow tint of sepia is so connected to an earlier era in photography. Add a sepia tone and a vignette to an image and you've tied your photograph to conventions we accept—assuming we're familiar with older photographs—as associated with an earlier stage in the life of photography. The response to color is a psychology we need to consider because it is we who make the decision to allow that color to be present in an image. Like everything else, color is—to some degree—both an element in the image and a decision we make about the image.

Color can be excluded, removed, changed in post-production, or left entirely alone, but it must be taken into account. I recently did an assignment in rural Bosnia for a client who wanted photographs that looked cold. It was cold, but recent rains had made the grass really green and we associate green grass with summer and dying grass with the coming of winter. It was November, and in order to maintain the feel of the cold I had to work hard to keep the green grass out of my backgrounds. Everything else—the leafless trees, the kids in

> "Don't allow yourself to be seduced by color or to mistake your reaction to the color in a photograph as a reaction to the photograph as a whole."

sweaters, the moody skies—said, "Winter is coming." The green grass said, "No, it isn't." Where the grass was unavoidable I was amazed how a simple black and white conversion made me read the image as much colder. Adding a cool, slightly blue tone to the black and white photograph made it even more so. Small changes made only to the color can create significant changes in our emotional response. It's the same reason novice wedding photographers make their images black and white, leaving only the red roses selectively colored. It's a cliché and it's hackneyed, but it creates a powerful pull and can easily convince us our images are more effective than they really are. Selective color can be an easy distraction from poor composition and the lack of emotionally charged moments present in the photographs themselves.

Don't allow yourself to be seduced by color or to mistake your reaction to the color in a photograph as a reaction to the photograph as a whole.

Creative Exercise

Whether you use a traditional darkroom or a digital one, create two versions of six of your favorite color photographs, rendering one of each into black and white. What changes when you remove the color? How is your eye drawn differently, and how do you respond differently on an emotional level? Some images will work better as black and white, whereas some will lose the impact that color brought to the photograph. Which one you like best is not the point of the exercise; the point is to see the difference color can make, and begin to recognize when color is helping the image, or even propping it up. There's nothing wrong with a photograph being significantly about the color itself, but it can often distract photographers from looking critically at lines and tones, moments, light, and other elements that could vastly improve the image if we gave them more attention.

Light

Light is our medium, our paint. Like paint, it has hue, saturation, luminosity. Like paint, what we choose to do with it creates—or conceals—textures and lines and tones. When it comes from behind, it creates a white line, which we call rim light, that gives shape to a person. Or it shines through a leaf instead of reflecting off it, creating a much different look and therefore a different feeling. When it shines from the side it can point to texture, whereas direct front light simply flattens that texture. When it is blocked by one object it creates shadows. When it is absent entirely it vanquishes the photograph. Without paint, there is no painting. So it is with light.

Light is not hard to identify in an image, nor is its effect. You can see it, and when used right, you can feel it, but it takes time to learn to see it. Whatever time it takes us to learn to see the light is worth the effort, as much as it's worth the time for a painter to become intimately aware of his paints and brushes. Light changes the mood and adds emotional impact; it reveals and conceals to provide or obscure information. Light in one circumstance will make colors seem to glow from within, and at other times of day will make those same colors flat and lifeless. Light falls on objects in certain ways; one way can flatten, another way gives the same object dimension and brings a sense of depth to an image, a technique called *chiaroscuro*—which was mastered by the painters of the Renaissance. In fact, there's much we can learn from painters because they have to study light well enough to create its illusion in a painting. We've been convinced that all we have to do is "capture it," when in fact we need to understand it, perceive it, and make choices based on it in similar ways as painters. Only the method of capture is different.

Two of the most important questions you can ask—mindfully, intentionally—as you look through the viewfinder are, "What is the light doing in this frame?" and "Is it doing what I need in order to create the photograph I want?" Light contributes significantly to mood, which means the reader of your image will experience that photograph in fairly predictable ways. There is mysterious light, dramatic light, moody light, sad light, and even happy light.

Similarly, when you look at a photograph, ask what the light is doing and what effect it has within the image. This will hone your ability to identify the role of

▶ Nikon D3s, 24mm tilt-shift, 1 second @ f/4.5, ISO 200

Death Valley, California, 2011.

Over much of the last year I've played with the mood that low light and the so-called "blue hour" can create. I've long been fascinated with the moving rocks of the Racetrack Playa in Death Valley, and the combination of this low, very blue light and a little carefully placed light from my flashlight gave me the feeling of a dream— something not quite real— that the idea of the moving rocks stirs in me. At other times of day the light goes from dramatic to flat and all kinds of in-between, but there's literally no other time of day to get this particular kind of light, and therefore this particular look and feeling.

Nikon D3s, 24mm tilt-shift, 1/100 @ f/8, ISO 400

Valley of Fire, Nevada, 2011.

The timing on this, like most natural light images, is important, illustrating again the interplay between elements (such as light) and decisions (our choice of moments). The orange sandstone spires in the background were being struck with the first light of the sun, and the pink sandstone in the foreground remained in shadow. I found photographing the pink rock in direct light bleaches it out—when what I like about it is the delicate colors of the early morning—whereas the orange-brown sandstone in the back looks flat and uninteresting, and provides less contrast with the sky, when shot without this warmer direct light. Understanding what light does and when, and playing with it, allows us greater creativity. The detail in the sky was held back in Adobe Lightroom by one stop.

light in your own photography. What does the light reveal? What about the shadows it creates? How does the quality of light affect the mood of the image? Once you can identify it, you can begin to make choices with it. When making your own photographs, you can move around a subject or have the subject move. You can wait for the light to turn, or anticipate it based on time of day and weather. But one thing is sure in almost all cases: the excuse that "the light just wasn't good" is rarely a good one. The light may or may not be right, but it's always our choice to make the photograph or not.

What we must learn to do is see the light as it changes within a scene and be able to look at photographs and discuss the light that created that image. What does everything in that image tell you about the light itself? If that's too hard,

look to where the light is not—in the shadows. Are the shadows hard and well-defined? That should point you to the source, direction, and quality of the light. Do the shadows point in different directions? That should indicate multiple light sources. Light, Joe McNally says, has a logic to it, and in stating the obvious like that he changed the way I saw light. It used to be complicated in my mind; now it's simple. If something is visible at all, it's because there is light. And light is easy to read if we know what to look for.

Ultimately, light is responsible for everything in our images. It carries color, creates texture, and forms shadows. When used well, it also adds the illusion of depth, and for this technique we owe a debt of gratitude to the painters of the Renaissance. Renaissance painters popularized an effect of light they called *chiaroscuro*, which is Italian for "light/dark." We take our clues from real life, and we are used to the way light plays on three-dimensional objects—and the way that shadows indicate depth or, on a smaller scale, texture. It's simple for us, as photographers, because all we do is press the shutter, but painters had to recognize this effect and learn to replicate it. Studio photographers have a similar task, but the rest of us can recognize, or even orchestrate, the presence of chiaroscuro and so bring depth back to the photograph.

▶ Canon 1Ds Mk III, 85mm, 1/500 @ f/1.2, ISO 800

Ladakh, India, 2010.

This dark room in a monastery in Ladakh had beautiful window light as its sole light source. Shooting with that light to the back and sides of these monks allowed for a very high-contrast image; the shapes of the faces are created by the slightest lick of light as it wraps around the sides of the faces closest to the camera. What drew me to photograph this scene was the subtly repeated elements of the two faces—one younger than the other—and the implication of prayer in the shape of the foreground figure.

Taking chiaroscuro further, it can be used compositionally. Early examples include subjects being entirely lit by candlelight, the light focusing attention on only that which was lit by the candle, the rest fading into darkness, creating its own negative space.

A similar effect is seen in landscapes where the play of light on land gives the image its texture and depth. When photographing distant mountains stacked together, the more distant mountains appear to recede because they are lighter in color, being more obscured by atmospheric haze over greater distances. Darker mountains appear closer while the distant ones seem further, even though these photographs often leave us without scale or perspective to give us clues about the depth.

Why does this matter, and what does it have to do with visual language? The illusion of depth is among the best tools we have to pull readers into the frame. We do not live in a two-dimensional world and do not resonate with images that appear to have only two dimensions in the same way we do with images that look and feel three-dimensional. The addition of depth pulls us in, invites us to explore, and on a most basic level it helps us speak the truth about a scene which was, in fact, deeper than two dimensions. Making use of visual clues like chiaroscuro returns that depth and fights against the flattening effect.

◀ Canon 1Ds Mk III, 29mm, 1/200 @ f/3.2, ISO 1250

Kathmandu, Nepal, 2010.

I love the idea of lighting a candle against the darkness. When I came upon this woman lighting these candles during a Nepali festival, I was particularly struck by the way her companions were using the sheet to block the wind, which had the happy effect of containing the light, reflecting it. It is this beautiful directional light that creates the chiaroscuro that gives this photograph its depth.

Creative Exercise

Here's a simple exercise I give to students who are having a tough time learning to see the light. Go for a walk and find some light. Unless you're walking at night, this should be easy. Now put your hand up at arm's length in front of your face, palm toward you, and watch it as you move your hand up and down, from side to side, even turning yourself in a wide, slow circle. Move from open sunlight into shade; keep moving and looking at your hand. What you're watching for is the effect of the light—most noticeable in where the shadows fall and what kind of shadows are produced—but you might also notice rim light and silhouettes depending on how bright the light is and where you put your hand. You should notice the effect of side light as the textures in your hand become exaggerated, you should notice harder shadows in open sun and softer shadows in shade. You'll notice, I hope, how much brighter your hand is against the sky when the light hits it directly. Watch the shadows and how they move. Note every effect you observe as you move in relation to the sun. Now do the same thing in daily life without the oddball antics with your hand. What is the quality of the light doing at this moment, and why? Is it being diffused? Bounced? Is it warm? Cool? The more conscious you are of the subtleties of light, the more able you'll be to use it to express yourself within the frame of the photograph.

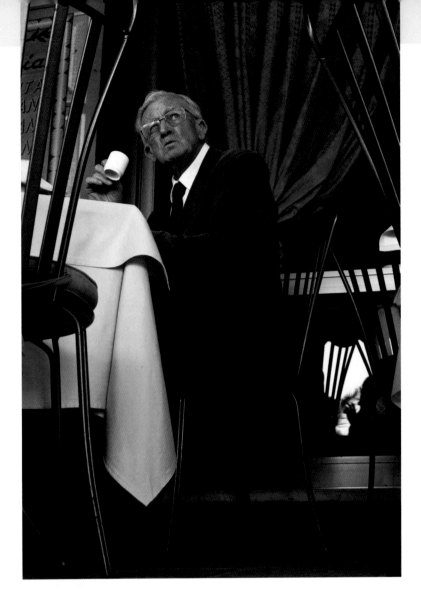

▶ Canon 1Ds MkIII, 50mm, 1/50, aperture unrecorded, ISO 400

Camogli, Italy, 2010.

I'll discuss this photograph in greater detail later, but I include it here because it's one of my best examples of the importance of the moment. There are a lot of things that make this photograph work for me, and I made several exposures while we sat at lunch beside this gentleman, but it's the choice of moment—a glance, a gesture that takes 1/50th of a second and is gone—that gives this photograph its life. The moments are handed to us as elements, and they're most often out of our control, but seeing these moments and being ready for them is up to us.

Moment

The difference between a mediocre photograph and a great one is often in the choice between moments so close together we'd miss them if we blinked. But even landscape photographers wait for great moments, knowing that in those moments the light or weather will make the shot in ways it couldn't have only moments ago. Often when doing critiques I see a photograph that in every other way would have been a great photograph, but it missed the moment and falls short. While we often have no control over the moments themselves, the choice of moment is in our control and is vital.

◀ Canon 1Ds Mk III, 17mm, 1/80 @ f/5.6, ISO 800

Seattle, Washington, 2010.

Photographers put a great deal of emphasis on the ability to see things, and well they should, but patience too is important. The ability to anticipate and wait for a moment, and then be ready when it unfolds, makes all the difference. It's what allows us to capture a glance, a gesture, a head thrown back in laughter, or a loon as it skids across the surface of a lake at sunrise. A few seconds—even fractions of a second—before or after that moment, and you miss it.

Capturing the moment is key, but just as important is understanding what the moment itself communicates. Only then can you anticipate the best moment for the photograph you intend to make. The question in learning to read photographs, and then in making them ourselves is, "What does this moment do for the photograph?" Yes, you got a great moment, but so what? What will the reader see, how will that moment affect them as they read the image? How does it change the image?

A man standing on a street corner is just static for a couple of moments, barely moving. A distant plane flies slowly overhead. You make a photograph. Suddenly he looks into the sky and points up at the plane. You make another photograph. The two images are very different, to be sure. But they differ only in the gesture, the moment you captured. What does the brief gesture contribute to the second image that was absent in the first? See how the line of his arm draws your eye to the plane, which forced you to frame the image vertically instead of

> "The decisive moment is the fleeting moment when the apex of the occurring action coincides with the other graphic elements within the frame to create the best possible composition."

horizontally, and now completely changes the story? See how the focus of the image changes, and with it the balance?

No discussion of moments would be complete without letting Henri Cartier-Bresson chime in on the subject, because it was he who first coined the term *the decisive moment*, and because understanding what Cartier-Bresson was saying contributes significantly to understanding *why* the so-called decisive moment matters. The way we often (mis)understand the decisive moment is that the photographer simply pushed the button at just the right moment. But that misses the point, because Cartier-Bresson was very specific that the decisive moment was not about storytelling; it was about photographs. The decisive moment is the fleeting moment when the apex of the occurring action coincides with the other graphic elements within the frame to create the best possible composition. There might, in fact, be stronger moments—as far as the story being told—but the best moment for the image is the one that interacts in the strongest way with the rest of the frame to create the photograph. There are many different moments—some of them are extraordinary—but extraordinary is not necessarily decisive. Decisive is about composition. Decisive is placing the visible aspects of that moment within the photograph in a compelling way, taking a moment and placing the apex of the action into the frame in the most dynamic way possible. Decisive is where the moments themselves are a key element, but you also intentionally make decisions about the other elements of the photograph, and the timing, that line up with your intent.

There are two gems within the notion of the decisive moment. One is the importance of the connection between the moment and the frame. The second is that moments themselves have an apex. There is a moment at which a funny situation peaks in head-thrown-back laughter. There is a look, a glance of worry that comes when bad news arrives. There's a moment in a child's leap-frog game that expresses the joy of play that visually shows this joy and captures the wholeness of the game in a better way than all the other moments. It's up to you to anticipate which moment that is, but pick the right moment and put it into the frame in the way that best serves your intent and the geometry of the frame. Not every moment will be decisive in the sense that Cartier-Bresson meant, but that doesn't mean it's not emotionally compelling. A moment itself, chosen well, can carry a photograph and make it profoundly moving despite sloppy exposure, composition, or even focus.

It's key to remember that the moment you want to express must be visible in your image. A video of a significant moment in history could be five minutes long and show the whole thing. But the photographer—with one frame to capture that same five-minute moment—needs to be much more selective. Which single fraction of a second contains the best gesture and re-creates the emotion or significance of that moment? It matters because it's that single moment that will occur in the photograph, and no other. Readers can't read between the lines; they can only see what's there.

There are, however, great moments that are equally important in our images that span, not fractions of a second, but minutes—even hours—and they matter, too. One moment may occur in the early morning mist, making a photograph that is read as moody, mysterious, ominous, or magical. The same scene photographed hours later—once the fog has burned off—will look different, be read differently, and be experienced differently. If everything else in the photograph is working but the photograph still lacks that one layer of impact to give it emotional connection to the reader, it is often the moment that is missing. Wait for it. A great moment that intersects with a strong composition is worth waiting for, worth coming back for time and time again until it happens.

Creative Exercise

Head out with your camera and shoot sequences—anywhere from five to eight images in succession—or choose images from your library that you've already made as sequences, and look carefully at the geometry of the frame in each one of them. You're looking for a change in balance or gesture that makes one frame stronger than the others. I find it easier to do this as thumbnails so I'm not distracted by the details within the individual images. Those details are important and may eventually make one image stronger than another regardless of a change in geometry, but for now begin to become more aware of the power of one moment over another. The same is true of portraiture. One moment may reveal a more subtle but honest glance, or it may reveal the difference between a subject smiling only with her mouth and a full-faced smile where the eyes are engaged.

Decisions

THE CREATION OF A SINGLE PHOTOGRAPH is the result of a series of decisions about organizing the raw materials or elements at our disposal. These decisions are the grammar of our expression, the way we move the words around to say something in a unique way. Even when the light is beyond our control or the moment happens so quickly we barely have time to react, it is our choice and that's what gives it the potential to be art. Art, my friend Jeffrey Chapman says, must have something of the artist within. That *something* is the series of choices we make in what we say and how we say it. We decide what to include and exclude, we decide which moment to capture from which angle, and with which settings and optics. Ultimately, when an image succeeds it is to our credit, whether or not we feel it was made entirely through dumb luck.

▶ Nikon D3s, 52mm, 8 seconds @ f/22, ISO 200
Cape Foulwind, New Zealand, 2010.

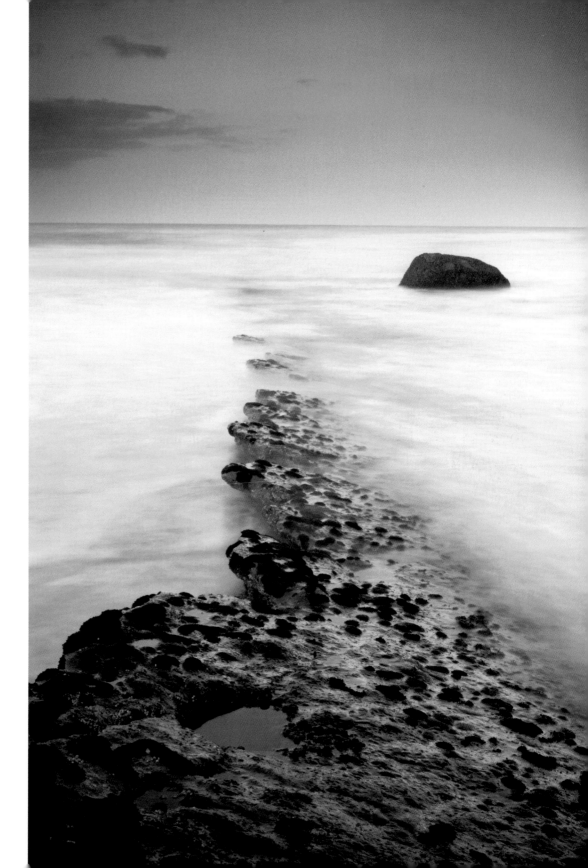

When an image fails, it is we who must take the responsibility. "But," I hear the voices protesting, "the light just didn't cooperate, there was no room to move forward or to the side, and the moment just never happened!" Fair enough, but it is we who still insist on making the photograph. If the elements don't line up, it is still we who choose to make, or not make, the image. If we decide to make it and it fails to line up with our intent, it's not the elements or the constraints that held us back that are to blame. Recognizing the role of our decisions in stringing together the words of our craft leads us to greater mindfulness, and that mindfulness leads us to photographs that are increasingly in line with our intention. If we're still in agreement that a successful photograph is one that best expresses our intent, then this approach gets us closer to creating those photographs.

Framing

When I speak with my students about a photograph, one of the things I ask them for is as complete a description of that photograph as possible. That includes consideration or description of the frame itself, and although students roll their eyes at its obviousness, it's important. The decisions we make about the way we use that frame are not mere details; this is the moment, before the painting begins, when the painter chooses his canvas and sets it on the easel. The frame is the stage on which we tell our story. If it's in the frame it matters and means something; if it is not in the frame, it doesn't exist. More than just the thing that holds the content of our photograph together, the frame is a part of the photograph itself and defines how the story is told. The crop, orientation, and aspect ratio of that frame determines how the story is read.

◀ Canon 1Ds Mk III, 1/2000 @ f/1.2, ISO 800
Ladakh, India, 2010.

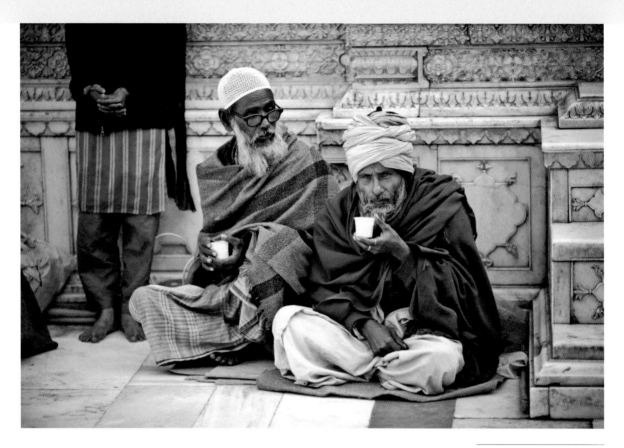

Crop

Our choice of crop—the things we allow within the frame—tells the reader, by excluding all else, "Look here." It says, "I could have included other things, gone wider, turned to the left, but I didn't. I photographed this exact scene." This is where photography begins, pulling life from its context and presenting it in vignettes and memorable moments by pointing with greater specificity. It creates new implied relationships and pulls the eye to new details by excluding all else. It's for this reason that objects partly in and partly out of the frame are jarring to us. They don't seem to belong either to the world of the frame or the world outside the frame. This isn't about right and wrong; the permeability of the frame can be used to great effect. What's important is simply to be *aware* of the frame. Implying a world beyond the frame can lead us to be more aware of the photograph itself, or to question what we do not see just outside the frame. But it must be done judiciously, and with intent. Readers seldom forgive or are engaged by sloppy storytelling.

▲ Canon 5D, 135mm, 1/3200 @ f/2, ISO 800

Delhi, India, 2008.

What's in the frame—and what's out—is important to the implications of this photograph, notably the absence of the face of the woman. What her anonymity says in the presence of these elder men—as though her sole purpose is to serve them or stand silently by—is directly implied by the way her face is cropped from the frame.

Orientation

The direction of the frame, whether vertical or horizontal, determines the direction in which the image is read. The way the image is read will either reinforce what you want to say with your photograph or it will work against you.

Orientation of the frame tells the reader, "The story takes place this way." We look at vertical images differently—up to down—from how we look at horizontal images—left to right. If your goal is to create a photograph that says what you want to say, and also does so for the reader, then beginning with the right orientation matters. When the story is better told vertically, a horizontal orientation of the frame diminishes the impact of the photograph, or even prevents the story from being told completely. Everything matters, and making a photograph is not unlike making a painting. You start by putting your canvas on the easel in the way that makes the most sense, not merely because "that's the way you were holding the camera at the time" or "to fit more stuff in the frame."

The horizontal frame is often a better storytelling orientation because life, for most of us, happens this way. We relate horizontally, move horizontally, and get our stories horizontally in the most prominent storytelling medium of our time, the movie. But when the story happens vertically—whether that's a rock climber scaling a long tall ridge or a man looking at a plane in the sky—the vertical frame will emphasize that by directing the eye of the reader.

Aspect Ratio

My friend Dave Delnea hates the 2:3 aspect ratio of the normal 35mm frame. Drives him crazy—especially when oriented vertically. He loves 4:5 and a square crop. They suit his vision and style much more. Frankly, the 2:3 aspect ratio is a hard frame to use, and the more my own voice evolves, the more space I find for alternate crops, which has pushed me to begin exploring the 4:5 ratio much more. Sometimes choosing an aspect ratio is something we do in the camera— sometimes we'll choose a camera based entirely on the aspect ratio—and other times it's something we do with the conscious intention of cropping to a more appropriate aspect ratio later in the darkroom. But it always matters, because it determines how the image is read.

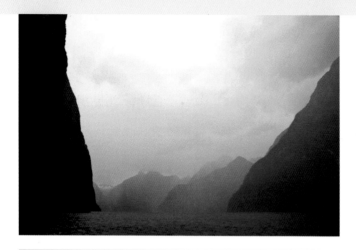

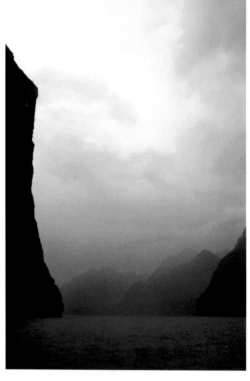

▲ Nikon D3s, 24mm, 1/60 @ f/9, ISO 400

Milford Sound, New Zealand, 2010.

▶ Nikon D3s, 24mm, 1/125 @ f/9, ISO 400

Milford Sound, New Zealand, 2010.

I made these two photographs seconds apart on the waters of Milford Sound in Fiordland National Park on the South Island of New Zealand. The horizontal frame was my first sketch image, but as I played around with the forms in the frame it was the vertical orientation that worked best for me. It forced me to change the relationship of the shapes to each other, allowing me to make the cliff on the left much larger and looming while also forcing me to include less of the landmass on the right, diminishing it in relative size. No amount of horizontal framing would have allowed me to achieve a composition with this same scale and the resulting sense of looming. The frame itself forces relationships on us, and we read the photographs differently.

Whereas the orientation of the frame tells readers which way the story flows, the aspect ratio tells them, in a sense, how powerfully it flows in that direction. The square frame says that the vertical world within the frame is as important as the horizontal world, and the reader's eye will move differently within that frame than it will in another. A 16:9 horizontal frame will flow strongly from left to right, creating a powerful wide feeling with little sense of height. Turn that same frame vertically and use it to photograph a towering redwood tree, and the photograph will be read straight up and down with little to none of the horizontal world included, which implies its absence. The same tree photographed in

A B C

▲ Nikon D3s, 24mm, 4 seconds @ f/3.5, ISO 200

Racetrack Playa, Death Valley, California, 2011.

This photograph was shot at 4:5 (**A**) and cropped afterward to both 1:1 (**B**) and 2:3 (**C**). Forget how much these aspect ratios allow into the frame—that can always be changed by moving around as you compose the image—but look instead at how the proportions of the frame change the weight of the elements and their balance and relationships within the frame. A good place to begin that study is with the appearance of the horizon and elements between the horizon and the top of the frame. Look, for example, at how the mountains and sky change in prominence as you move from 1:1 to 2:3. Subtle differences in this image, yes, but each implies something the other doesn't.

a 1:1 square or 4:5 would not create the same towering feeling. The orientation of the frame is part of this, but *how* towering that tree feels is in part due to the aspect ratio of the frame.

Second to how we read a frame in terms of its length is the proportions within the frame. The choice of a 4:5 aspect ratio over 2:3 allows us to frame elements with more width, and although this seems obvious, it's important to remember that this increased width will completely change the relationships in the frame, and therefore change the meaning of the photograph. A 4:5 ratio, for example, will allow an S-curve within a photograph that winds its way deeper into a vertically framed image, along a wider diagonal, than a vertical 2:3 ratio will allow. If you have an interest in further exploring aspect ratios, I can think of no better resource than my friend Bruce Percy's excellent ebook on the subject, which

you can find at www.brucepercy.co.uk/. Bruce discusses some of the challenges of aspect ratio and its effect on the form and meaning of our photographs. For now, in this book my purpose in briefly discussing it is to make you aware of the fact that aspect ratio is a choice—not merely something you *must* use because of 35mm convention—and that choice affects the way the image is read.

Being mindful of the way in which we want the image to be read, and therefore experienced, will help guide our decisions about the kind of frame we use.

Creative Exercise

Look at a dozen of your favorite photographs. They could be yours, they could be classics of the masters. Now do two things. First, simply describe the framing—the orientation, crop, and aspect ratio. Now speculate about what the frame itself contributes to the image. How would a vertical framing change the way the photograph works? Would a different crop or aspect ratio strengthen or weaken the image? Why does this particular set of decisions—the photographer's choice of orientation, crop, and aspect ratio—work with this image? The more mindful we are of this most basic set of decisions, the stronger our foundation as we move forward.

Placement

In a larger sense, the notion of placement often gets pigeonholed as composition, but composition is a much broader subject, and it's worth considering in pieces. Balance is one of those pieces, as are our choices of frame and crop, as well as implications of perspective, which we'll look at next. Placement is about where we put our elements within the frame. In fact, it is our choices regarding placement that lead to a balanced—or imbalanced—image. And it's our choice of framing that influences the decisions we make about where we place elements in the frame. So, like the distinction between Elements and Decisions, which I make purely to ease the teaching, this distinction too is connected and ultimately a little contrived. Composition is all much more organic than this sterile dissection suggests.

Gesture

First of all, to channel the esteemed Jay Maisel, everything has gesture. In fact, it was Maisel's breaking down the basic elements of a photograph to light, color, and gesture that got me thinking about what makes a photograph, and what might make a photograph good. Gesture isn't easy to explain, mostly because we're so accustomed to thinking of gesture as a human movement that it's hard to think of gesture as something intrinsic in an unmoving photograph, much less in a photograph lacking any human element. But it's gesture that brings an image to life; it points, it leads the eye, it gives the photograph motion and energy. In one sense, it's everything in the image that points, that says, "Look here." Instead of expanding on the idea of gesture too much here, we'll look more carefully at it as we walk through the photographs in the second half of the book. But I want to make a couple of observations that might inform how we perceive, or read, gesture in an image.

When I talk about implied motion, I do not mean a slower shutter speed that allows moving elements to blur. That's less an implication of movement than an illustration of it. By *motion*, I mean the way the elements work together in the frame to give it a sense of dynamism, often through balance or strong diagonal lines. Much of this has to do with the way in which we read photographs. The eye scans an image, moves back and forth. If the elements in the image slow the eye, trap it, or stop it entirely, it takes more energy to get the eye moving again—or it *feels* that way. On the other hand, if the placement of elements takes advantage of the momentum of the moving eye, and flows with it, the energy builds. The best I can do in explaining this is to use the metaphor of Judo or Aikido. Both martial arts use the energy of a moving opponent against that opponent rather than trying to stop it cold; the same feels true of our experience reading an image. If the photographer takes advantage of the momentum of my moving eye and guides it rather than stopping its flow, the experience feels more dynamic. This is one of the reasons we talk so much about the so-called rule of thirds, and why in more advanced discussions of composition we talk about the golden spiral, or golden ratio. But we're getting ahead of ourselves.

◀ Nikon D3s, 20mm, 1/100 @ f/10, ISO 400

Oregon Coast, USA, 2011.

▲ Canon 5D, 23mm, 1/50 @ f/9, ISO 800

Varanasi, India, 2007.

The gesture in these two separate frames is different. It's been suggested that gesture isn't in the content of the image but in the composition, but what is composition if not an intentional arrangement of the content? Here the gesture in the first image comes from the entry of the leg, the pointing of the boat, and the glance of the dog.

Related to the idea of motion and how we read a photograph is the fact that, in the West, we read from left to right. Whether this translates to other cultures I don't know, but from the written word to graphic novels, to cinema, and into the still image, we generally read from left to right. As a result, our eyes enter the image at the top left and move right. This is why the primary diagonal is the stronger of the two possible extreme diagonals in the frame—the left-to-right and top-to-bottom directions of that diagonal have both the momentum of our eye and the force of visual gravity working for it. There's nothing to slow the movement of the eye. Going the other way takes more work—and we're still inclined to see the secondary diagonal as a line going from bottom left to top right, rather than having our eye go all the way to the other side of the frame and reading the image from right to left. We just don't seem to work that way. Understanding this as the way most people will read the image enables the photographer to place elements in the frame to work with this tendency, creating images with either more or less energy—or gesture. For most of us, a photograph of a car driving down a slope on the primary diagonal seems faster than the same image flipped horizontally, such that the car goes downhill on the secondary diagonal. Furthermore, if you wanted the car to drive *up* the hill, it would go up the hill faster if it went up from the bottom left and toward the top-right corner of the frame, in the direction the eye prefers to read the photograph, rather than having it moving up the secondary diagonal against the natural movement of the eye.

Not all gesture need be so dramatic. Gesture can be soft, following the lines of a woman's naked form or the contours of bubbles under river ice in winter.

Gesture is the dark sweeping line made by a length of burnt driftwood on a light beach. It's the reaching arms of a child that form lines that direct our gaze to the top of the frame. It's the glance in a portrait, and the line of a face. Gesture is the *form* of the photograph, and it is a big part of how we create—and find—meaning in photographs.

Thirds

No discussion of composition is complete without a discussion of the so-called rule of thirds, but I think it's been given more attention and priority than it is due. That is to say, like many rules, we've followed it without so much as question- ing it. Does every photograph benefit from an unwavering obedience to this so-called rule? Of course not. So the more interesting question is, "How can we understand and apply the rule of thirds in a way that leads to more expressive photographs, and not merely drop elements into a one-size-fits-all template?" Furthermore, is our usual understanding of thirds—one entirely concerned only with two dimensions—sufficient, or can it be expanded?

The rule of thirds states that if you divide the frame into three equal vertical columns and three equal horizontal rows, then placing elements along one of those lines or at one of the points where those lines intersect will make the pho- tograph more interesting. The implication is that a horizon placed along a third will be more interesting than if it bisects the image across the middle. There's nothing wrong with this principle per se. It forces us to place key elements somewhere other than the center of the image, and for many beginning photog- raphers that's a good first step. But it's no closer to making expressive photo- graphs than if a painter is told, "Use more red. Red makes things more exciting."

The rule of thirds matters because, when used, it forces us to dynamically balance the elements in our frame. Placed in the center, the elements can be perfectly balanced, but they're static. They engage us less. But move those elements into thirds and we're forced to re-balance, to consider the visual mass of objects in the frame and balance them against each other. We're left with the greater possibility of tension and the energy that comes with the feeling of potential, or implied, movement. Our eyes, seeing one element on a third, scan the rest of the image to find enough mass there to balance it. Used correctly, it is much more engaging. But is it a rule? No. It's a principle to be used or ignored in service of expressing your vision.

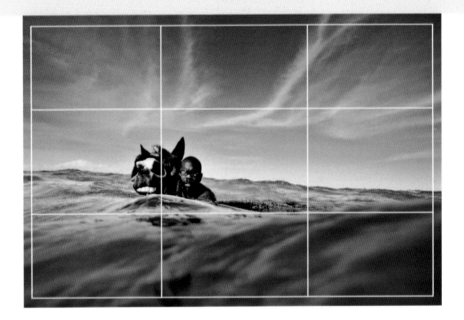

▶ Canon 5D, 30mm, 1/500 @ f/10, ISO 200

Jamaica, 2010.

There are always choices to be made, and in this image I chose not to place the horizon on a third; it ends up roughly in the middle of the frame. Giving the sky and water equal weight works in this image, in part because of the way the clouds repeat the wave pattern, and I wanted to keep that. But the horse and rider do align with the vertical line on the left third of the frame, giving space on the right to balance them out and lend a sense of motion with the implication that they've come from that direction. Remember that the so-called rule of thirds is not a rule at all, but a principle to be adapted according to your tastes and your vision. I could have used the rule of thirds several ways here, but it was this one that resulted in a photograph expressing what I wanted.

The other thing for which the rule of thirds is helpful is implying a *visual hierarchy*. That is to say, you tell the reader that some elements in the photograph are more important than others. You can do this in two ways.

The first is by placing the most important elements at the points where the thirds meet, which is where the eye seems to be naturally drawn. By implication, that element—though never to the exclusion of other considerations—will draw the eye a little more. In doing so, you are telling the reader that this element is more important than others. Using the thirds is only one way to do this, but it's helpful, especially if used in conjunction with other principles of visual pull.

The second is simply a matter of how much of the frame you fill. If you make a vertically framed photograph of the rolling ocean under the boiling sky of an inbound storm and place the horizon at the center, you tell the reader that both elements are equally important. You, in fact, make the horizon the main focus. You're telling the reader, in the absence of other clues, that the meeting place of ocean and sky is the subject of the image. Now place the horizon on the bottom third of the image. The framing forces you to include more sky and less ocean, cueing the reader to read the sky as much more important than the ocean. Simply because there is *more* of it, the image is *more about* the sky than the ocean. The balance potentially changes, too. If the sky is dark, the change in composition gives the sky greater visual weight and makes the image a little more top-heavy. It's still balanced, but that implied top-heaviness gives a dynamic balance to the photograph.

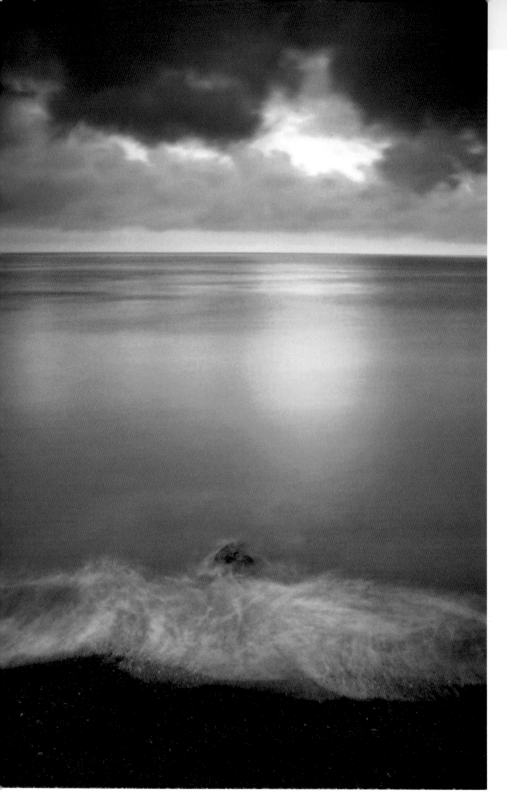

◀ Canon 5D Mk II, 32mm,
6 seconds @ f/22, ISO 50

Italy, 2010.

Placing the horizon so high
within the frame—at the
topmost third—gives the ocean
greater prominence than the
sky. And though I could have
placed it lower—the sky was
fantastically moody—I would
have lost the meeting of wave
on shore, which effectively
divides this photograph into
one third for each element
here: earth, water, sky. It also
allows the dark beach and shore
break to echo the brooding sky.
Changing the composition by
raising the camera would have
made the sky more important
than I wanted it to be.

Now consider a horizontally framed image. If you place a solitary person in the center, the eye has little exploration to do within the frame. The balance is static. The visual hierarchy is clear, and there's not much left to do but enjoy the photograph and move on to the next image. Moving that person to the left third of the frame gives you room to suggest a relationship between this person and his background; in fact, it forces you to balance that person against other elements, creating that dynamic balance. The eye will read the image from left to right, and it will move on from the person on the left third toward the right edge of the frame, encountering something else that diverts the eye, forcing it to explore. And if you've added enough depth and placed the elements accordingly, the eye can be forced into a spiral—never leaving the frame—and have a longer and more engaging experience. We'll get to a discussion of the spiral soon, but I want to expand our discussion of thirds into the third dimension—the depth of the photograph—which it's seldom associated with.

The usual discussion of thirds is communicated as a rule, and I think it's time we stopped talking in terms of rules and discussed principles instead. Furthermore, it's almost always discussed—as I have in the preceding paragraphs—as it relates only to the height and width of the frame. But the principle of thirds can as easily be applied to the perceived depth of the image, and that application makes for images with not only greater dynamic balance or tension, but greater depth and balance and tension in that perceived dimension as well. I say *perceived* because it's still a two-dimensional photograph, but we can create the illusion of depth using perspective, and within that illusion the principle of thirds can contribute to more compelling compositions. Consider the image of the man and horse in the water (top of next page).

I've overlaid a traditional thirds grid to show you the rough thirds on the horizontal and vertical planes. But it's the red Xs that indicate, roughly, the *depth* of the image. The Xs get smaller to roughly correspond to the effect of perspective, with A, B, and C indicating the fore-, mid-, and background. What I'm trying to illustrate is their position roughly on thirds within the depth of the photograph. If thinking of it as a cube (rather than a grid) helps, great. If merely thinking of it as considering placing elements on thirds *into* the image rather than only across or up and down, then that might help, too. Again, the goal isn't compliance, but adding in depth to deepen the experience of the reader.

As far as the so-called rule of thirds, what was once such an easy "rule" is getting more complex, but it's not so difficult if you take a moment to consider that

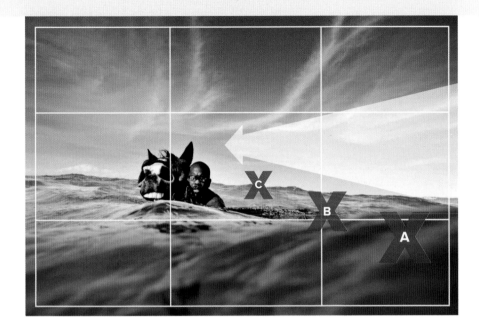

all we're doing is re-mapping our thinking to apply the principle of thirds to the depth of the image, which we read into photographs because of perspective. If the balance and tension along the thirds and at intersections of thirds is a helpful place to start in our compositions on one plane, it's a good starting point as we place things into the depth of the frame as well.

While this "cube of thirds" isn't the usual way of looking at things, the notion of foreground, midground, and background is common enough; we're now giving that notion some context. If the advice to "make sure you have a foreground, midground and background" is as unhelpful to you as it always has been to me, this cube of thirds shows us, as a starting place, where balance and tension can be found. It reminds us that the depth of the canvas matters as much as the other two dimensions, and it can push us to make decisions about the elements in the frame that we might not have otherwise considered. And it's here that knowing your optics is so helpful. If you want to place elements in relation to each other and within this imagined cube in a certain way, then the compressing effect of longer lenses can help with this, as can the expanding effect of wider lenses, depending how deep your cube (the actual scene) is, and where, from front to back, you want these elements to be placed.

Placing the foreground (**A**), midground (**B**), and background (**C**) all roughly on thirds creates a depth to the photograph that wouldn't be there without the arc of the foreground wave or the background line of the horizon, either of which

could have been left out by a simple repositioning of my camera and a change in the angle of view. Including both gives the image that foreground, midground, and background, but does so in a meaningful way—not to follow a rule, but because we know it creates greater depth and, therefore, a greater feeling of inclusion. The use of thirds allows me to accomplish all that while still maintaining—or creating—a dynamic balance and movement within the image. If my goal in this image is to create a more inclusive experience for the reader of this photograph—and I think the experience of the reader is one of the reasons we create photographs to begin with—then these decisions matter a great deal.

The Golden Ratio and Golden Spiral

Although the rule of thirds is the compositional aid every photographer learns, it is in fact a simplification or variation of something called the golden ratio. Based on some interesting math, the golden ratio and the golden spiral appear significantly in the natural world and have influenced Western art for centuries, though I'm not sure it really has the importance it's often afforded. Without going into a long explanation of the background or math behind the golden ratio (and anyone who knows me knows I am the last person in the world to comment on mathematics), let's look at the ratio itself and why it can be significant in suggesting the placement of elements within our photographs.

The golden ratio is graphically represented as a rectangle. Where a square would represent a symmetrical ratio of 1:1, the golden ratio is 1:1.618. Notice how the golden ratio grid is similar to, but deviates from, the rule of thirds. Same concept, different ratios, and therefore a different balance created through its use. Whereas the rule of thirds encourages a certain asymmetry, it is not nearly as elegant, or subtle, as the golden ratio. I didn't compose the image of the rocks in the water (top of next page) thinking about conforming to the golden ratio, but about tension and balance. It is, however, interesting to see how well the elements fit into that grid.

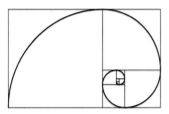

The golden spiral, or shell, is based on the same ratio; it's an asymmetric spiral that starts with a slow, elegant arc and spirals tighter and tighter into itself according to the golden ratio, also called *phi* or Fibonacci's ratio. In the illustration of the spiral here, a series of squares has been laid on top of the spiral to make the ratios clearer. Each of these squares is roughly 0.618 the size of the next largest square. We'll leave the math at that; what's important is that

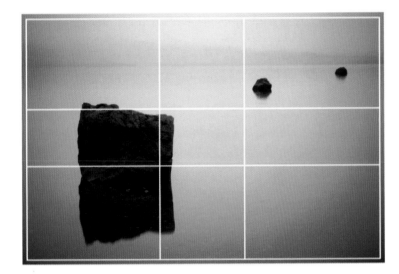

the spiral is not symmetrical. Why does this matter? To the artist, it's about the aesthetics, and there seems to be something about asymmetry—specifically the golden spiral—that fascinates us. It's been considered aesthetically pleasing for over two thousand years. Also known as the divine proportion, this spiral—like the rule of thirds—forces us to reconsider the placement of elements in the photograph, pushes us to rebalance things more dynamically, and in some cases, puts the eye on a spiraling path that never leads outside the frame.

I've read articles that want to make more of the golden ratio and the golden spiral than I think is helpful. I'm sure there are pages and pages of reasons why the divine proportion matters, but as a photographer without much attraction to academia, what matters to me is the aesthetic. Using the golden ratio or the rule of thirds helps me consider the balance of my images. It's a starting point. A reminder. It's not much more than that. It is not a recipe or a template. But it's another helpful visual aid as we explore the placement of elements in the frame.

Every image is different; slavishly following these guides can just as easily lead to poorly balanced and cookie-cutter photographs as it can to beautiful and expressive photographs. Still, imagining the golden spiral overlaid on my own work has sometimes reminded me that the eye follows a path, and where that path is asymmetrical and inward spiraling, the photographer has more potential to create greater engagement and visual exploration for the reader, as well as adding a greater sense of depth and dynamic balance.

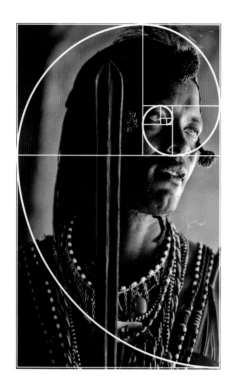

▲ Nikon D3s, 200mm, 1/40 @ f/2.8, ISO 800

Maasai Mara, Kenya, 2011.

Not one to make more of the golden mean or spiral than is pragmatic for me, I do find the shape and proportion—even roughly—to be helpful in describing ways in which our eyes move through some images. In the case of the alternate crop of this portrait, which we'll look at more later, the path of the eye is cleanly described by the elegant spiral from the eye, around the face, around the arc of the head, and down to the beads, before returning to the eye.

Neither the rule of thirds nor the golden spiral is magic; they're both simply guides that, used well, encourage us to create stronger compositions. Nor are the rules infallible or inflexible. Where elements have such strong visual mass that they significantly overpower other elements, they may call for a different placement in the frame—perhaps not on the left third but on the left fifth of the frame, allowing for more negative space or room between elements. As more of us become used to the language of photography, and as placing elements on the thirds becomes the de facto placement, placing an element at the center or much closer to the edges of the frame will be read differently. Putting an element, for example, on the leftmost sixth of the frame instead of the third can force us to make that element smaller, allowing its new proportion in the frame to make it feel smaller, creating a photograph that expresses something very different about the subject, exaggerating how we feel about a subject's smallness or the greater vastness of space surrounding that subject. Reconsidering these so-called rules and asking what they contribute to our photographs—why they've been used so effectively, or intentionally ignored, to great visual effect—can lead us to more mindful and expressive compositions. The question is not whether these tools "work." The question is, what does the use of these tools or guides do for the look of, and the reader's experience of, the photograph? What do they force, or allow, in terms of the balance, tension, scale, and the pull exerted on the eye, the awareness of which then permits us to choose them or ignore them based on our intent for the photograph?

Relationship

Where we place things in relation to the frame is important, but no more important than where we place elements in relation to each other. If you take it for granted that everything within the frame means something, then that meaning comes not only from that element's presence in the frame, and where it is located, but also from its relationship to the other elements. When, for example, we press the shutter and flatten three dimensions into two, perspective forces us to see larger objects in the frame as closer than distant objects, which appear smaller. This creates depth but it also creates implications that will be

▲ Canon 20D, 17mm, 1/60 @ f/10, ISO 800

Vancouver, BC, Canada, 2005.

My point of view (POV) in this shot—straight on toward the cooks and staff at one of my favorite restaurants—allows the relationships between the characters to play most fully to the reader. One is standing and looking elsewhere; the others, all sitting, relate to each other in different ways according to where they are looking and their body language. Had I shot this from other angles, the relationships between the cast in this image, with each other and the frame itself, would have changed. Straight on, they are all equal and each look or gesture holds equal weight, allowing us to read each piece of the frame equally, while questioning the odd man out. Why is he standing? Late to the party?

read by the viewer, an implication that the larger object is more important or more powerful than the smaller object. When you swing the camera farther to one side, you widen the apparent distance between those same objects, implying something about distance. Doing the opposite—swinging the camera in an arc that places the two elements into a near-straight line with the camera—will make the distance seem less exaggerated, allowing the photographer to imply connections or intimacy, or make comparisons. Elements relate to each other, and those relationships say certain things. Our framing is not merely a matter of "I just liked it better that way," but of intentionally communicating not only what we saw, but *how* we saw it.

Point of View, Picture Plane, and Perspective

I suspect if we were to gather all the millions upon millions of images out there in one place like Flickr, a full 80 percent of them would be created from standing-up, eye-level height, and with a standard lens. In my first eBook, *Ten*, I suggested we could change the perspective of the reader by first changing ours. I wish I'd pushed harder on this one. Our POV changes the relationship of *every* element in the frame, and it's not only our own body position that I'm talking about—moving from standing to kneeling, for example—but the angle of the camera as well.

When we move our bodies, and the camera with it, or we angle the camera up or down, or left or right, we change perspective, which in turn changes the way elements relate; it changes the way lines move within the frame, and even how dynamic those lines are. Remember, the moment you press the shutter you collapse a world that we perceive in three dimensions into two, and the photograph created is not buildings, trees, or people; it's lines and tones, all in a spatial relationship to each other, and to the frame. Pressing that shutter forever freezes everything in the frame; your *only* chance to get it right is to be mindful as you compose, to learn to see those lines and tones and the way they relate. The good news is, you can see them—you just have to pay attention.

It's this lack of mindfulness that is responsible for trees and poles coming out of people's heads. What we saw in the viewfinder was perceived as three dimensions, and our minds saw the distance between the foreground subject (person) and the background (tree). When we flatten it in a photograph, our eyes cease

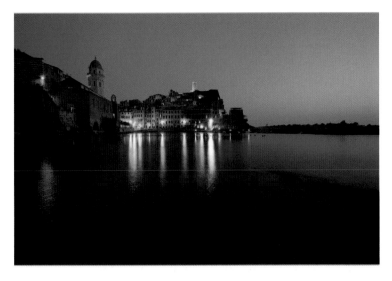

◀ Nikon D3s, 18mm, 20 seconds @ f/13, ISO 200

▼ Canon 1Ds Mk III, 45mm, 20 seconds @ f/8, ISO 200

Vernazza, Italy, 2010.

At the extremes it's easier to see the dramatic difference POV can make. Both of these were made in Vernazza, Italy—one from low on a rock at the waterline of the harbor, the other from a promontory overlooking the town, almost directly above where the first was made, though with a couple hundred feet separating the two.

to be fooled, resulting in the merging of person and tree. If only we'd been more aware of that flattening, and had moved to the left or the right, shifting perspective and putting the elements in less distracting places before they were forever flattened.

"Although we can't move most things in a scene, we can move them in relation to each other by simply moving our own position."

If you skipped the primer on perspective in fourth-grade art class, here are the basics, explained as best I can without simply copying and pasting from someone with a clearer explanation. Objects close to us appear large; with distance, those objects look smaller and smaller until they disappear on the horizon at the point we call the *vanishing point*. Parallel lines do the same; they recede into the distance and meet at the vanishing point. Because of this, shapes too, will take on a distorted appearance. Circles appear as ellipses, squares as rhomboids. That's part of it, and in art class we had to draw illustrations with lots of lines like the ones I've overlaid on the image here (opposite page, bottom) to show the teacher that we understood. Furthermore, as we move, and as our relationship to the vanishing point moves, so too does our relationship to every other object between us and that point. And the relationship between those elements themselves changes. This is a fancy way of saying that although we can't move most things in a scene, we can move them in relation to each other by simply moving our own position.

A change in your position, and therefore in the perspective in your photograph, can turn a normal horizontal line into a great diagonal, changing the feel of the image and the direction in which the eye moves. It can place subjects closer together or further apart, changing not only the balance of the image—and therefore the way it feels—but also the way those subjects are seen to relate to each other, which changes the message of the image. Changing your POV can change the way we feel about a subject, or it can eliminate a distracting background. The changes can be significant, but they don't happen automatically. We need to be mindful of them. Where is our background in relation to the foreground? What lines are formed, and how is the image balanced as a result? If we shot from a lying–down POV, would we see less of the ground and get better lines?

When it comes to learning to read photographs, it's just a matter of reverse-engineering an image. Initially, this is easier to practice with existing photographs because the flattening has already occurred, and that makes it a great

▲ Nikon D3s, 50mm, 1/60 @ f/10, ISO 400

Liguria, Italy, 2011.

I've overlaid lines along the obvious lines in this photograph to show you the perspective. Notice two things: first, that the parallel horizontal lines all lead to one vanishing point; and second, that due to my own position and the position of the model, the vanishing point is immediately behind her, leading eyes powerfully through the image toward her. Had I moved my shooting position, the lines would all still lead to the same vanishing point in the reality of the scene, but that point would be at a different place relative to the frame, depending on how I composed the photograph.

starting point. When you look at a photograph, as we soon will, ask yourself how the position of the photographer contributed to the image. Where was the photographer, what's their POV, and what does that do to the lines and elements in the image? How would that change if the photographer had been differently situated, perhaps 90 degrees to the left or right, or standing on a chair or taller building? Sure, this is all "what ifs" but it's this ability to think critically and even hypothetically about existing photographs that gets us used to this kind of thinking when our own eye is behind the viewfinder.

Our mind is one of those photographic tools that gets too little attention. I recently read a comment on the Internet by a photographer who said that if he had to think about every photograph he made, he'd give up photography. Thank God songwriters, playwrights, architects, and choreographers don't approach their art with such a ridiculous mind-set. My friend Yves Perreault recently called it *photo-parreseux*—French for "lazy photographer." Indeed.

Adding the illusion of depth is in part a matter of perspective. We're used to seeing two-dimensional representations of the three-dimensional world, and we understand that as objects recede into the background they get smaller. It's one of the conventions of the language we use in photography, and it can be used to create the feeling of depth. But that's not the only way. We've looked at how the use of light can create a sense of depth or dimension, but there is also the way we arrange foreground elements in relation to background elements, and unless either the foreground or background can be physically moved, the way we do that is primarily through our choice of POV. This can be exaggerated optically as well, so our choice of lens contributes to this, but as the effect is one of exaggerating the relationship—rather than changing it—we'll concentrate on POV here.

We've already discussed the key ways in which our own POV affects the relationships of elements within the frame, and how the laws of visual perspective guide that. *Picture plane* is the formal term for the angle at which we permanently view the scene within the photograph. The picture plane determines the perspective and the way in which foreground and background relate. You can shoot straight on, so your picture plane is parallel or perpendicular to your subject, or you can shoot obliquely, from one of innumerable angles. What matters are the lines you produce, how the elements line up, and what mood you create.

Creative Exercise

Next time you're out with your camera, ask yourself how many distinct photographs you can create, all of them with a different picture plane. Practically, this means you move around your scene, and within it. Get low and angle the camera up, creating a dramatic picture plane that emphasizes the size of towering objects, or get as close to the wall as you can and shoot along it, creating a dramatic vanishing point. If you've got a distinct foreground, walk around it, get close, back up, change focal lengths, and keep an eye on where the background elements go in relationship to the foreground. Then look more critically and ask yourself how the resulting relationships of the foreground and background change the message of the photograph. How will one viewer read these photographs differently? What will she feel? What meaning will she infer from the changes? How will the eye move differently within the frame?

Balance

The way we frame an image and manipulate the elements within that frame creates balance, or a lack of balance, within the photograph. That balance (or its lack) will affect the way the reader experiences and reads that image. This is one of the reasons we've used the well-worn so-called rule of thirds so much that we've forgotten *why* we use it. The problem, of course, is that perfect placement of a boring subject won't make the image any more interesting. What the rule of thirds *can* do is create a different sense of balance.

We have a natural inclination to balance our frames, and the easiest way to do that as a beginning photographer is to place the main subject matter in the center of the frame. This does balance the frame, but it's static. Moving the subject to one of the imaginary lines a third of the way into the frame also generally balances the frame—depending on what else is in there, and how much pull it exerts on our eyes—but it is now a more *dynamic* balance. A dynamic balance engages our eyes, creates tension—in some cases, the feeling of potential movement—and allows room in the image for other elements and an implied relationship between them.

Nikon D3s, 14mm, 1/100 @ f/10, ISO 200

Pacific City, Oregon, 2011.

Mentally dividing the frame and evaluating the visual mass of each half has been helpful to me in studying balance. In this case, my friend Dave Delnea and the rock in the surf have roughly the same mass—in part because we're drawn so powerfully to human figures, and in part because his shadow adds to his mass, making him more visually massive than he looks at first glance.

That implied relationship between elements has much to do with balance. At the center of the issue of balance is the issue of visual mass, or weight, which is a good way of looking at it, but I prefer the idea of "visual pull" because it has more to do with the way we interact with the elements in the photograph. Understanding visual pull changed the way I make photographs, so rather than specifically address the idea of balance, let's approach the subject obliquely and talk about visual mass, or pull.

Everything in the frame exerts some force on the eye, and pulls it. Some elements pull our eye with much greater force than others. When we talk about balance we're talking in metaphor, because of course you can't pull visual elements from a frame and weigh them. But that's exactly what the eye does. We read the frame and are pulled differently to the elements within the frame; we judge the relationships between those elements to be either balanced or imbalanced in relation to the frame; and we experience the photograph correspondingly. That's the basis for the notion of visual mass. We notice some things more readily than others. If you were sitting at your kitchen table, staring at a spot on the wall, and two people moved into your field of view, you would notice the one moving quickly or erratically sooner than the one creeping slowly and smoothly. Magicians, taking advantage of this psychological phenomenon, will conceal smaller movements with one hand by making larger, faster movements with the other. Similarly, within the frame a large object will usually pull our eye more than a small one. A light-toned object will pull more than a dark one. An element that is sharp and in focus will pull more than one that's blurred. Organic elements often pull more than nonorganic ones, and warm objects more than cooler objects. But before you make notes and consider these as hard and fast rules—they aren't. Context and contrast make a big difference. While we're usually pulled to large elements over small ones, and light objects over dark ones, a small black stone in a field of large white ones will pull the eye more because it's a break in a repeating pattern. The "rule" of being drawn to large or light objects first is set on its ear by the context of the image. Contrast pulls our eye, and it's that contrast of one element against the rest of the frame that gives that element visual mass or pull—not specifically that it is a yellow object in a sea of blue.

Understanding visual mass is not something you grasp with a formula; it's something you get a feel for. You see it in some photographs, an exquisite sense of balance that keeps the elements in the frame in perfect tension with each other.

"Understanding visual mass is not something you grasp with a formula; it's something you get a feel for."

It allows us to place elements within the frame in relation to others and, through that placement, to change the way we feel about the image. Statically balanced images lead to a sense of calm and will be read more passively than an image with a dynamic balance, a feeling of potential movement or energy. Imbalance too can work strongly in our favor—if what we want is to throw the reader off kilter, or to communicate a sense of unease or chaos.

▶ Nikon D3s, 14mm, 1/40 @ f/7.1, ISO 400

Pensacola, Florida, USA, 2011.

In the first image, the static balance is most easily identified by placing an imaginary fulcrum through the middle of the image. In the second image, which is dynamically balanced, the fulcrum needs to come much further to the right, just past a third, giving us further hints about the way the rule of thirds serves our sense of balance if we let it—and if we do so with flexibility.

It might be helpful to think of static versus dynamic balance by considering these two frames (opposite page). Both of these were photographed from the same boardwalk on a lagoon in Florida. In the first, the balance is static; one element cleanly balances against the other from one side of the frame to the other. The fulcrum is in the middle, indicated by the line in the center. In the second frame, the strong point of interest has to be placed well to the right to allow the remaining space to balance it. That remaining space is more than two-thirds of the photograph. It's balanced dynamically because it takes the leverage of that large majority of the frame on an offset fulcrum to create the balance.

Remember that balance is not merely about one element within the frame. Of course, there are photographs with this kind of elegant simplicity, but the more you add elements, the greater the need to balance those elements—and their respective amounts of visual pull—against each other and the frame itself. The photographs of the three rocks (page 118) represent the way visual mass changes—and therefore the way we balance an image—depending on our decisions, in this case, our POV and choice of lens. Looking at them as they sit side by side, each of them a few inches from each other in a horizontal line across the frame, they have roughly the same pull on the eye and balance each other out. In the second image, I moved in an arc toward one of the stones on the end of the line. The closer you get to one stone, the further you get from the others; a vanishing point is created, the rules of perspective kick in, and that closer stone is now larger within the frame, while the furthest stone is smaller. If you put a wide-angle lens on the camera, which I did, and get closer to the nearest stone, the effect becomes even more pronounced. Now open the aperture and allow the stones to get blurred as they recede; the pull on the foreground rock is even greater because your decisions have given it greater visual pull. And the greater the pull, the greater the need to balance that pull with other elements.

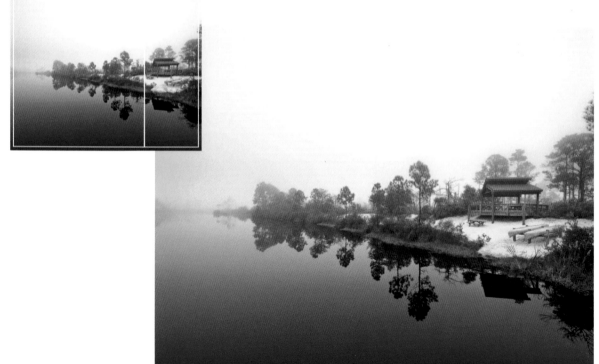

This is a great example of how our decisions interact with the elements in a scene. It's also a good example of how the flattening effect of the photograph will change the reality of the image. In real life, those three stones are the same size. In the second photograph, they become three differently sized rocks that all interact with both the frame and the reader, according to how they behave as graphic elements, not rocks. The reader's mind is likely to know that the three rocks are all the same size, that the foreshortening effect of perspective is just an illusion. But the eye will read it as it is in the image, and move to that apparently larger stone first. Because the eye goes there first, that stone has greater mass and will affect the way you choose to balance, or imbalance, your photograph.

Balance isn't easy to teach; I suspect it's something you come about internally as you begin to understand, and get a sense for, visual mass. One of the ways I look at balance in an image is to look at the elements and ask myself, of a possible 100 percent within the image, how much pull does each element exert? It's approximate, but if I can give myself some loose values for each significant element, I can also get a sense of whether they balance out in the frame. The point isn't the math; the point is looking critically and mindfully, and recognizing

that if one element has significant pull then it needs to be balanced by something else, even negative space. Another trick—and a good exercise once in a while—is to flip the image horizontally in Aperture, Lightroom, or Photoshop. Looking at it flipped can force us to see the relationship of elements to the frame in a new way. Although it will read differently because we shot it assuming the reader would see it as we do, from left to right, the balance will either be there or it won't.

Negative space is space within an image that is not our immediate subject matter. Its use allows images to breathe and to balance. Having space that is not the subject matter creates a contrast and directs the eye to the thing you want it to see. Negative space has very low visual mass, but it has enough that an element of interest placed, for example, near one of the thirds of the frame will balance out against the two-thirds of the frame now occupied by the negative space. It's the same concept designers refer to when they talk about white space. It's the space within the frame that allows the eye to move freely and to balance the subject matter, either dynamically or statically. Its name is misleading as, in fact, negative space is positive in the sense that it has mass, balances the frame, and gives the eye room to move. Negative space does more than provide balance, but I mention it here because without considering the role of negative space it would be easy to assume that you always need multiple objects in the frame to balance each other, when in fact one element will do if you think of negative space itself as an element with its own mass, or pull.

Creative Exercise

Choose one of your own photographs and ask yourself, is it balanced? If so, where does that balance come from? Which elements have more visual mass than others, and what is acting as a counterbalance to that element (or those elements) to keep the frame in balance? Is it dynamically or statically balanced? If it's static, could you change the composition to make the frame more dynamic while still maintaining balance? The best way to learn balance is to study it in as many photographs as possible; balance is learned and honed with familiarity. We all have a slightly different sense of balance and, among other things, it's that uniqueness that gives a specific photographer her own unique stamp on her photographs.

◀ Canon 5D Mk II, 85mm, 1/400 @ f/4, ISO 400

Vancouver, Canada, 2008.

The negative space in this photograph comes from the fog shrouding the freighters on English Bay in Vancouver on a rare snowy day. The three benches are echoed somewhat by the two freighters, seemingly floating, and are balanced against the elegant gray tones of the fog. Negative space is space for the eye to move, to balance the frame. Why we still call it negative, I'm not sure, but I'm thinking of starting a petition.

Optics

As you grow in your craft as a photographer, you become more intimate with the tools of your expression. Among the most significant of these aesthetic tools are your lenses. As you become increasingly familiar with them—assuming you do it mindfully and pay attention—the more readily you'll be able to predict the look that each focal length creates. After 25 years I'm only now getting to the point where I can look at an image and guess, with some accuracy, the focal lengths used, but it shouldn't have taken me this long. For years I didn't pay attention, and that delay has cost me in my ability to best visualize images before putting the camera to my eye.

I'm not a zealot about it, but I think the ability to see a scene through various lenses in your mind's eye—even in rough approximations—is as important as a painter knowing what brushes give a certain aesthetic. It's for this reason I'm an unrepentant advocate of being mindful. Never mind how much stuff a wide-angle lens permits within the frame, though that's one of the behaviors of a wide-angle lens. The more important questions are, How does it treat the elements in the frame? What does it do to lines? Does it have the appearance of compressing elements or expanding them?

I've fielded a number of emails from people on the far end of the geek spectrum, people who seem to know more about the math and science of optics than I do (which is not very much, to be honest), and they've pointed out that long lenses don't change perspective, nor—technically—do they compress things. Maybe. I'm neither a scientist nor a mathematician. I do know that looking at a photograph is not, for most of us, a scientific or mathematical experience. If all the lenses do is create a certain perception or illusion, then that's

what matters. Lenses do not change perspective—only your position does that—but, in the case of wider focal lengths, they will exaggerate the feeling created by your perspective. Or, in the case of the longer lens, it'll create the sense of a flatter perspective. And for most of us, that's what matters. As for compression, well, that's the same thing. Perhaps we should be talking about the visual illusion created by the cumulative effect of magnification and angle of view, but saying "longer focal lengths compress things" is simply easier. In the realm of art, I'm not sure our priority needs to be technical accuracy. It's about the look of the image and the experience of the reader. Illusions are powerful things, and math seldom enters into it. The reader doesn't care what lens you used; they care only about what the image looks like, and how they react to it.

◀ Canon 5D Mk II, Lensbaby, 1/40 @ f/4, ISO 400

Ladakh, India, 2009.

◀ Canon 1Ds Mk III, 265mm, 1/100 @ f/10, ISO 100

Kenya, 2010.

A companion to the Burning Bush image that we'll look at later (page 211), this one was shot with a 265mm focal length, flattening the image and pulling the cloud bank against the tree, which forms an implied relationship between them. As photographers, depth is not always the device we want. When a strong graphic photograph is what we need, the longer focal lengths accomplish that, creating both a flattened/compressed look, but also creating the implication of connection. If you want to imply that the bush is burning, even metaphorically, the wider lens won't help.

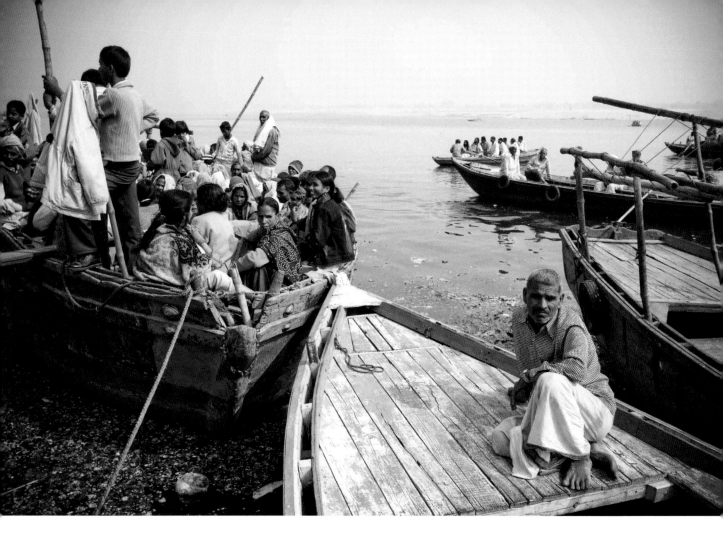

If it's about the look, and if different lenses are part of our visual toolbox, then the more familiar we are with the tools, the better we'll be able to use them to create images that say what we want to say, the closer we'll get to being able to mindfully creating compelling images.

It might be most helpful to think of these behaviors in terms of the look they impose on the image. Although they are often described in terms of compression and expansion, I prefer to think of them in terms of exclusion versus inclusion. A wider-angle lens (24mm, for example) is a more inclusive lens both in terms of how much it allows into the frame and in terms of making the reader feel part of the scene. A longer focal length (200mm, for example) usually has the opposite effect; it isolates elements, creates a greater feeling of flattening foreground with background. It's not that one is better than another. It's

different brushes for different paintings, and learning to identify the aesthetic—and what that look accomplishes in terms of how we experience the image—is a first step in learning to create compelling images with these tools. I've come to associate my different lenses with different feelings, and the inclusion/exclusion or inclusive/expansive thinking has helped me immensely. If I know the feeling I want in the image, it gives me a simpler starting place for the selection of my optics.

The amazing thing about the learning curve of photography is that it's all visible. There are no secrets. If you look at two photographs, one taken with a wide lens and the other with a longer lens, you'll see the difference for yourself. Yes, you'll have to move back to get even roughly the same elements in the frame. By moving back you'll necessarily change your perspective—which is always relative to your position, not the kind of lens you use—but you'll also create images with a distinctly different sense of space. The sense of compression given by the use of a long lens can place an element closer to a background, thereby implying something about the relationship between them, while also excluding more of what does not belong, creating a simpler composition in which each of the remaining elements has more impact. Or you can use the wider lens to draw the reader in, or increase the wrap-around feeling of lines and shapes.

The focal lengths of our optics are not the only qualities worth understanding. Certain lenses have greater contrast than others and treat colors a little differently. I have a Zeiss 50mm f/1.4 that I adore, and I have found it gives me a look a little more like film than any other 50mm lens I've ever used on my digital cameras. I know there's a scientific reason for this, but the thing is, I just don't care. What I care about is the look, and this lens is just profoundly nice to use. It also creates a beautiful bokeh, which is a fancy word for "the shape of the bright out-of-focus bits" in your photograph when shot at wider apertures. That bokeh is the reason Canon photographers—myself included at one point—have spent a small fortune on the EF 85mm f/1.2 lens. At f/1.2, the bokeh is simply gorgeous, and although this kind of thing can lead to pixel-peeping and geeking out, it's not a stretch to say that anyone who cares about the look of their photographs will consider worthwhile the tools capable of creating that look. What I mean to say is, paying attention to the lenses we use, experimenting with others, and knowing that the lens can make the difference between a good photograph and something stunning, can improve our photography. Just remember, ultimately it's about the photograph, not the lens, and shelling out

Varanasi, India, 2007.

A longer lens, even stepping back several yards, would not give this look. Here, the wide angle of a shorter focal length allows the lines of the foreground boat to spread and create an exaggerated sense of space. In contrast to the crowded boat behind the seated man, the exaggeration of empty space is what pushes the contrast and, therefore, the sense of story in this photograph. If you're trying to say, "Look at this empty boat when the other boat is so full!" then the wider lens is a strong tool to say that.

▶ Nikon D3s, 200mm,
1/800 @ f/6.3, ISO 400

Maasai Mara, Kenya, 2011.

The 200mm lens, one of
the shortest I had with
me on the drive that
particular day, has an
apparent compressing
effect, pushing the balloon,
acacia trees, and Land
Rover together, isolating
them (where a wider lens
would have included more),
and creating an implied
connection between these
elements, so typical of an
African safari these days.

for the most expensive piece of glass may not be the best choice if you prefer
the look rendered by a $100 Canon 50mm f/1.8 made mostly of plastic. Similarly,
a poorly conceived image with beautiful bokeh made with a $2,000 lens is likely
to move very few people.

Filters

Filters don't qualify as optics in the usual sense, but there are no other catego-
ries into which they all fit, and I want to talk about filters generally. If we were to
take them each on their own merits, we'd be discussing different filters in dif-
ferent places—neutral-density filters in the section on exposing for aesthetics,
for example.

When I transitioned to digital, I was told in no uncertain terms, "You don't need
filters when shooting digitally. You can do it all in Photoshop." As the years
passed, I began to miss the benefits that filters brought not only to my work but
to my workflow. Working with filters allows me to see possibilities right there in
the camera, and to make changes and find inspiration as I work, ending with a
significantly better photograph. The notion of fixing it later in post-production
took away some of the happy accidents I used to experience, but more than
that, forsaking filters meant a significant change in the aesthetic of my images.
Having left filters behind because I could "fix it later in Photoshop" began to feel

like cheating to me. But more importantly, it began to feel misguided. Photoshop and other post-production software programs are unquestionably powerful, and they have their place. Yet there are things that the right optical filters can do with significantly less work than Photoshop, and there are things some filters can do that no amount of basic Photoshop skills can re-create, like the effects of a polarizing filter.

If we accept that the look of the image has a bearing on the things we say with that photograph, then we must also accept that tools that significantly affect the look of the image in-capture also affect the way we read them, that they are tools to be used in forming sentences with the visual language. Look at the two images I shot at Cape Foulwind on New Zealand's South Island. They were taken only a couple minutes apart; the first is the image the way I intended it to look, with nothing done in the digital darkroom except a little tweak to the contrast and exposure. I shot it with a solid three-stop neutral density filter and a three-stop graduated neutral density filter stacked together. This combination allowed me to hold back the sky—preventing overexposure and loss of highlight detail—as well as use a slower shutter speed to blur the water. The second is the best I could do in-camera without the use of filters. The difference in the way the images feel is significant because the photographs *look* different. Mood is a function of how the photograph looks. They look different because filters allowed me to do things I couldn't otherwise do.

Neutral-density filters, either solid or graduated, expand the ability of the camera to use the tools it already has, allowing the use of larger apertures or longer shutter speeds. In the image shown here (top), the longer shutter speed allows the

▲ Nikon D3s, 60mm, 10 seconds @ f/22, ISO 100, Singh Ray 3-Stop ND and 3-Stop Graduated ND, hard transition filters

▶ Nikon D3s, 60mm, 0.5 seconds @ f/22, ISO 100, no filters used
Cape Foulwind, New Zealand, 2010.

water to blur, which has an effect not only on the feel of the image but on its focus. It has an isolating effect, freeing the photograph from the clutter made by the texture of individual waves and rocks. The difference allows me to create a simplified composition of an otherwise cluttered scene. The longer shutter speed enables me to get more color into the image and keep the moody feeling of the clouds. Remember, these two images both contain such minimal adjustments after the fact that they're negligible. The amount of work required in Photoshop to render the second image into something remotely close to the first would be significant, never mind a loss of the image's integrity. Put simply, they feel different because they look different. They say different things because they're using different words. The movement toward more post-production and less in-camera work, combined with the idea that carrying less gear makes life easier (which it does), has taken us further from the possibilities of our craft. I now carry a heavier tripod than I ever have, and I almost never leave home without my filters, but my work has become more expressive and I have a wider gamut of creative options available to me than ever before.

◀ Nikon D3s, 24mm, 30 seconds @ f/16, ISO 400

Cinque Terre, Italy, 2011.

Three photographs of Manarola, one of the villages of the Cinque Terre, Italy. The first two show Singh Ray's Gold'n'Blue polarizing filter in use, spun to different positions that change the colors of the light. The third is the same view without the filter at all. Any of these would be considered a different expression of the same scene, each creating a different mood.

Polarizers too can bring new words to the visual language, words not easily (if at all) produced in the darkroom. Like the final image of Cape Foulwind—simplified from distraction through the use of the right filters—polarizers can reduce glare and significantly change the way an image feels. True, in the darkroom you can duplicate the saturation effect polarizers have on colors, but you can't easily remove glare or sheen the same way a polarizer does. Although these are small matters, it is these seemingly small things that make the difference between images that say precisely what we want them to say and images that merely come close. Nuance and small details are everything. Poets choose their individual words very carefully.

Other polarizers, like Singh Ray's warming polarizer or Gold'n'Blue polarizer, play with the light and change the way colors are represented. The Gold'n'Blue is one of my favorites, and while it can be easily overused, it's able to create a feel to the images that I've been unable to reproduce successfully in Photoshop.

Focus

If art points at something, then what we focus on—and how much we focus on—can significantly change the message and meaning of a photograph. I'm conscious as I write this that I've covered much of this in my first book, *Within the Frame*. My goal in *Within the Frame* was to draw attention to these technical

▶ Nikon D3s, 24mm, 1/60 @ f/3.5, ISO 800

Nevada, 2011.

I loved the chaos of this plant and wanted to show it, but without pulling the attention from the flower and letting that chaos take over. A shallow depth of field allows me to create textures and subtle lines, but diminishes the visual pull of those elements, letting me feel the mess of the foliage without being so blindsided by it that I see nothing else.

matters. My goal here is to talk about *what these possibilities can communicate* in our images. Imagine you see something on the horizon and point it out to a friend with a wild, rather unspecific gesture. He sees you point, he looks in the general direction, and still has no idea what you're pointing at. Until he sees what you're pointing at, the two of you have two separate experiences. You're seeing something, he's searching. You're pointing, he's guessing. Photographs can be like this. The photographer sees something, takes a photograph as a means of saying, "Look at this." But unless he points clearly and specifically, we don't have the experience of seeing; we have the frustration of merely looking.

Focus—specifically, our choices regarding what we focus on, how much we focus on, and along what plane—determines what viewers look at, and how they read our photographs.

Depth of field defines how much within the image is in focus, and when used well it's a powerful tool to direct the attention and push/pull the eye within the image, but it's not the only means of selectively focusing. We'll look at depth of field later when we discuss exposing for aesthetics—our choices regarding depth of field are necessarily tied to our decisions about how we expose our photographs—so for now let's look at the other significant, yet often ignored or neglected, subject of *plane of focus*.

When you make a photograph with an SLR, your plane of focus sits on the same plane as the film plane, or sensor plane. When you focus on something parallel to that film plane, like a wall directly in front of you, the wall remains in focus from left to right because it lies on your plane of focus. You can see the effects of this when you use a shallow depth of field on an intimate portrait; if the model is not facing you straight-on, parallel to the film plane, the photograph can show a person with one eye, perhaps the closer one, in focus, while the far eye is blurred. Older view cameras had more flexibility in this regard, and with DSLRs we've lost that with the fixed relationship between our lens and our sensor plane. What puzzles me is that tilt/shift or perspective-control lenses free us from exactly this, and give us an expanded range of freedom in what we focus on, yet these lenses are still thought of as specialty or architectural lenses.

The tilt/shift lens is capable of changes to the aesthetic of the image and is, therefore, well worth reconsidering, not as a specialty lens but as an expansion of our abilities to control the look of the photograph. Tilt/shift lenses can be intimidating, but rent or borrow one for a few hours and you'll become less intimidated and begin to see the possibilities. On the most basic level, a tilt/shift lens—usually available in a manual focus 17mm, 24mm, 45mm, or 85mm focal length—can make two significant movements. One is the tilt, which allows the front element of the lens to move in an arc and change the plane of focus. The other is the shift, which allows you to move the lens up and down or side to side, changing the angle at which you need to hold the camera to photograph a subject and to therefore reduce the convergence of lines. The best way to understand it is to look at a couple photographs and then go play with one.

Why the tilt/shift lens figures into the visual language is the issue of control. The more options we have to change the look of the photograph, the more freedom we have over what we say with our photographs. I first played with a 24mm T/S lens on my first trip to Iceland. I'd wanted to learn to use one, and I knew the best way was to throw it on my camera and play. Two weeks in Iceland gave me that chance. While the T/S lens is often used for its well-known miniaturization effect, this look can at times be a substitute for creating photographs that actually say something. An image that draws attention because it's novel is not the same as a photograph created with specific tools and a knowledge of what those tools allow our images to say. What my Iceland images allowed me to do was leverage this illusion of miniaturization and, in so doing, comment on humankind's relationship to the environment. Selectively focusing on man-made elements and placing them on a tilted plane of focus makes those elements feel small, which is exactly how I felt in Iceland. Iceland is a vast country, and although I photographed many traditional landscapes (the Canon EF 24mm f/2.8 TS/E lens is an exceptionally sharp wide-angle lens and can be used without either tilting or shifting), it was the almost trivial presence of man's impact on the land that most struck me; using this lens to communicate that seemed a perfect fit between the visual language and the message I wanted to tell. Given the range of focal lengths available, there is no reason tilt/shift lenses can't be creatively used for portraits—with or without the miniaturization effect—or for sports, like the compelling work of Vincent Laforet.

Tilt/shift lenses are not the only means of selective focus, and their cost makes them prohibitive to some. In the last few years the makers of the Lensbaby have closed this gap, creating selective focus lenses that allow a great range of creativity and control—though they operate more generally like a tilt lens without the shift capabilities. I've often used a Lensbaby to take one of my cameras out to play. And though it's easy to consider them a toy, they too change the

▷ Canon 1Ds Mk III, 24mm TS-E lens, 1/640 @ f/4, ISO 100

Iceland, 2010.

The selective focus of the tilt/shift lens lets me point at my subject in a much more specific way. Here I wanted to focus on the presence of tourism in an otherwise spectacular place in Iceland. I like not only the ability to point selectively, but the illusion of miniaturization that's created, allowing me to create further commentary about what I feel and believe about man's trivial—if still destructive, at times—presence in a place like Iceland.

aesthetic of the image and create an alternate plane of focus worthy of consideration when you want to speak about your subject in less traditional ways, when you want to point to your subject selectively and say, "Look at this, but not this," or to lend an ethereal feeling to your images.

Creative Exercise

Take some time, somehow, and beg, borrow, or steal (i.e., rent) a tilt/shift lens and play with it for a weekend. Tilt it, shift it, rotate it. Just play with it. But play carefully and look at the changes that occur in the photographs based on the adjustments made to the lens. While a tilt/shift lens lacks the full plane of focus controls that, say, a 4x5 field camera has, it will give you an increased understanding and awareness of the focus plane, regardless of whether you ever use one again. It will make you aware of where your plane of focus is, and while you've got no specific control over that in your DLSR, it might lead you to angle the camera in new ways, to make that plane of focus intentionally aligned with, or oblique to, your subject.

Exposure

When I learned to make photographs, I had a 35mm camera with a light meter that was little more than a pin floating between + and − signs. Move the aperture ring or shutter speed dial until that pin was in the middle; that was what I first learned. Then I learned the meter could be fooled, so I learned how to roughly use the zone system so I could add a couple of stops for snowy scenes and drop a couple of stops for darker scenes. It seemed to work. If I wanted a specific effect I might slow down or speed up the shutter, but my understanding of exposure was almost entirely technical, and always primarily concerned with getting the right amount of light into the camera. It was years before I truly understood that it was *my* responsibility to make the photograph look the way I wanted it to.

◀ Canon 5D Mk II, Lensbaby Composer, 1/640 @ f/4, ISO 100
Vancouver, 2008.

> "Every chosen exposure has potential implications on the look and meaning of our photographs; only we know which combination will create the photograph we see and feel in our mind's eye."

Expose for Aesthetics

Getting the right amount of light into the camera is still important. But it's merely *one* of the ways we create our image; it's not the goal. Few people respond to a photograph because the exposure is perfect. For any desired exposure, a number of combinations are available, based on our choice of aperture, shutter speed, and ISO. Our range of choices means we need to have some criteria for making those decisions and not just leave it to the camera. That's why we should expose for aesthetics. In other words, choose your exposure settings based on the way they affect the look of the final image. Every chosen exposure has potential implications on the look and meaning of our photographs; only we know which combination will create the photograph we see and feel in our mind's eye. Yes, you want the right amount of light, and that itself determines the look of the image— underexposing a stop while the last light of day hits the peaks over the Himalayan town of Lamayuru will make the colors more intense, for example. But as the tools we use to create the desired exposure also control so much more, we're impoverishing our ability to express ourselves if we think merely technically. The big question, as it is with every decision, should first be: What do we want it look like?

At any given distance, do you know roughly how much depth of field any given aperture will give you? I don't mean we should be memorizing hyperfocal distances; just understand the effect of that aperture well enough that you're aware of the differences between f/2.8 and f/8 and f/22, because the resulting images will look and feel—and be read—differently, and those aesthetic choices are yours to make, not the camera's. One aperture will give a depth of field that another will not, whereas another aperture (usually something small from f/16 and smaller) will render small points of light into a perfect

▲ Canon 1Ds Mk III, 153mm, 1/25 @ f/10, ISO 200

Lamayuru, India, 2010.

Exposing with the final aesthetic in mind—in this case, underexposing according to both my meter and the histogram—allowed me to capture the intense colors of the last light on the peaks over Lamayuru in the Indian Himalaya.

▲ Canon 1Ds Mk III, 85mm, 1/125 @ f/2.5, ISO 800

Bhaktapur, Nepal, 2010.

While my EF 85mm f/1.2L lens could have completely de-
focused the foreground pots, it's important to remember
that our readers need enough visual clues to interpret
what's going on. Still, at f/2.5, the resulting shallow focus
lets me isolate the potter, as well as show my proximity
to him, as though I were sticking my head into his window
(which I was). The depth of field isn't just pretty or a
minimization of distraction. It mimics our own lack of
focus at close proximity and gives the reader a sense
of presence—if not outright voyeurism, at times.

starburst. Whether or not you want these effects
determines your selection of a particular aperture.
It's the same with shutter speed. As you create the
image, are you conscious of the visual effect of the
shutter speed? It might be irrelevant to your image,
but you should still be aware of it. If it doesn't mat-
ter, then delegate it to the choice of the camera
by using Aperture Priority mode, while you make
choices about settings that do matter to that par-
ticular image. But again, these are up to you first.
Do you want the image to communicate motion?
Do you know what happens to the look of moving
clouds, or the color of the sky, during a three-min-
ute exposure? Do you know how to drag the shutter
before firing your flash? Each of these decisions
changes the look of the image and implies new
things about its meaning.

Depth of Field

Depth of field allows us to specifically focus the
attention of our readers, to tell them that some
things are more important than others. Techni-
cally, as you tighten the aperture on your lens (f/22
as opposed to f/1.8), making the iris smaller, you
increase the depth of focus. That is to say, there is
much more in focus. When you open that aperture
wide (f/1.8 as opposed to f/22), you significantly
reduce the depth of focus, which is another way
of saying there is much less in focus. The resulting
look, from one image to another, is very different.

As you select the depth of field, ask yourself what
will be in focus and what will be out of focus, and
how out of focus those elements will be. What will
the relationship between focused and unfocused
elements imply in your photograph? When you

Canon 1Ds Mk III, 24mm, 30 seconds @ f/20, ISO 200

Kho Samet, Thailand, 2010.

This pier in Thailand is one of my favorite places. It's made of bric-a-brac and may fall over at any moment, and it seems to go on forever. So a shallow focus that allows the pier to just get soft and blend with the horizon wasn't what I wanted. The upshot, of course, is that the tighter aperture allowed me a longer shutter speed without me having to dig out my ND filters. But it was first the desire for an endless depth of focus that drove my choice of aperture.

focus on the bride and allow the groom to go soft in the background, what is that photograph saying about their relationship? Remember, it may not matter what you are trying to say so much as how the image will be read, and the majority of people who are not specifically wedding photographers will infer meaning from these decisions. Again, it's not about good or bad, right or wrong; it's simply about how the image will be read. Blurring the groom to the point that he is insignificant or unrecognizable, or gives the feeling of being little more than a ghost, may show off the amazing bokeh of your new 85mm f/1.2 lens, but it may not be the message your bride and groom are hoping to see on their wedding day, even if it's only perceived intuitively. We get bored as photographers; we're so used to photographing similar things, and so hungry for something to stir us creatively, that we try new things. Just remember that we're playing with language; you can play all you like, but people will still read things the way they do. The moment the author forgets her audience and gets too clever is the moment she starts alienating the very people she's trying to speak to.

Shutter Speed

Shutter speeds, too, can significantly change our aesthetics from one photograph to another. We've all been told that a faster shutter speed freezes action and that a slower one will blur that action. What we're rarely told is that these choices can dramatically change how the image is read, how readers *feel* about the resulting photographs. A slow shutter speed can imply motion or passage of time, or even be used simply as an isolation device. In Kathmandu last year I struggled to photograph a blind man who showed up daily to beg. People walked past him all day, almost never looking his way. What struck me about him was the contrast. Here was a man both unseeing and unseen, and I wanted to show this visually somehow, to show the isolation I imagined him to feel. Initial photographs at higher shutter speeds were static and felt empty, and then I slowed the shutter down enough that the people began to form a blur. Who they were didn't matter; the blind beggar couldn't see them, and they didn't engage him. They were just blurs. To him they were probably just a mass of passing noise, not individuals but an unchanging crowd. I wanted to show this, and later to show the same thing with another beggar working in the same area. I had wanted to create a visual cohesiveness between the two pieces,

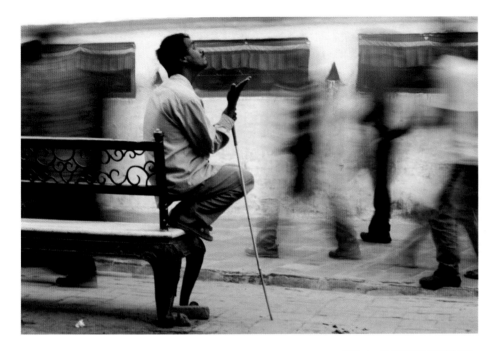

Canon 5D Mk II, 85mm,
1/4 second @ f/14, ISO 100

Kathmandu, 2010.

Canon 1Ds Mk III, 28mm,
1/4 second @ f/22, ISO 100

Kathmandu, 2010.

and to—in a very small way—make photographs that expressed my thoughts and feelings about these two people, unseen in the crowds. Only slower shutter speeds allowed me to express this.

There are myriad ways to use shutter speed—and the resulting contrast between what's blurred and not blurred—to imply things. Wind-blown grasses at the base of an unmoving tree...wave-tossed boats beside a concrete pier. The greater the contrast between the two, the stronger the implication. In the two images of the beggars shown here, the motion of the people registers because the unmoving elements in the frame—street, bench, buildings, the beggars themselves—give a point of reference. It's this contrast with the point of reference that allows the reader to interpret these images as she does. Remove them and the photographs are just a meaningless blur. (This works with color, too. If you want something to look more saturated, place it next to elements that are less saturated. If you want cool colors to look cooler, put them next to warmer colors.)

Creative Exercise

It's time to take that camera off Program or Auto mode and set it to full manual for a week. I know, this will scare some of you, but it's how we used to learn the craft, and if I could figure it out as an awkward fourteen-year-old, you'll do fine. The goal here is simply to make you conscious that the shutter and the aperture, as well as the ISO, all affect the look of the image, and that it is, in fact, possible to mindfully choose each one. And since you're on manual, you will have to set each of them anyway, so now's the time, with each frame photographed, to ask yourself which specific setting you want and why. After a week, if you want to return to an automatic way of exposing your images, try Aperture Priority mode, which at least allows you to choose the aperture and might keep you more aware that these are your aesthetic decisions, not technical decisions for the camera to make.

If all this is overwhelming to you now, remember this is a difficult craft and most of us spend years studying it so we can—finally!—be free of the tyranny of all these damn buttons. The easiest way is to shoot a lot, to become so familiar with the tools that they get out of the way during creation. Studying photographs themselves is also important. Being able to look at an image and determine that the feeling it evokes is created by a shallow depth of field or a slow shutter speed makes us familiar with the language and, more importantly, it helps us make the transition from technical understanding to knowing how images feel when created in certain ways. When someone looks at and experiences a photograph, they don't care a bit how you created it; they care about how it makes them feel and what it tells them, and you can't do that without knowing and using your tools mindfully.

Moving On

We've spent half the book working through the visual language and the basic elements and decisions that allow us to speak through our photographs. Although this is scarcely an encyclopedic exploration of the subject, it gives you the building blocks to move forward. In the last part of this discussion, we'll look at 20 of my own photographs to talk about how all this comes together. Remember, the point of this is not to give you a step-by-step procedure, nor to make you think this is simply a matter of getting it all "right." This is language, and it allows us extraordinary freedom. Your photographs will not look like mine. They will be, it is hoped, vastly different in style and content; you will say different things and use different subjects, subject matter, and composition to do that. But learning to recognize the elements and decisions that go into forming your photographs is the first step in being able to more intentionally give your photographs a voice.

"Remember this is a difficult craft and most of us spend years studying it so we can—finally!—be free of the tyranny of all these damn buttons."

20 **PHOTOGRAPHS**

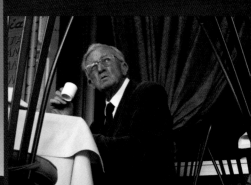

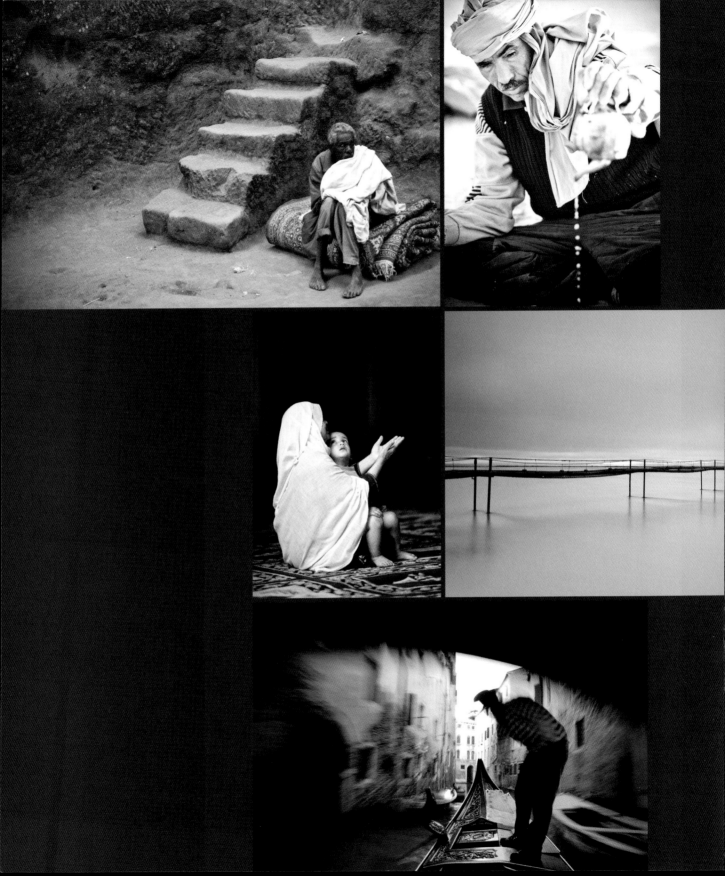

Introduction

THE FOLLOWING 20 PHOTOGRAPHS were chosen to represent as broad a cross-section of my own work as possible, but specifically with regard to discussing the concepts we've explored so far. I've chosen them to initiate conversations about the photographs themselves, not to praise them or give them more attention than they are due. A couple years ago, after the release of *Within the Frame*, I invited readers to submit images to a Flickr pool, and I did a series of 20 podcasts not unlike what I'm

about to do here. I pulled the image up on screen and talked about the elements and decisions that led to its creation, and discussed those in terms of possible alternatives the photographer might have explored to make the photograph stronger. As a critic, I found this challenging insofar as I had no idea what the intent of the photographer was; I could only guess. If we're to judge an image on its success at communicating a photographer's intent, then I was missing a full half of the equation.

Likewise, in discussing these 20 images of my own I am fully conscious of my intent, but I'm a little blind as to how these photographs connect with the reader. The best I can do is talk about them as objectively as possible, a task I think is ultimately impossible. But that's where you come in. My hope for this section of the book is that you first engage these images on your own terms. I hope you'll look at the photographs for a while before you read on. In fact, I hope you'll have your own one-person discussion about the images. Pull out a piece of paper and pen and write down as much as you can about the image. From what you see, what was my intent? What is the photograph *about*? What elements did I include that make you think so? What decisions did I make that led to the final image? If meaning is found

where subject, subject matter, and composition meet, describe the subject as you see it, the subject matter I chose to include, and the composition I employed to express it. Write it down and think about it. For now, don't move on to what *you* would have done; there will be plenty of time for that later. Just study the photograph, describe it, and then read my own description and thoughts. Where your notes differ from mine, don't assume mine are right and yours are not. Ask yourself why you are seeing what you're seeing. Perhaps one of us—not necessarily you—has a blind spot or an unidentified assumption, or maybe we're reading the same image differently because of the differences in our experiences, memories, or culture. As important as my own desire to express myself is, it's more important—at least in this book—that you become conscious of how you read images. It is that understanding we're working to hone and then take back to your own process, to inform the way you create your own photographs. Resist the urge to make judgments, and where you like (or dislike) the photograph, remember the more important question is, "Why?"

One of the first rules I give students in an image critique session is that the photographer has spoken through his or her photograph and they should just listen. It's going to be hard for me to do this as the following photographs are my own. I also want to be able to tell you about my intent for the photograph, to give you that insight so you have the ability to decide whether or not the image succeeds. My hope going into—and later coming out of—a discussion of these 20 photographs is that you emerge with a keener understanding of what makes a photograph work. Most of all, I hope you emerge with a honed ability to read photographs and thus create photographs that say something through their words and grammar—images that create an experience for the one reading them.

Lastly, the way I approach each image will differ from one to another. Some of the photographs lend themselves to further explanation with illustrations; others are much easier to just talk through. And while there's a good chance I'll miss something, I hope you're reading this with the intent to interact and learn and will be able to identify elements and decisions that make the photographs work—or fail—for you. Remember, the point of this exercise isn't to praise the photographs but to dissect them and see why they work. And if they don't work, then knowing why is equally helpful.

Line on the Horizon, Iceland, 2010

▲ Canon 1Ds Mk III, 24mm, 10 seconds at f/22, ISO 100

THIS IS A PHOTOGRAPH of a footbridge across a moving river in eastern Iceland. The image is framed horizontally to draw the eye from left to right, which is the direction in which the story moves, both in terms of the line of the bridge and the movement of the river. I considered cropping this in several ways, playing with all the usual suspects in Lightroom. A square crop stopped the horizontal movement of the image, which immediately suggested a swing in the other direction toward a 16:9 crop, but that removed too much of the sky and water, and this image is about the meeting of sky and water (**A**). The bridge is that meeting place, and it's why I chose to place myself where I did. A lower point of view (POV) would have placed the bridge higher, allowing me to see more of the distant horizon. A higher POV, perhaps from the roof of my truck, would have placed the line of the bridge more across the water than across the horizon, and would have made a larger shape of the line of land where the bridge now meets the far shore. Instead of a line it would have become a large triangle, and the simplicity that now marks this image would have been lost.

The light is soft and diffused, a function of the foggy weather that is exaggerated by my use of both solid and graduated neutral density filters. These filters allowed me to do two significant things. One, they let me darken the sky relative to the water and bring the value of the tones closer to each other. I wanted to show the meeting of two realms, water and sky, and aside from the presence of the bridge, to make them one and the same. To do that I needed to closely re-create what my eye saw. Our eyes are able to see a greater dynamic range all at

A

once than our camera is, so in order to create the image the way I saw it, my digital sensor needed a little help. Two, the filters significantly reduced the light entering the lens and allowed me (because the ISO was already lowered to 100 and the aperture was already cranked tightly shut at f/22) to open the shutter as long as I could—in this case, 10 seconds. That slower shutter enabled the texture in the flowing water and the sky to blur. When photographed at a faster shutter speed, water picks up light and shadow on the ripples and texture of the water's surface. Lengthening the shutter speed permits these brighter and darker textures to blend into each other.

The longer shutter speed also creates a sense of expanded moment. This may be felt only by those familiar with the way this aesthetic is created, but

to an increasingly technology-aware audience, this awareness of the device is part of how we read images, not unlike the way we now generally respond emotionally to sun flare rather than seeing it as a technical oversight that makes the reader too camera-conscious. Our visual language is evolving—photography is a young art—and as the audience becomes aware of camera techniques, such as double exposures and extremely limited depth of field/selective focus, it allows us an expanded vocabulary. In this case, that awareness creates the ability to read this image as a longer moment than our usually faster shutter speeds create.

The color balance on this image is cool, adding to the ethereal feeling created by the smoothing of the water and almost complete lack of texture in the photograph. It was cold and wet in Iceland, and I want my photographs to be more than a record of "I was here. I saw this." I want them to say, "I felt this way about this moment, this place." Although a warmer color temperature might have looked

nice too, my intention was to re-create the feeling in my memory and, I hope, to create in the readers of this image the same cool, damp feeling I had. I would consider it a success if you looked at this image and felt you could almost tell me what temperature it was outside, almost viscerally feel the need for a sweater. Given my intention for this image, it never occurred to me to render it in black and white because the color is a significant part of the subject. A black and white version would place the focus too powerfully on the bridge and strip out the mood and feeling that drew me to the scene in the first place (**B**). Besides that, there simply isn't enough tonal contrast in this image to make it interesting to me as a black and white photograph.

I played with my focal lengths on this image, but in the end chose 24mm because it allowed me to get the entire length of the bridge into the frame without including the shore on which I was standing. Earlier images in the sequence of sketch images that led to this one included several POVs, among them a couple where I played with including

B

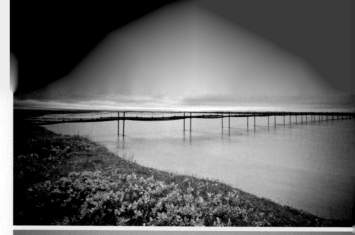

C, D

the shore as a foreground element (**C**). None of them worked. They imposed a scale on the image, a reference point that made the image feel too grounded. What I wanted was an image that had a Zen-like quality, and the inclusion of the near shore prevented me from leaving that shore. It also created another line in the image, and the more lines I added the more the image lost its simplicity. The 24mm focal length also let me get a little closer to the bridge and change the relationship of the bridge to the frame, creating a vanishing point and adding depth. A longer lens, which I tried and then rejected, flattened the image too much, and anything much wider than 24mm prevented me from excluding the elements I didn't need or want in order to keep the simplicity I wanted to point at.

What I love about this bridge is the same dynamic I mentioned earlier about repeated elements becoming a pattern. In this case the vertical lines of the bridge become a pattern that forms a horizontal line (**D**). The interaction between the vertical lines and the foreshortening forced by the rules of perspective means that the vertical lines get smaller and create a dynamic wedge, creating the illusion of depth, while the horizontal line of the bridge's surface joins the land on the far side in a perfect horizontal, splitting the scene evenly in two. This addition of a dynamic element makes the image more interesting, allowing visual exploration *into* the photograph and not merely *across* it, while still maintaining the balance of the image. It's statically balanced, and although I could have moved the elements around to make it more dynamic, the point of this image was a feeling of serenity and calm, so

the symmetry and perfect static balance assists in expressing that.

The contrast in this image comes from the tonal contrast between the dark bridge and the light water and sky. There is a juxtaposition here between the solid and the ethereal, the moving and the stationary. Like doorways, bridges are a widely understood metaphor, which can be read symbolically or—at the cheesy end of the scale—result in songs like "Bridge over Troubled Water." They represent the possibility of overcoming obstacles or—more obviously—of getting from one place to another.

Seahorse, Jamaica, 2010

I PHOTOGRAPHED ROBERT AND HIS HORSE, Pretty Boy, in Jamaica in December 2010. I encountered them on the beach offering rides to tourists. After Robert told me he and Pretty Boy swam together, I wanted to photograph it. Two hours later I was in the water with my dive mask, camera, and Aquatech housing, having the time of my life.

The best of the series is this image. It's framed horizontally, and the horizon was placed almost directly across the middle of the frame, allowing both the water and the sky to remain equally important. The legs of the horse are visible below the water. Had I placed the horizon on the lower third, where most of the textbooks tell you it should go, I would have cropped out this element. That decision alone would have changed this image, and although the horse being up to his mouth in water would have implied deep water, it's by showing that his legs are dangling that allows the photograph to read as though the horse is swimming, which it was, and not just standing in deep water.

As I discussed earlier in the book, my placement of the horizon down the middle of the image doesn't mean I ignored the rule of thirds or the resulting dynamic balance. I simply made choices about *which* elements sat close to thirds and which did not. You can't put everything on a third, so there are choices to be made. Placing the horse and rider on the left third was a decision made to emphasize where the swimming duo had come from—in this case, even deeper water. Had I placed them on the rightmost third, that would have kept a strong dynamic balance but would have been more about where the horse was going, and that wasn't what I wanted. In part it's a reaction to the oft-quoted wisdom about placing your subject as though they are entering the frame, not leaving it. It's not bad wisdom, as photographic clichés go, but frankly, after 20 years of placing subjects in the frame that way, I'm beginning to explore the frame a little more.

The crop was left as I shot it, in part because I'm picky about getting things as close to my vision in-camera as possible, and in part because I lucked out and nailed it with this frame. Shooting with a waterproof housing carries with it a high failure rate, even more so when you're just learning, as I was. But the long 2:3 horizontal frame was necessary to give this photograph the energy it has, emphasizing the horizon and giving room for the waves to really roll. A square crop couldn't do that, and a 16:9 crop that further exaggerates the horizontality would force me to get rid of both the legs of the horse and the sweeping lines of cloud.

The lines formed by the clouds are one of my favorite aspects of the image. I love the way they create soft lines on the blue of the sky that both echo the waves of the water—creating a repeating element—and lead the eye from the top right across and

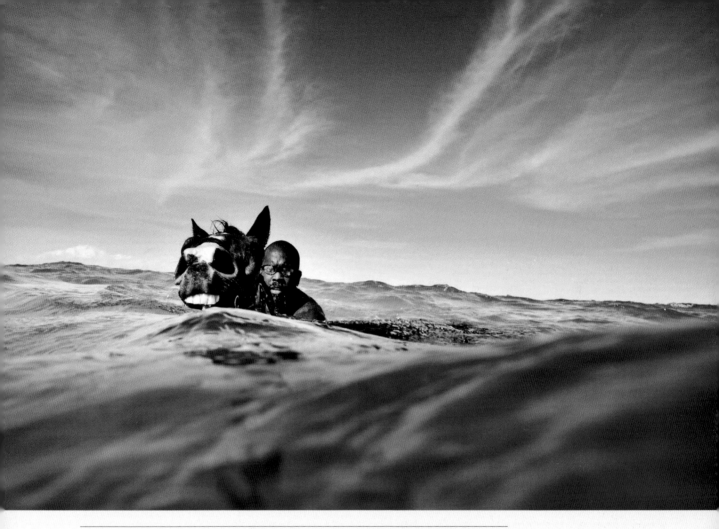

▲ Canon 5D, 30mm, 1/500 @ f/10, ISO 200

down to point to the rider (**A**). That diagonal triangle of converging clouds suggests a vanishing point and is part of what gives the image its depth.

The other element that gives depth to this image is the extremely low POV. I am in the waves, and most of the frames before and after this one have the waves splashing over the camera. That low POV allows the rolling waves—especially the foreground wave that forms almost the whole of the lower third of the frame—to suggest proximity. In part that's the

depth of field. Being slightly out of focus is a visual clue to us that the wave is either close or moving, or both. The final strong line is the horizon itself, and I've left it as I shot it, diagonally sloping across the frame to increase the feeling of imbalance or a lack of solidity (**B**). I wanted nothing about this photograph to feel solid. As I shot it I was treading water, trying to keep the waves out of my mouth. It wasn't scary; it was just a very fluid situation, full of energy and a lot of fun. I wanted the image to *feel* that way, and what I chose to do with the lines

Seahorse, Jamaica, 2010 **155**

A, B The lines in this photograph create zones that add depth, and while we've discussed it previously using the same photograph as reference, it's worth remembering that it's the lines themselves, combined with the quality of focus, that create distinct zones in this photograph, adding depth and pulling the reader into what is a more (forgive the pun) immersive experience.

the timing work together to do that. Graphically it's just a dark slice, but that darkness pulls our eye into the middle of the image where the water is lighter. Also, the contrast between the lighter water and the darker tones of both the horse and rider is greater. Greater contrast pulls our eye and allows there to be no question about what this image is about.

The light in this photograph was bright midday light. I was in the water with Robert and Pretty Boy from about 2 p.m. until 3 p.m., so the sun was still high, giving this image the dramatic shadows and the specular highlights on the water, enforcing the already dramatic feel of the image (which I further added to in post-production by removing some of the saturations from both the blues and the greens, which were incredibly vibrant but gave the image too much a feeling of a tourist poster). I normally avoid making photographs at this time of day, and when I do I'm often using reflectors or diffusers—not easily done by myself while trying desperately not to drown or get run over by a swimming horse. Fortunately, the Caribbean Sea was its own large reflector and gave me enough light in the shadows that the already difficult dynamic range between the brightest whites and darkest blacks didn't overwhelm the sensor. A waterproof housing makes using graduated neutral density filters and even circular polarizers impossible, so I was left to work with what I had—which happily gave the image enough color and sparkle without blowing out the sky. My decisions in post-processing were simple ones intended to pull back an almost overwhelming blue palette, and to cool it down a little and push

in this photograph would either help me do that or work against me.

Notice, too, that the wave, as I've discussed before, isn't really a wave. It's a shape that represents a wave. It's a dark section of a similar hue on the lower third, and it sits at a slight diagonal. We know it's a wave, but to give it that feeling of "waveness" we need to put it there. The wide angle, the POV, and

some attention to the texture of the water (C). I wanted the image to be a little wilder, if that makes sense. Perhaps "grittier" is a better word.

It almost doesn't need saying that the choice of moment here is crucial. I fired my shutter almost 350 times during the hour we were in the water together. Most of those frames got deleted later, many of them are just frames full of waves. It is the combination of the way Robert is looking—straight at us, which creates a sense of interaction between the subject matter and the reader, and therefore a potentially more immersive reading experience— the wild look of the horse with his mouth open, and the rolling waves that makes just the right lines in the frame. As with most photographs, it's not one thing that makes the image work; it's the convergence of many things. Compare this moment with one taken only a few minutes later (D). Aside from the very static composition, where almost everything has changed, the moment is anything but wild. It's boring.

Ultimately, when our images succeed, they do so for a number of reasons—what I've earlier called the accumulation of layers of impact. In this case, all of the layers I just discussed create a photograph with an unexpected juxtaposition at the heart of it, and that gives it the visual hook of unexpectedness.

C

D

Distracted, Camogli, Italy, 2010

I PHOTOGRAPHED THIS ITALIAN GENTLEMAN in the middle of lunch in the little seaside town of Camogli, Italy. He and his wife were enjoying a quiet lunch together when our workshop rolled in and they just went on enjoying themselves like we weren't even there, eventually lighting a cigarette and enjoying an after-lunch coffee. I was drawn to the look of this man and wondered if I could make a photograph that felt like the images I've been so influenced by—not just those by particular photographers like Elliott Erwitt or Henri Cartier-Bresson, but by an era. I felt like I was looking at a scene from 60 or 70 years ago. The problem, as it often is, is that how I felt was influenced by so much that would have to remain outside the frame: the smell of the seafood, the people walking by, the architecture of the town itself, even the noise and clatter of daily life and the kitchen inside. If we are to make the photographs retain some of that feel, we have to put it into the image.

The photograph itself is vertically framed to emphasize the predominantly vertical shapes and lines, and the crop remains as I made it in-camera. What drew me to this scene, aside from the character himself, were the lines, so all my decisions—besides the moment I chose—went into making the photograph about those lines. In part that was the vertical framing; a horizontal framing would have cut those lines short, preventing them from breathing and moving and giving the photograph the movement it has, which in this case is both an up-and-down movement along the lines of the chairs, but also a back-to-front movement as the chairs—foreground (yellow), middle ground (red), and background via a reflected foreground chair (purple)—form an elegant repeating and receding element that gives depth to the image (**A**). That depth pulls the eye in and past the man, whom we believe to be the main subject matter, to a surprise—a reflection of another man in the same position, glass raised to drink. That surprise isn't always noticed, and seeing it isn't necessary to appreciate the image, but for those who do, a surprise element is always a welcome, deeper level of experience, like an inside joke between the photographer and the reader. These same chairs also frame the man, and in some ways even loom over him. Is he looking at something on the street with curiosity or eyeing the looming chair with suspicion?

▶ Canon 5D Mk II, 50mm, 1/50 @ unrecorded aperture (perhaps f/16), ISO 400

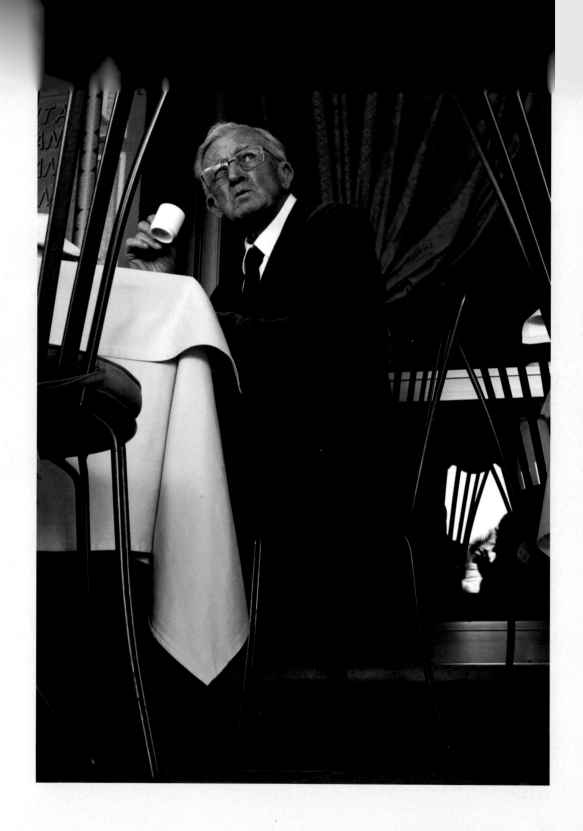

A

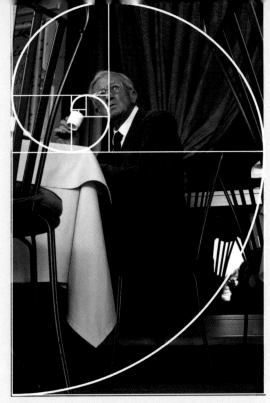

B

The other lines I loved in this scene were the curtains, which also echo the shape and direction of the lines formed by the chair. To have photographed this from a straight-on POV would have minimized the diagonal sweep of all these lines, especially the foreground chair, which would have been merely in the way. These lines, made more dynamic because of the lower and upward-angled POV, give the photograph a graceful rhythm, a subtle energy they wouldn't have if I had shot straight on, or if they were straighter chairs. I shot this with the camera set on the floor and angled up, using the LiveView function on my rear LCD display to frame it up initially, then turning it off and just watching the scene with my finger on the button. My lens was a Carl Zeiss 50mm f/1.4 manual focus lens with the aperture (unrecorded on a fully manual lens, but I suspect f/16) set to allow enough depth of field to compensate for not being able to really focus on my subject matter through the viewfinder. I was able to keep absolutely everything in focus, giving me sharp lines from foreground to the reflected, and therefore even deeper, background. The 50mm lens was all I had on me, but it's close-to-normal compression and angle of view gives what my friend Chris Orwig calls an honest

feeling. Without the exaggeration of a wide angle or the compressed depth of a longer lens, we're left a little less aware of the technique or equipment. It's as close to old-school photography as I get, but happily it allowed me to re-create exactly that old-school look I wanted, because so many of the photographs from that era were made with lenses in the 30–50mm range.

As far as placement within the frame goes, both a rule of thirds and a golden ratio grid overlay show the face of the man and the line of his body roughly on the intersection of the left and top thirds. Overlaying a golden spiral (a little stretched to fit the crop and therefore not quite a perfect golden ratio) on top of the photograph is even more interesting and, for me, shows very closely the path my own eye takes as it explores this image, beginning at the face of the man and spiraling outward, to his cup, the leftmost chair, the chair on the right, down the lines of that chair, then right back along the spiral to where I began (**B**). The spiral itself isn't relevant, but I think it suggests that there's a reason we find these compositions pleasing, and it makes these overlays helpful in thinking through our compositions. I didn't have it in mind when I made the image, because I think that balance and tension is what matters, not conformity. Still, I think it's interesting that the images I like best—the ones that have endured the longest as my favorites—are ones that seem to align, even loosely, in some fashion to these grids or the spiral. If spirals and grids help suggest new compositions to you, then make use of them.

I've already referred to it, but the moment here was key, and in some ways completely serendipitous. So much of our photography relies on serendipity, on moments we could never have predicted or orchestrated. The skill, and what separates the good photographs from the ones we remember forever, is in recognizing the moment and being ready as it happens. I've got a few photographs of this man; I was so interested in his charm, the way he talked and moved like an old-world gentleman. An Italian Humphrey Bogart, now aged but still charming. So I photographed him for a few minutes. Smoking. Talking to his wife. Drinking coffee. The problem is, most of those were just photographs of him smoking, drinking coffee, or talking to his wife. There was nothing interesting, nothing even particularly worth pointing at, and in particular nothing that represented any of these moments in one frame. Until, in the middle of drinking, he cocked his eye and looked off at something beyond the patio on the walkway. It was a fleeting moment and by the next frame it was gone and he was back to drinking his coffee (**C**).

It's this look that makes the photograph engaging, if only to me. Even having been there it still makes me wonder what he was looking at, still makes me feel, like him, a little distracted. It's the choice of moment that allows the photograph to create that within a reader. Or it's the recognition of that moment. But later, in the editing stage, when we choose from three frames, we make decisions to allow this one moment to be the one that best represents a longer one. Editing, like the moment we photograph and

like our choices made in the darkroom, is part of the language we speak as photographers. I think it's also worth noting that his gaze forms another diagonal line—this time implied—but it does lead up and in the same direction as the graceful diagonal of the back of the leftmost chair.

The light plays an understated but important role here. It's diffused by a large awning, though it's bright enough in the street beyond to reflect back into the reflective surfaces, particularly the gentle-man's spectacles, and in his eyes, giving a spark of life from the resulting catchlight. Without the awning the light would be high overhead, create harsh shadows, and obscure the more subtle details in this scene.

My choice to render this in black and white was made from the moment I put down my fork and picked up my camera to photograph the scene. If you look at both the color and black and white versions you'll see the mood created is different in each, but it is the black and white version that allows the gesture of this photograph—i.e., the rep-etitions of the lines and the distracted gaze of the gentleman—to be the focus (**D**). It feels as though it has more texture, and although the color version seems to place the image rather contemporarily, the black and white treatment gives the image its timelessness, or at least a certain ambiguity where time is concerned.

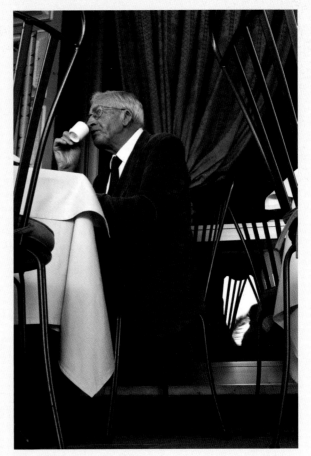

C

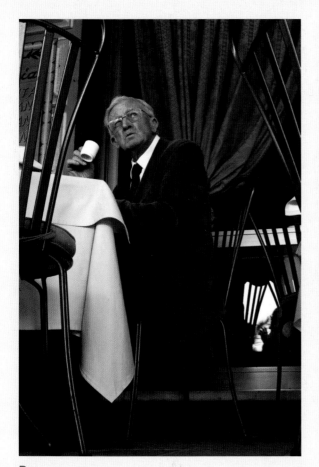

D

Restless, Death Valley, California, 2011

"RESTLESS" IS A VERTICALLY FRAMED 4:5 photograph made on the Racetrack Playa in Death Valley, California. It is one of a series of photographs made with a very specific mood in mind, and as such there were specific elements present and choices made that I hoped—and still hope—accomplish this. The mood I was looking for is best described to be not literal landscapes but more abstract or impressionist dreamscapes, as it were. I wanted images that were about—to use a word I've thought much about this past year—liminality. Liminality is about the threshold between states, like twilight, which is neither night nor day. Of course, this photograph is about other things as well.

Twilight has associations with sleep, and our dreams often contain an element of surrealism, so I chose to shoot this and others in the series with a tilt-shift lens, which gives me finer control over not only the relationship of elements to each other—allowing me to slightly exaggerate the diagonal line caused by the rock's movement—but also finer control over the plane of focus. Altering the plane of focus by tilting the lens lets me keep the trail of the rock in focus while blurring out much of the rest of the image. Because our eye doesn't normally see things with this shifted focal plane, we read the image as "not quite right," surreal, or dreamlike.

The lens I used was not only a tilt-shift lens but a wide-angle 24mm lens. This shorter focal length enabled me to get very close to the rock, about 12 to 24 inches away, while keeping as much of the textured playa as possible within the frame. A longer lens would have pushed the rock closer to the mountains, but would also have reduced the sweep and power of the diagonal line of the mud-trail, which gives the image its sense of movement and connects the foreground to the background, leading us from small rock to large, and implying that one came from the other. My position also played into this feeling. I moved around a lot while finding the framing for this photograph, moving up and down, side to side, taking many sketch images before settling on the very low framing I eventually chose. In the end I was sitting down with my tripod low, in order to place the horizon in the middle of the frame and split the image into two clear spaces—mountains and sky, and rock and playa. While popular adherence to the so-called Rule of Thirds generally suggests I not place the horizon so centrally, I'm more concerned with the image

▶ Nikon D3s, 24mm tilt-shift, 1 second @ f/4.5, ISO 200

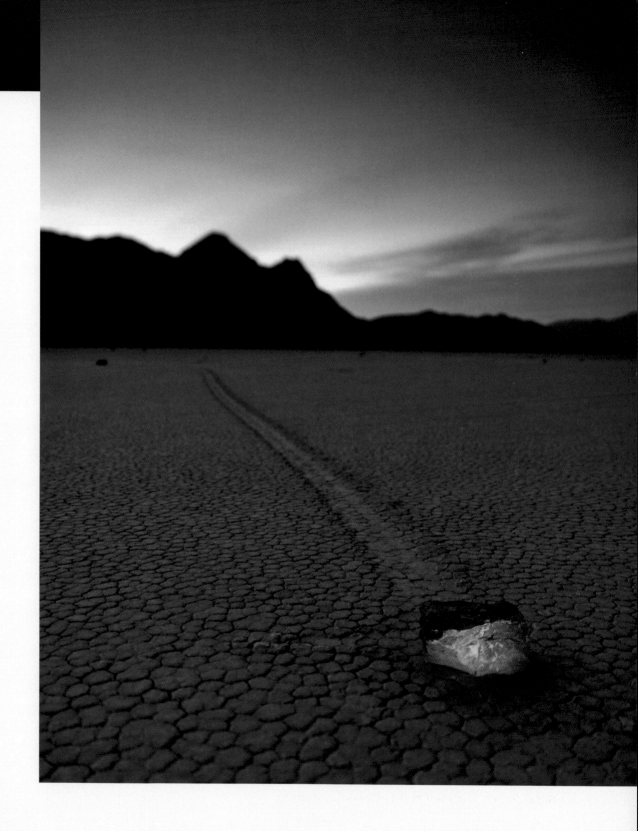

A

include more sky and/or more of the playa, neither of which is the point of the image. The point of the image lies in the connected relationship between rock and mountains; more sky would have added nothing to the image and therefore, at least to my taste, detracted from it.

My position and the POV I chose relates to the line formed by the rock as much as it does to the placement of the horizon. I shot several frames of this same rock from a position that forced the line of the mud trail to be more closely vertical in the frame than diagonal (**A**). The resulting lines were actually very strong but resulted in a photograph that felt almost threatening, as though the rock were coming straight toward me, and not merely passing by. Although I did like the way these frames looked, they didn't feel the way I wanted them to, and that's an important awareness. The fact is we often have several good options as we frame a photograph; what makes one better is that it more perfectly expresses what you're trying to say. In this case I wanted the reader of the photograph to be a passive observer, not a target. Moving to the left of the rock pushed the rock to the right in the frame and forced the line into a diagonal, which in the end is more powerful.

having the right amount of balance and tension. It only really felt right when I placed the horizon centrally, allowing the tension in the image to come from other elements, like the placement of the rock, which is more the point of the image than the horizon. This is also the reason for the vertical frame, which encourages the image to be read up and down instead of side to side, and the reason for the 4x5 crop. A longer frame would have forced me to

Aside from exploring the relatively cerebral theme of liminality, it's the contrasts and juxtapositions in this scene that most appealed to me, not the least of which is the oddness of a rock—usually something unmoving and inanimate—moving. While the rock was moving through natural forces external to itself—in this case, wind—it had the appearance

of being alive and I wanted to exaggerate that. To do that, I used an LED flashlight with an orange (CTO) gel on the front and carefully painted the rock with the beam during the longer exposure. The final photograph is a composite of two images, one made with the light-painted rock, the other without, which allowed me the most amount of control and to keep some of the light that spilled onto the ground from distracting.

The light in this photograph is crucial (**B**). Taken during the so-called blue hour with longer exposures, the camera can record a blue that the eye doesn't see. Over an exposure of several seconds to several minutes, the sky takes on a rich blue, clouds streak and blur, and the photograph takes on a dreamlike appearance for just this reason: we never see it with the eye. We feel this kind of mood, and we've all experienced the long magic of dusk, but the eye doesn't record it this way.

Because the light and the long exposure were so important, the only way to keep enough light from hitting the sensor was to shut the aperture. Doing this, however, would have given me more depth of field than I wanted, ruining the surreal effect of the tilted plane of focus. The solution was a solid 3-stop Singh-Ray Neutral Density filter sandwiched with a 2-stop Singh-Ray Soft-transition Graduated Neutral Density filter, handheld and gently moved during the exposure to both hide the scratches on the filters and prevent a hard line on the horizon, the telltale sign of an ND filter. These filters allowed me to hold detail in the sky (the graduated filters do this) and to reduce my exposure by three stops, allowing

B This frame was one of my sketch images, made 30 minutes before my final image. It was made with an exposure of 1/30 at f/11 instead of a full second at f/4.5. That 30 minutes made a lot of difference.

me to keep the aperture open while still lengthening my exposure as much as possible. I could have waited longer for the light to go down further, but wait too long and blue hour just turns to darkness and you lose the color, and therefore the mood.

Vernazza Harbor, Italy, 2010

THIS PHOTOGRAPH WAS MADE in the small harbor town of Vernazza in Italy. The classic post-card view of the Vernazza harbor is taken from a promontory above the town, and while I eventually photographed that view as well, it was from a desire to find something new that I found this scene. Ultimately the higher vantage point so favored by photographers is about the same things as this one—a colorful seaside fishing village at dusk—but I wanted something different, and a little more universal, so I set about finding it. That's my way of saying I didn't want to walk up the trail and shoot the same thing everyone else has shot. What I got was an image I am much happier with.

The image is horizontally framed in a 2:3 ratio. The horizontal frame allows the eye to follow the line of the boats without being affected by the other elements in the scene, the ones that this choice of framing and crop allowed me to exclude—like the church at the other end of the harbor and the other boats and on-shore restaurants to the right, all of which are an important part of Vernazza, but not of this photograph. This photograph is about the harbor—a place that is both water and land—and the boats, which are really neither water nor land. Because this photograph is about both water and land, I gave each of them equal space in the frame, allowing the cobbled shoreline to split the frame in two, though I did so diagonally, which gives the

frame more energy and also allows me to include the stairs, which other alignments didn't allow.

The depth in this photograph comes from the perspective created from that diagonal line, which in turn comes from my camera position (**A**). There's a vanishing point implied in this frame, as the boats get a little smaller from left to right, giving us clues to the actual depth of the scene. Furthermore, as we start reading the frame at the left and move along the line to the right, we're visually invited down the stairs, into the boats, and along that line. This pull to explore the image visually creates engagement, interest, and a stronger experience for people reading our photographs.

The contrasts in this image are intentionally strong. This photograph took a couple of hours to make, bookended by late afternoon light that was too bright for a long exposure and too strong for a pleasing one, and my need for pasta and wine. What I was waiting for was later light that allowed me a much lower exposure value (15 seconds at f/22 and the lowest ISO I could force my camera to use) and therefore enabled me to take advantage of the moving boats. Contrasts, in order to work, must be obvious. Had I not included the concrete shoreline, there would be no point of reference, only blurring boats and water and a sense that the photographer—in this case, me—had absolutely no

▲ Canon 5D Mk II, 30mm, 15 seconds @ f/22, ISO 50. Singh-Ray Gold-N-Blue Polarizer and 2-stop Singh-Ray ND Grad filters

A This frame isn't perfect for comparison; it's tighter, and it's framed differently, giving the water and boats much more space than the shore, and therefore much less negative space. But it was one of my sketch images and the one that pushed me away from aligning the shoreline horizontally in an effort to find greater energy, depth, and visual pull that resulted from my final POV. I include it here to show that although two images can be very similar, it's the small changes that make our final photographs say precisely what we want them to, much as a change in a few small words can make a significant difference in the tone or content of our speech.

idea how to focus the camera or hold the camera still. Including the very sharp shoreline does a couple of things. First, it gives a reference; we know the boats are moving because the shore is not. Our feeling of motion comes only from the contrast to that which is stationary. Second, the feeling of

solidity about the shoreline comes from seeing the motion in the boats. The contrast is all-important. Including the shoreline gives the photograph a conceptual contrast, a conflict that implies story. In this case, that contrast could be expressed as water versus land, or even moving versus unmovable. If

you want your contrast to read, it must be strong. Shakespeare said that if you want to make something seem tragic, precede it by that which is comic, and vice versa. It's the contrast with the comic that makes the tragic seem that much more so.

The inclusion of several boats allows for a repeated element, almost a visual rhythm, from left to right reading boat (wait a beat), boat, boat, boat, boat. The foreground boat, slightly separated from the others, breaks that rhythm and gives us something to focus on.

The light in this photograph allows for the longer exposure but is not solely responsible for the colors. I used two filters on this exposure. One was the Singh-Ray Gold-N-Blue polarizer, which gives the photograph its color shift and warmth, as well as managing some of the reflections on the water. The second filter was a 2-stop Singh-Ray Graduated Neutral Density filter held diagonally along the line of the concrete wharf, allowing me to brighten the wharf a little without also overexposing the water elements. Together these filters allowed me to re-create a mood that an unfiltered photograph would not have been able to do. Still the choice of time of day was important, as no other time of day would generate either this quality or quantity of light. The filters helped, but they don't do much more than support already beautiful and suitable light; they don't create it or act as a substitute for it.

The 24–70 f/2.8 lens used for this photograph was set at a focal length of 30mm, still considered a wide-angle lens. Remember that while I shot this on a full-frame digital sensor (so the 30mm lens suffered from no conversion factor), even on a cropped APS-C sensor or similar, a 30mm lens is still a 30mm lens. It is not *the equivalent of a 50mm lens* as is often claimed. A smaller sensor will certainly crop the scene differently, but it will not change the behavior of the lens itself, which is important when the angle of view and resulting relationships between elements is important. I'm not sure that digression is relevant to this particular photograph but it's worth remembering all the same. Here, that 30mm focal length lets me include enough of the scene, and to keep it feeling inclusive and open, without including too much. Stepping back with a longer lens would kill the great lines formed by the cobbles as they converge to point at the boats. And using a much wider lens would have been impossible without including more in the frame, even if I'd pushed in much closer with it. Remember that you can move in and out with a wide focal length but you can't change its angle, and that angle has much to do with what is—and what isn't—in your background.

Gondolier under Bridge, Venice, Italy, 2010

THE SUBJECT OF "Gondolier under Bridge" is not the gondolier himself; the subject is the experience of riding in a gondola, navigating the narrow waters of an extraordinary city. This is important because if meaning comes where subject, subject matter, and composition meet, then knowing what the subject is allows us to make the best choices about the subject matter and the composition. I bring that up because I want to talk about this photograph in terms of subject, subject matter, and composition and how the three intersect, but let's look at it backwards—starting with the composition—which is the way everyone but the photographer himself must look at a photograph.

Compositionally, this is a horizontal 2:3 frame, shot with what I'd assume (if I weren't the photographer) is a wide focal length based on the angles of the buildings as they recede to the far background. That choice of frame is important. It allows for the strong vanishing point (**A**) that, combined with the motion of the camera, creates a feeling of motion and energy in the photograph that neither a vertical frame, a 2:3 or 1:1 aspect ratio, nor a tighter focal length would have created. It is the width that enables the lines to gain momentum and therefore the strongest sense of motion. Most of the lines in this photograph are diagonal, and they lead the eye to the very middle of the frame. The waterline, the lines of windows, the lines of the gondola itself, even the lines on the boatman's shirt all point in the same direction, pulling the eye powerfully to the place where the boat has come from, giving the photograph a sense of *departure*, or *leaving something behind*. The posture of the boatman himself, as abstract as his darkened, blurred form is, shows the direction in which the boat is moving, and that heightens this sense.

The fact that within the frame there is only one sharp element—the boat itself—does a couple of things. The first is the implication of motion we've just discussed. The strong visual contrast between sharp and blurred, and the fact that it is the boat that is sharp and not the buildings as we might normally expect, makes it feel a little like it is not the boat that is moving at all but the world around the boat. The second thing it does is allow the photograph to become an impression, even an abstract, permitting us as readers to become less distracted by the particularity or identity of the boatman, and more easily put ourselves in the place of the person sitting in the boat, which is why—one imagines—the photographer chose this POV. I get the feeling as I look at this image that the gondolier is looking at me, as though the walls are rushing past me.

▲ Canon 5D Mk II, 23mm, 0.8 @ f/14, ISO 200

The sharpness of the boat is what it would look like if it were me sitting inside. Compare this to a photograph taken from the bridge under which the gondola is passing. The photographer sets his camera on a tripod and shoots this scene with a similar shutter speed. The boat emerges from under the bridge and is blurred, the surrounding canals razor sharp. The sense of being on the boat, or even the possibility of imagining it, is removed because you've removed any of the visual cues that would otherwise place me there. This is a fundamental difference between photographs that show me how it looked and show me how it felt to be on the boat itself. This is a more immersive and experiential photograph precisely because of the choice of where the blur was put and where the photograph was taken.

Aside from the diagonal lines that lead toward the background, giving the image depth, the other

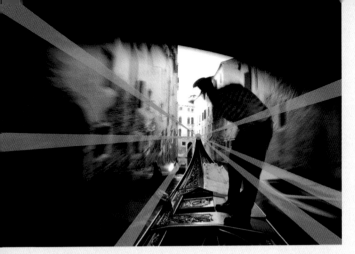

A

significant line is the large sweeping black arc of what one assumes from life experience is an overhead bridge. The weight of that arcing line makes the image top heavy, pushes down on the gondolier himself, making him stoop his body (a moment intentionally chosen), which itself then echoes the line of the arc. The dark sweep of the bridge and the bent frame of the boatman create a dynamic balance. In a photograph whose motion is otherwise only in one direction, this brooding overhead foreground arc creates tension, and tension is, almost by definition, a more involved experience on the part of the reader. The arc also pushes the eye back into the frame. Images I shot prior to this one, without the bridge overhead, had nothing to push the eye back into the frame, which allowed the eye to follow the long lines to the vanishing point of the background—which also contains the brightest tonal values and therefore has a natural pull on the eye—and then toward the sky and out of the frame. This bridge keeps the eye exploring

the photograph by pushing it back into a spiral; each time the eye completes the spiral and would otherwise be pushed out of the frame by its own momentum, it is pushed back in, prolonging the visual exploration and the experience of the reader.

That this photograph is black and white also affects how we read the image. If this weren't my photograph I'd still assume the photographer made an intentional choice to strip the color from the final image; that absence of color allows me to concentrate on the tones and lines, like the arc of the bridge and the lines on the gondolier's shirt, in a way I'd be less able to do were this not a black and white photograph (**B**). It allows the movement and the mood to play stronger, without competing for attention. And it allows for a feeling of timelessness—suitable to the old buildings and the essentially antiquated transport that gondolas have become—that very few color photographs manage to achieve.

Hopefully the feeling or experience I am trying to re-create is intuitively perceived on some level. It could be that most people looking at this photograph will never consider the choice of lens or the arc of a line any more than they think about the nouns and verbs in their favorite song, but those decisions on the part of the songwriter work together to make something that is perceived—and experienced—without effort. For photographers, unpacking these compositional choices should make the process of learning the visual language a little more conscious and intentional, and eventually intuitive.

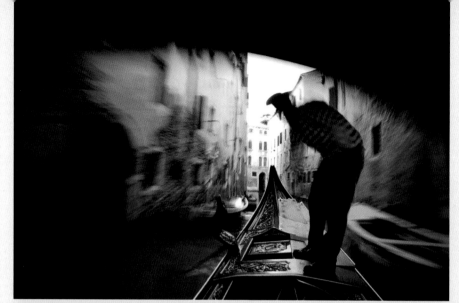

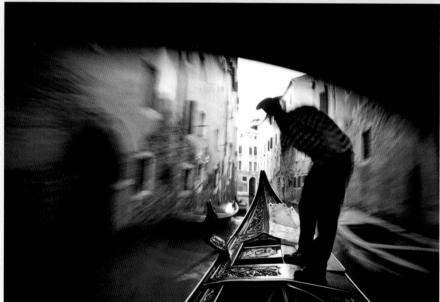

B

Cling, Haiti, 2005

"CLING" WAS SHOT on my very first assignment for a nongovernmental organization (NGO) in Haiti at a church service one Sunday morning. It's a vertically framed 2:3 photograph representing four boys looking into a church service for which there is no more room inside.

I think this photograph works for a couple of reasons, despite some weaknesses I've always wished I could change. On a purely visual level, it was the vertically outstretched arms of two of the boys that suggested the vertical frame. Framing this horizontally would have meant either cropping more of the boys than I wanted, or stepping back too far and losing some of the isolation I worked hard to get. Cropping the boys horizontally would have prevented the long lines of their bodies from exaggerating the stretching feeling of their gesture. In general, the gesture in this scene was very vertical and was part of what drew me. The lines of their arms and bodies lead the eye to the shape of the cross, which is also primarily vertical, and is where I felt the focus of the image should be. Pushing the eye to the cross even more are the diagonal lines of the window grid, which show up strong against the black background and provide some of the tonal contrast that makes this a strong black and white photograph. Those lines themselves are a repeated element, making their pull even stronger.

The symbolism in this photograph won't be read equally in all cultures, but while the idea of clinging to the cross is specifically one a churched person will understand and resonate with, the idea of people in dire situations holding tight to a faith in something external to themselves is universal. In that sense, this image might at least speak about faith to a wider audience, and that brings it closer to speaking more universally, which is something we all long for: to have our photographs touch the broadest audience possible. However, as I write this I am in Louisiana at a state park and the folks across the way have a song blaring from their stereo, the chorus of which keeps imploring, "Jesus, take the wheel." I'm struck by how saccharine and banal the sentiment is when coming out of a cheesy country-western song. It's a song about faith, not unlike this photograph, and the challenge of using such strong symbols is that they can come off as cliché if approached too obviously. There's a thin line between propaganda and art at times. I sometimes wonder if this photograph remains safely on the art side of that line.

▶ Canon 20D, 50mm, 1/1600 @ f/1.8, ISO 800

The gesture of the boys is a key part of this photograph, so the timing and choice of moment were important. Another minute and they might have lowered their arms, or the two boys who are not raising their arms might have joined in and ruined the rhythm of one set of arms raised, one set not, etc. Any more arms and it might have been too busy with arms. Fewer and it would have, I think, lost its impact.

My POV was intentionally low, from the level of the boys. There is a time and place for looking down from an adult's height at children, but this was not one of them. I wanted a photograph from the boys' perspective, and looking down would not only have forced a kind of condescension but would also have prevented the vertical lines from remaining straight.

I don't often use a 50mm lens in my work but do so often with images like this. The 50mm lens, regardless of the sensor it is used on, is the closest focal length to what the eye usually perceives, and so doesn't create any unusual change to lines; it allows the photograph to retain a look that is as close to "normal" as possible. Any wider and I'd have problems keeping it all in the frame as simply, and a tighter lens would have contributed nothing.

The light in this image is a result of finding a scene in the hot, high-contrast midday light that was also in shade and knocked the harshness out of the light. There are no harsh shadows or burned-out highlights. Dark shadows present themselves in a photograph not as shadows but as representations of shadows, which means dark lines and large areas of dark tones that can change the balance of a photograph or just clutter things up. This photograph has a lot of lines and tones, and adding to them with additional shadows might have made this scene so busy with visual clutter that it lost its simplicity and impact.

The tones in this photograph are perfect for a black and white image, though technically this is a slightly warmed duo-tone, which I think allows some of the dust and August heat in which this was shot to remain. The original colors in this scene didn't work well together; a turquoise-colored wall and a funny palette of thrift-store clothes didn't so much clash as just kind of bore me. The duo-tone eliminates that distraction and allows the image to retain a certain sense of nostalgia—and that's the weakness of the image for me. I was so seduced by the nostalgia and symbolism of the potential photograph in this scene that I didn't frame it carefully. There is a real danger in being seduced by our subject matter, allowing what we *feel* about the scene before us to so distract us that we forget that photography is *first* about the frame. Here, the presence of the partial fifth boy suggests a larger crowd existing outside the edges of the frame, which I like because there was that crowd, but I wish I'd included a little more of him. The leftmost boy is similar; I've cropped his arm in a way that I don't like, creating a disembodied forearm. Had I swung the camera a little to the right I could have solved both problems and eliminated the very light-toned concrete wall on the left as well, which I feel causes

a slight off-balance. Do these weaknesses make the photograph a failure? I don't think so. I think the moment and resulting gesture are strong enough to carry it despite what I feel is a sloppy composition, but it could have been stronger. Part of the learning process happens in the willingness to be honest and critical with our work, even if it takes a couple of years to gain that objectivity.

Upwards & Distracted, Srinagar, India, 2007

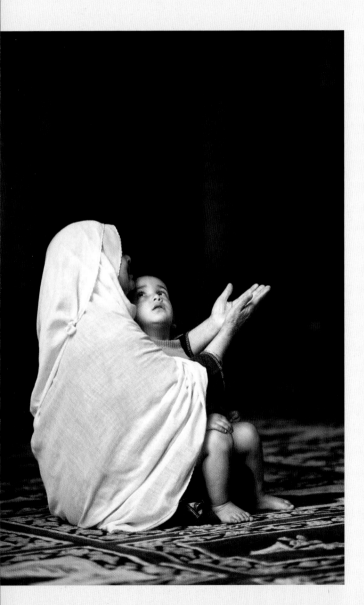

"UPWARDS" IS A PHOTOGRAPH about faith, and I'll discuss it here with its companion image, "Distracted." "Distracted" is about faith as well, but both say—or endeavor to say—different things about faith. The difference between the potential message of each photograph lies entirely in the choice of moments and the difference in framing.

Both of these were photographed with the permission of the woman, a grandmother praying in a mosque, with her grandson. The gesture of the first image, "Upwards," is an upwards gesture. That gesture comes from the vertical framing and the fact that the center of interest—the woman and child—occupies the bottom half of the image. It also comes from the implied line created by the gaze of both the woman and child (**A**). I know the child is likely looking at his grandmother, but I more often see it as him looking up to the ceiling, as if wondering who she's talking to, and trying to see Him. Whatever you believe about it, faith, of course, is about seeing the invisible, and this child's efforts to see something, or Someone, that to his grandmother is so undeniably real, is, well, childlike. There's an innocence to his gaze, and its subsequent silent commentary on his grandmother's prayers.

The second photograph could say an entirely different thing about faith, and this image works

better for me for that reason. In "Upwards," both the woman and child are looking in the same direction, more or less, if only symbolically. If you identify with one of them, you identify with both. But in "Distracted," the gesture of the image changes; it becomes more complex (**B**). The woman's posture is unchanged, her body generally pointing across the frame (1), but the child is now looking left and out of frame (2). She is looking and gesturing heavenward (3), he is looking at something earthbound, and it's this gaze that I think is most interesting; it's

why I changed the orientation of the frame when his gaze changed. A vertical frame points up and down; a horizontal one is earthbound. The difference between the direction of gaze between our subjects becomes the central contrast of the image, and I think provokes stronger interest. It now gives the reader two characters to identify with, and both seem to want different things. As a person of faith, I resonate with this image strongly because it is an honest representation of my own faith. One part seemingly wiser and spiritually aligned, the other

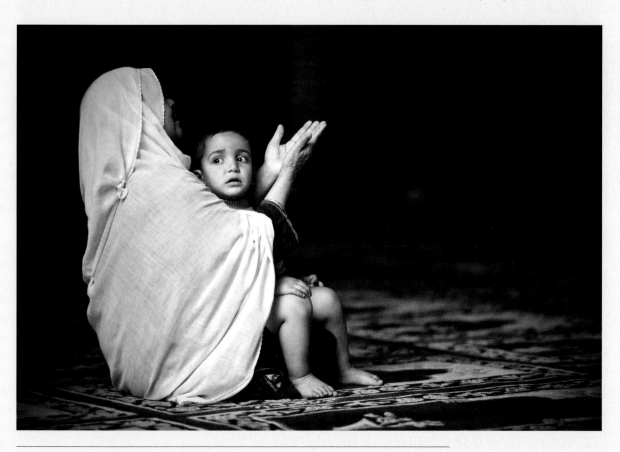

▲ Canon 5D, 135mm, 1/3200 @ f/2, ISO 800

A

B

distracted and full of wonder about things in the here-and-now. I suspect there's maturity in a faith that embraces both postures, so the implications of this photograph resonate more honestly for me.

There are, of course, other contrasts that make this image work. An older woman and young boy. One well covered, one less so—his bare legs, hands, and face being the bulk of what we see of him. We know that he's dressed, but the contrast is there. The two of them sit in soft window light, only the patch of carpet under them illuminated while the rest fades to darkness. If you're looking for more symbolism, it's there. The way the light feathers off so quickly allows that dark isolating background.

I photographed them with a 135mm lens, wide open at f/2. The compressing effect of the longer lens allowed me to isolate these two individuals. A shorter focal length, with its necessary wider angle, would've included others who were praying in the mosque, and I wanted them alone to give the photographs a sense of intimacy. The wide aperture also has an isolating effect, blurring the background, making both of these photographs about two apparently solitary people, instead of allowing the distractions of their environment to creep in. When I stop down, increasing the depth of focus, I am necessarily telling the reader of my photograph that the newly focused elements matter, that they are part of the story; in this case, they were not. Both of these photographs are about the two people, not really about their environment. There are enough visual clues to place them in a context, and that's all that's needed. If you notice my shutter speed, it was 1/3200, so while I probably should have dropped my ISO, my aperture wasn't open merely to get more light in. It was because the aesthetic of a shallow focus was important;

anything deeper would've cluttered either of these simple frames.

My POV here is very low. I could only have been lower if I'd been lying down on the carpet, a bit of an uncomfortable posture when you are trying to be respectful in a place of worship. Instead, I sat cross-legged, my feet tucked under me, slightly bent over, shooting with the camera on my knee. A photograph with this kind of intimacy doesn't happen when you make it standing up and looking down. Imagine the changes that would've occurred if I'd made this from a standing POV. The background would've included much more carpet. I'd have lost the profile of the woman and the full view of the gaze of the child. Instead, I'd have been looking down on them. The feeling too would've changed. As it is now, as a reader of the photograph, I am on their level, in this visual story perhaps praying beside them. Standing over them I would've become merely a bystander at best, or a condescending outsider at worst.

C

Lastly, I'm showing you the black and white versions of these images (C). Look at the way the final photographs feel in contrast to their color counterparts. You lose something, you gain something, and while I present these images in color I still play with their black and white counterparts. My usual axiom is that if the color doesn't add significantly, or if its absence significantly strengthens the photographs, it should be removed. In this case, the black and white versions remove the distraction of color, and I think immediately allows the contrasts between the gestures of the woman and child, which are absolutely the heart of this photograph, to stand on their own. But it removes the mood. Perhaps a few more years' distance between myself and the memories of the event will make me more objective, but I'm showing you them here to highlight the differences. What you say in your photograph includes your decision to keep or remove the color.

Waiting in Lalibela, Ethiopia, 2006

"WAITING IN LALIBELA" was created on Ortho-dox Christmas in the ancient town of Lalibela, in northern Ethiopia. I was struck by a couple things in this scene that I wanted to express. In contexts like this, my tendency is to move in close, to make a portrait if I can gain the collaboration of the sub-ject. But when I did so here, I realized I was losing everything about the scene that I loved. So this was not going to be a photograph about a specific man. It had to be wider, to include the context and the elements that most intrigued me, which were the rock-hewn stairway to nowhere, and the huge, heavy carpet. That initial realization led all my other decisions in the creation of the photograph.

The image is framed horizontally in the native aspect ratio of the Canon I was shooting with. That longer horizontal frame, combined with the wider (40mm) focal length, gives me space to balance the man on his carpet with the rest of the image and with the negative space that gives a sense of soli-tude. Combined with his gesture—as he is wrapped in his garment in a protective, huddling posture— the photograph begins to imply not only solitude but loneliness. Part of that implication comes from the fact that the man is literally sitting in a corner, his gaze directed outward beyond the frame of the photograph. Had this man looked at me, this

photograph would've ended up in the deleted bin. It is exactly his unawareness of the camera that allows us to look into the scene without feeling con-scious of our intrusion. The moment he looks out at us is the moment our presence there becomes part of the reality of the photograph, making it no longer a photograph about this man in his context but instead a photograph about our presence and intrusion into his reality.

For me, there is a feeling here of the words from "The New Colossus," the poem at the feet of the Statue of Liberty: "Give me your tired, your poor / Your huddled masses yearning to breathe free." In this case, though, it's the huddled and alone. When we're conscious of these influences as we create a photograph, it can be a tremendous help in find-ing the language to express ourselves visually. In this case, the image needed to be wide. In fact, if there's a weakness to this image for me, it's that I should have used an even wider focal length and made the photograph from a little closer, to keep the sense of solitude but to make it a little more personal. I'd love to see the look on his face, to see his eyes more clearly. I might not have accom-plished that, but looking back, that's a decision I'd change if I had the chance again. Hindsight is use-less in changing this photograph, but it's helpful as

▲ Canon 20D, 40mm, 1/100 @ f/4, ISO 400

I learn from my own work and move forward. There will be a next time, and next time I will express myself more clearly.

Because of the orientation of the staircase—with the steps echoing the line of the secondary diagonal—these steps imply stairs that go up, instead of stairs that come from somewhere, or from nowhere in this case. I think that implication furthers the sense of hopelessness, as though the man is

stranded there on his impossibly large carpet, and his only way out are stairs that go, literally, nowhere.

The light in this photograph is diffused, which keeps the contrast down and the subdued and organic palette quite soft. Brighter light would've introduced hotspots and brighter colors, and I think it would've created a less contemplative photograph. It would've pulled out more texture in an already heavily textured scene, and that texture—now with

A, B

relationship with this place." A sense of belonging is implied.

I often encourage my students to look at their work in black and white, to see if removing the color contributes to or detracts from the image. In this case, the black and white image is strong, but with the loss of the earthy palette, it loses much of its mood (**A**).

The contrasts in this photograph come not so much from color and tone—although both are there, and you only have to do a quick conversion to black and white to see the tonal contrasts. In color, that contrast is very subdued. Instead, it's the conceptual contrasts that create the interest in this photograph. Stairs that lead nowhere, a carpet without a floor, a seemingly vulnerable man in a very hard and unforgiving context—these contrasts provoke questions, and questions provoke and engage the imagination of the reader.

Compositionally, placing this waiting pilgrim on the rightmost third of the frame gives me two thirds of the frame on the left against which to balance him, giving the image some tension (**B**). Had I moved the frame over, to place the stairs and pilgrim on the leftmost third, I'd have had a photograph with no room to move up the stairs, and instead of staring out of the frame, the man would've simply been looking through an empty frame. The feeling would've been very different, and that difference is felt in some of the alternate crops. When I first processed and printed this image, I toyed with a tighter crop, perhaps a 4:5 or 1:1, but found that

greater visual mass—might've competed for the visual attention of the reader. What this organic palette does is link the man and his environment. Very different colors—for example, red in the rock and bright blue garments on the man—would've separated the two. A shared palette connects them and says, "This man belongs here—he has a special

my eye suddenly stopped going up and down the stairs (C). Without the space to move in the leftmost third of the frame, everything felt too tight, too static. Aside from the 1:1 crop—which was so tight that it removed all negative space—the other option was to keep that space on the left and pull the crop in from the right, but that crept in too tight to the carpet, which then intersected the frame and blocked the otherwise clear path that my eye took around the photograph. The moment I moved that crop back out, I had more room and the photograph felt right again.

Balance, as I've said before, is something you feel your way around. Your own unique sense of balance is one of those things that mark your own images as yours...not whether the image is balanced or not, but how it is balanced—against what, in which direction, and with how much tension.

While we're still talking about composition, consider the POV of the photographer. Standing, looking down toward the subject. The POV creates a further impression of vulnerability. Had I shot this from a lower POV, that feeling would've changed. A lower POV would've felt less intrusive, less voyeuristic. I suspect if I were making this photograph now, I would more readily get lower to the ground, though I wonder if that would diminish the feeling the current POV gives. In terms of message, I lean more toward dignity and am usually uncomfortable with the idea of looking down on people, but forcing others to see the scene from this angle—to feel those feelings, even if they're unaware of why—may serve a greater storytelling purpose than my own feelings of discomfort as I photograph.

C Two alternate crops for "Waiting in Lalibela," a 4:5 and a 1:1, neither of them giving the image enough breathing room to balance the way I like. For me, the horizontal nature of this scene required the longer frame of a 2:3 crop.

Sweeper, Taj Mahal, Agra, India, 2007

MY PHOTOGRAPH OF THIS SWEEPER at the Taj Mahal came early one morning in the wake of my disappointment about the Taj Mahal itself. I had arrived expecting something extraordinary, something that leapt from the pages of Kipling. No doubt I thought there would be elephants and swamis. What I found instead was exactly what I ought to have expected: a beautiful monument full of bones, the dust of history long past, and tourists. I made the requisite frames, the same ones everyone else does. And then I gave up and went for a walk. When I finally settled in the mosque to the left of the Taj (when facing it from the main entrance), it wasn't long before this sweeper appeared, and his presence there, sweeping the detritus left by pigeons, was exactly what I wanted. Here before me was the current state of the Taj Mahal. It's simply in maintenance mode. Once an over-enthusiastic shrine to love and the final resting place of Mumtaz Mahal, the wife of Shah Jahan, this place is now just biding its time.

The long vertical frame was my only option for incorporating the lines I love so much about the Taj, allowing me to create a frame-within-a-frame composition that neatly divides the photograph into two worlds. There's the world inside, where the man diligently sweeps, and the world outside, with the Taj lit by morning light. That vertical frame also plays well with the strong lines on the floor that give this image some of its depth as they lead the eye toward the vanishing point, which happens to sit very closely to the Taj Mahal itself (**A**). These lines give the image depth and are a function of both my own POV—which is as precisely centered as possible—and of the wide angle lens (17mm).

The POV here is important. What I wanted was a frame that was as symmetrical as possible. The Taj Mahal is precisely symmetrical with only one asymmetry—the posthumous placement of Shah Jahan's cenotaph, which was always meant to be placed in a building like the Taj Mahal but on the other side of the Yamuna River. The concept of symmetry is central to the Taj Mahal, and it's one of the reasons I love the architecture so much. So I wanted as symmetrical a photograph as possible. In this image, the only real asymmetry is the sweeper himself. He breaks the perfect pattern of the floor, the arch, and the distant Taj, and this creates the central contrast of the image.

▶ Canon 5D, 17mm, 1/250 @ f/13, ISO 500

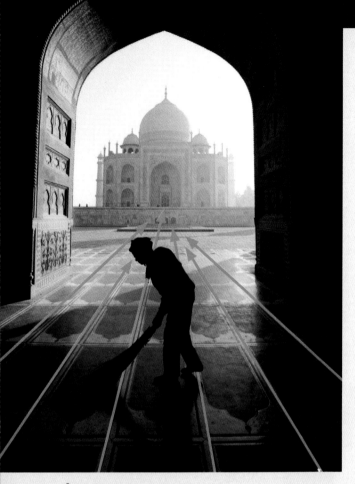

A

The fact that the dynamic range outpaced my sensor's capability enabled me to plunge the sweeper, already in a shadow, into silhouette. This has important implications. To the vast majority of visitors to the Taj Mahal, this man is invisible. He's not relevant. Abstracting him to merely a form of a man removes his identity, much like laborers everywhere.

In terms of composition, this is a good photograph for a discussion of thirds. Although this symmetrical photograph places all kind of elements tidily within the grid, and the sweeper on the bottom third—which balances with the top of the frame (**B**)—there is still the depth of the image to consider. This is a good chance to imagine the image as a cube, and look at the thirds as they recede *into* the photograph and provide interest in the foreground, midground, and background (**C**), giving the eye a visual path not across the photograph but *into* it, following from the foreground sweeper (**1**) to the midground arch (**2**) and finally across the courtyard to the Taj Mahal (**3**). Yes, the lines of perspective would've led the eye on the same path, but without something to look at in the fore-, mid-, or background, what's the point? Giving the reader of your photograph a strong path for the eye is no favor to them unless you're pointing at something along the way.

Here, that visual path also suggests a visual hierarchy. The man is clearly the center of interest, and although the Taj has a great deal of visual mass, it balances against the black that forms the silhouette of the sweeper and the near surface of the arch. Its

The fact that the light was still so low gives the fantastic sidelight on the left side of the arch, pulling out some important textures, but it also creates that strong line formed by shadow along the secondary diagonal of the photograph, giving another strong line for the eye to follow into the image. That light also feathers off at the top of the arch, and this chiaroscuro gives further depth to the midground.

B

C

size—small relative to the fore- and midground— also suggests that this is a picture that *contains* the form of the Taj Mahal, but is *about* much more than that. It's about the present state of the Taj Mahal, simply being maintained by anonymous grounds-people. It's not about the man himself, per se, because I've given no visual clues to his identity, but it is certainly about laborers. That's the best I could do with my own desire to express

those things. The image itself gives off those clues but will be interpreted by readers in many different ways. Such is the way of art.

There's one more element in this photograph that I think makes it interesting, if not for anyone else, then for myself. Repeating elements here are strong, and they mirror each other, repeating the form of the arch that sits at the top of the Taj Mahal

itself (**D**). This is a uniquely Muslim form (or was at the time), and it's repetition has become symbolic. You'll see it on the floors of masjids or mosques the world over; the patterns on the floor point the faithful in the direction of prayer. That element, repeated, gives the image rhythm and interest, and pulls in the power of symbol, if only in this case to establish the context of faith. Most would recognize this as an Islamic symbol, even if they did not recognize the foreground as the floor of a mosque.

As with most of my work I considered it in black and white (**E**), but it lost so much of the red clay that's such a part of the complex around the Taj Mahal, and which gives this photograph its warmth, that I kept it in color. But I keep showing these alternate versions because I think it's important for us to be sure we're not shortchanging our images by allowing the color to seduce us. In this image, it's more than the mood that gets lost when I convert it to black and white. The warmth of that arch and the chevron of warm light on the floor have greater visual mass for me than their black and white counterparts, and so they don't pull me into and through the photograph in the same way as the color version.

D The repeated element of the shape of the arch pulls us into the image. It also provides a rhythm—like a visual echo—and, for those familiar with the symbol, gives context and meaning.

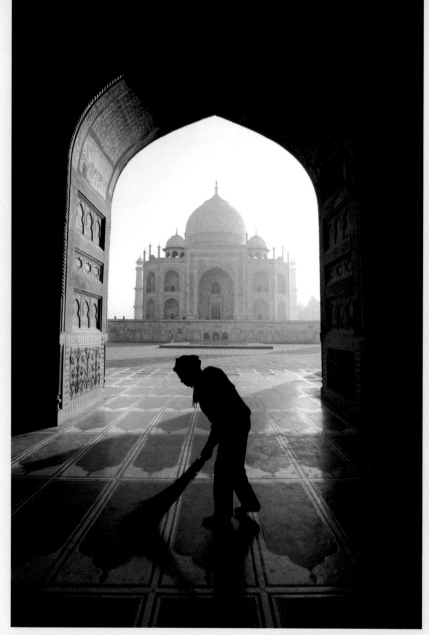

E

Unseen Too, Kathmandu, Nepal, 2010

"UNSEEN TOO" IS THE SECOND of two photographs I took here. I've shown both with a duotone treatment earlier in the book, and they are meant to be part of a longer-term project. Kathmandu has become a place that feels like home to me, at least the Tibetan side of town, Boudhanath. Boudhanath is home to a large stupa, a circular monument around which Buddhist devotees walk, spinning prayer wheels, fingering prayer beads, and chanting. In the midst of this are some very regular beggars. The first one I photographed was blind, and I was struck by how many people passed him without a glance. So I set out to make photographs of these beggars and somehow show the isolation that I imagined they felt.

So "Unseen Too" began with a very intentional concept. I wanted to explore the sense of isolation, and perhaps in some ways to turn the tables on the scene. In reality, the people passing by didn't seem to see this man as an individual. They just ignored him. But I wondered if, like the blind man in the first image, "Unseen," the crowd too was invisible. Clearly they were in different worlds.

The first thing that is obvious about the aesthetic of this photograph is the slower shutter speed, which required a lower ISO and my tightest aperture in order to give me the shutter speed of 1/4 of a second, with the camera mounted low on a small tripod. The small aperture, which usually results in having so much in focus from foreground to background—and therefore too much visual mass given to irrelevant details—didn't matter in this case; while so much is in focus, it's all moving, and therefore blurred again. That blur implies not only motion, which is very much the spirit of this place, but anonymity. The blur abstracts everyone except the man standing so still, just hoping for someone, anyone, to put something in his bucket.

It's true we make assumptions about the visual stories we tell, and I don't think I'm making a judgment one way or another on this except to interpret it as I see it, and my choice to tell the story from the perspective of this lone beggar. Whatever I believe about begging, I am passionate in my desire to see the forgotten, the poor, and the weak be given a voice. This photograph won't change the world, but for me it expresses my sorrow for the unseen.

Other decisions included my low POV. Because the POV you choose implies identification, I wanted to be closer to eye level with this stooped figure

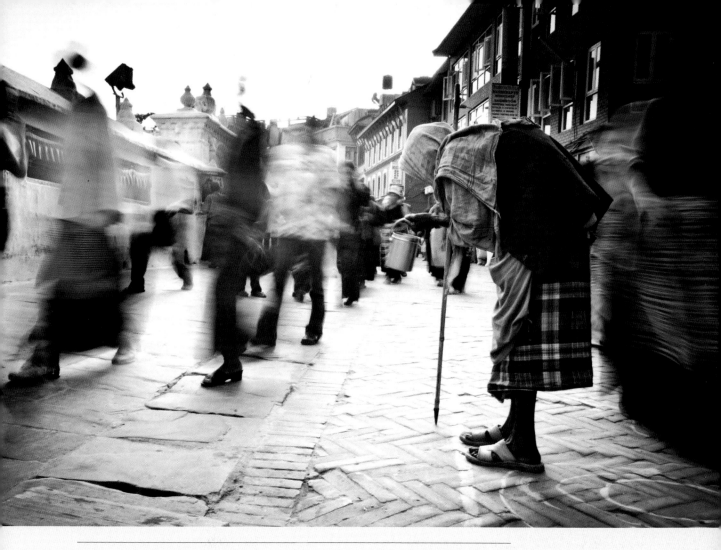

▲ Nikon D3s, 28mm, 1/4 @ f/22, ISO 100

A

than with the people passing by. Go low and you identify with the child; go high and look down, and you identify—or cause the reader to take the perspective of—the powerful or condescending. So I was low, with an unextended tripod, wanting to shoot into the coming people, hoping they would go around both the beggar and me and carry on, which they did. This behavior led to a V-shaped space in which the beggar, and only the beggar, exists. That V is echoed in the lines of the rooftops, and together they draw the eye, once it has seen the beggar, into and through the image, giving the photograph greater depth (**A**). At least three of those prominent lines point directly to the bucket of the beggar, giving the photograph an unmistakable visual clue about who or what this man is.

Placement of the center of interest happens, again, to line up with the traditional thirds grid (**B**), but I still contend that the actual rule of thirds is some-what irrelevant. I didn't place the stationary figure of the beggar on the rightmost third because I was even remotely mindful of the rule, but because the balance felt right. Remember, the sharp focus on this man, and the way his presence in this photo-graph contrasts so strongly with the others, creates a stronger visual mass. He is stooped, textured, unmoving, and because he is hooded, carries a certain mystery—all things that give greater visual mass to his form than to anything else in the image. So to balance that and still retain some tension in the frame, I placed him much further right than

B

central. And that works in conjunction with a longer horizontal frame, as well as the wider lens.

"Unseen Too" was made with a 16–35mm lens at 28mm. Why we still refer to lenses by what, to most of us, is meaningless math, I'll never know. Ask someone what angle of view their lens has, and they have no idea. And yet the angle of view on a lens has a significant aesthetic effect. In this case, it determines the angles of the lines I pointed to earlier. Had I used an 85mm lens, I would've had to back up significantly to keep even roughly the same amount of the scene within the frame, and I would've lost the sense of depth, because the angles would've been significantly reduced and

the perception of compression would've increased. Roughly—and this one's easy to remember— a 24mm lens has an 85 degree angle of view. Inversely, an 85mm lens has a 24-degree angle of view. Now get your old protractor out. That's a big difference, and the loss of those 61 degrees is significant in the resulting look and feel—and therefore the meaning—of the photograph.

That was a long digression to simply say that the lines and feeling of immersion in this scene come largely from not only my POV, which determines perspective, but my choice of optics, which determines the angles of the lines.

Impressions I, II, III, Rideau County, Ontario, 2011

SO MUCH OF WHAT I'VE TALKED ABOUT to this point has been very literal. We've discussed language in descriptive terms, but not all expression is so literal or descriptive—least of all photographic expression. There is incredible latitude in the tools of our craft to pursue abstracts or impressionism. "Impressions I, II, and III" were made to explore these possibilities.

Never having been an art history student, I've learned most of what I know by visiting galleries and looking at work that resonates with me. Impressionists have always pulled me, I think, because it's clear they were unconcerned about the question that dogs photographers who pursue expression over documentation, specifically, "Did it really *look* like that?" The Impressionist is much more concerned about "Did it *feel* like that?" As a result, in Impressionists from well-known Europeans like Monet to the Canadian Group of Seven, a group of painters from whom I get immense inspiration, you'll see a greater priority placed on light and mood over precision of composition. Initially the painters, like Monet, who were labeled Impressionists, were criticized strongly for breaking from the established forms the way they did.

For me, where this all came from was a moment in the National Gallery of Canada, looking at "The Jack Pine" by Tom Thomson and wondering how I could get the mood of these great paintings into my photographs.

That's the background, which is important to consider when looking at these three photographs, because knowing my intent helps you determine whether or not they are successful. My larger hope is not only that these photographs will express something, which they do for me, but that they'll communicate to you—make you feel something like I feel about the summer rain in the countryside.

"Impressions I, II, and III" were all shot horizontally. We were driving, the countryside moving past us, and the raindrops pushed across the window in the same direction. So the lines were immediately suggestive of a horizontal photograph, which gives the eye room to read these photographs with the energy you feel in a moving car. I cropped them to 4:5 not to intentionally decrease the energy that a longer frame gives, but for the more pragmatic reason that in most of the frames I made on that drive there were some problematic reflections on the lower left due to the shape of the car's windshield.

▲ iPhone 4, cropped to 4:5, and processed with Golden Hour filter, then bordered in the Camera+ iPhone app

So I made a couple frames, and in the Camera+ app, I played with various crops, finding that a crop to 4:5 (they call it 8x10) would knock out that reflection.

Rather than look at all three photographs in detail separately, they share some similarities that I think are worth discussing together.

The first of these is the quality of focus, which, more than any other decision, gives this series its distortion, like the loose brush strokes often seen in Impressionist paintings. That look came from pressing the camera as close as I could to the glass so that the camera retained some focus on glass and created that distortion. If I'd placed the camera too far from the window, the water drops would've become elements of their own, resulting in photographs that were more about rain on windows than about landscapes shot through rain. What I didn't want were photographs that distracted readers with thoughts of, "Hey, you shot this through a car windshield, what great raindrops." I wanted to create something new, something more than I could've achieved simply by sandwiching two exposures together.

The second shared aesthetic is the mood, accomplished both through the element of diffused light and the decision to tint the photographs with yellows and greens, pulling much of the blues from the images, warming them up and giving them the feeling of a summer rain. That's not to say the original colors present in the photograph didn't communicate something all their own; they did. But they

A The unprocessed image, straight out of the camera, was—for the sake of the mood I had identified and wanted to create in this image—too blue and *felt* too cool for a warm, muggy, summer rainstorm.

were much more realistic, and my goal was to create a specific mood. To my eye the original image (A) looked and felt gloomy, which was precisely not my own emotional response to the rain and the passing green countryside. So the question was, what do I need to do to the color to restore my own emotional responses? The most obvious suggestion seemed to be a change in the white balance and the tinting, making it more yellow than blue. I don't think that change, however, makes it happy per se; it makes it merely warmer. The absence of direct light and the otherwise somber tones still give it what I wanted in the first place—the magical feeling of a sudden summer storm in the country.

The third aesthetic this series shares is the frame, and I've included it here because the frame is read as part of the photograph and is not merely an afterthought. How we respond to a photograph can

very much change from one frame to another. Look, for example, at the two alternate presentations of "Impressions II" (**B**). The first has a broad white border that immediately suggests a fine art matte. The second is a preset reminiscent of the Polaroids with which many of us grew up, and suggests an old snapshot. Barring the usual snobbery against instant photographs as art, one is not better than the other; they merely imply different things. Aside from the fact that these choices have forced me to change the aspect ratio, which changes the rest of the photograph, the Polaroid will likely be read with greater nostalgia, even judged by more relaxed expectations, than the one with the large white border, which begs us to take it more seriously. In the case of the three final images, for this book I applied a frame with a weathered look. I think the Camera+ app calls it Vintage.

Outside the context of this book, this series will be finished with the broad white frame; it gives the eye room to move while still being pushed back into the photograph. But the weathered border complements the mood of the photograph, and different choices—like the choice to use a faux medium-format film frame—would imply different things, even subtly influencing your reader to take your work more or less seriously. Do I think that changes things? Of course it does. We see what we want to see, and rightly or wrongly, your photograph will be read differently for the choices you make here. Some borders are nostalgic, some perceived as more serious or artful; still others force the eye to remain inside the frame when it might otherwise leave. This is your decision, and one that changes the message read into the photograph by your reader.

B How we finish the photograph becomes part of the photograph itself, and therefore changes how it is read and what it says. The photograph here, changed only in aspect ratio to cram it into an old Polaroid frame, will be perceived differently depending on which border it is given.

The Pour, Sahara Desert, Tunisia, 2008

"THE POUR" IS A PORTRAIT of a guide I hired in Douz, Tunisia, to take me out into the Sahara. He was an intense man, and was so focused on serving us and so free from the burden of any English whatsoever that my experience of him revolved entirely around his hospitality.

The vertical orientation of the 2:3 frame gives the frame the verticality that it needs to tell the story. The two main elements are the man and his work, both vertical: the man, even leaning, is primarily vertical, and the kettle and line of water drops are also vertical. The frame exaggerates that, leading the eye from top to bottom more than a horizontal frame would've done.

Before we talk about the placement of the elements—and I think this photograph has some interesting things to teach about balance—let's look at the depth of field, which hasn't played as prominently in most of the photographs we've looked at so far.

As you can see from the EXIF information, this was shot with a longer lens, 170mm, at its narrowest aperture, f/2.8. The combination of longer lens and wide aperture allows me a shallow depth of field, giving me sharp focus on the face of my guide and a subtle blur on the tea kettle, while rendering the background a complete blur. This one choice, clearly not made just to get more light into the camera, accomplishes something important; it gives the face of my guide the greatest visual mass, pulling the eye there first. There is now a visual hierarchy. The difference in quality of focus on different elements tells the reader to look to the face first, specifically his eye, then move to the object of his gaze, the kettle and the line of water he's pouring out in preparation to make tea. Reversing this would've made the kettle more important and rendered my guide a non-specific Arab, which was not at all what I wanted to say. Alternately, I could've stopped down to f/8, which would've allowed both the kettle and the face to be sharp, making them compete with each other. Again, it's not a question of which decisions were right—it's a question of which decisions accomplished an aesthetic that said what I wanted to say.

The quality of focus also divides this photograph into three zones: a soft-focused foreground (the kettle), a sharp midground, and a blurred

▶ Canon 5D, 170mm, 1/400 @ f/2.8, ISO 100

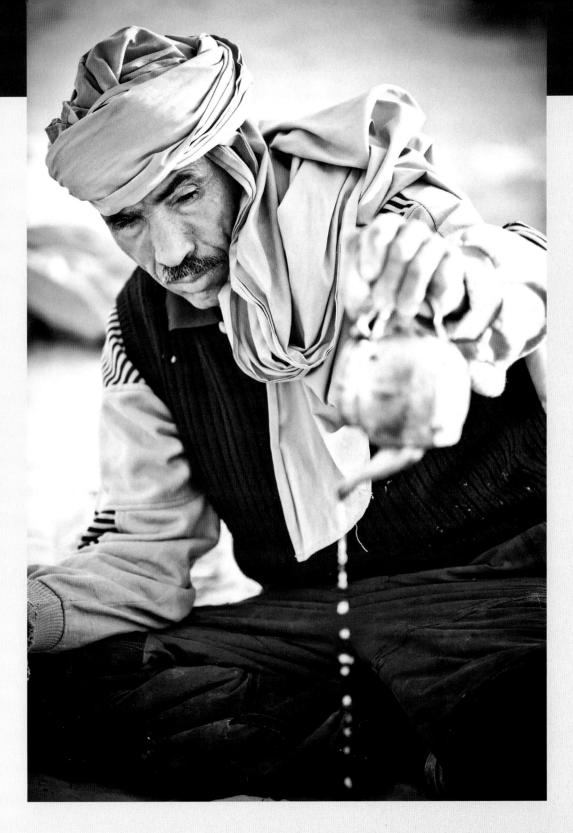

The Pour, Sahara Desert, Tunisia, 2008

A The original orientation of the photograph.

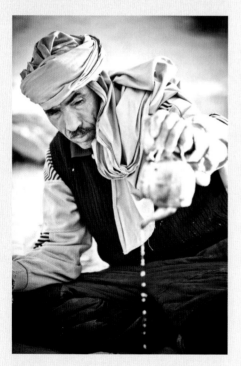

B The horizontally flipped photograph.

background. This separation gives us depth, and goes to show that while we don't often talk about longer lenses as characteristic of creating depth, there are many ways to create a device like depth. Aside from assisting in the softer depth of field at this aperture, the longer focal length—with its much narrower angle of view—isolates our story. A wider lens would've pulled in much more context, losing the intimacy of this photograph and diluting the story.

The shutter speed, 1/400th of a second, was enough to freeze the action of the drops, letting them stand on their own as drops instead of a steady stream. A steady stream requires little attention, but by slowing these drops down I'm implying a level of concentration and care, which was exactly what was going on. Our guide—and I wish I had his name, but I lost my Moleskine notebook that night (I suspect when my camel decided she didn't like me and tossed me to the ground like so much unwanted baggage)—was meticulous. He was not a showman; a showman would've looked at me, smiled, flourished his kettle. Instead he just performed his task with great attention to detail. The faster shutter allowed me to imply this in a way that a slower shutter would not.

Before we move into the discussion of composition, remember that the photographs I show here, even how I present them, are a result of decisions about how best to teach these ideas. So when I tell you that I've horizontally flipped this photograph for the sake of this book, I trust you'll stick with me while I explain. Take a look at both photographs together. In one, the original orientation, the kettle is held in what is his right hand (**A**). In the image I have flipped and presented first, the kettle

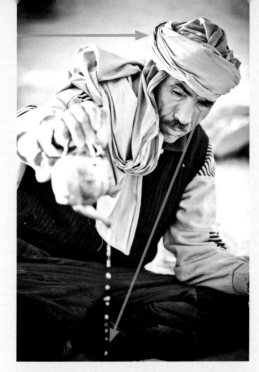

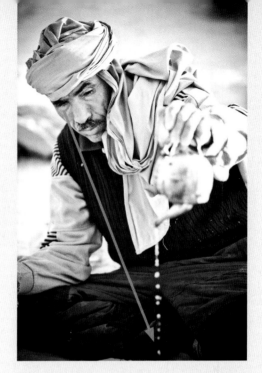

C The path and energy of the eye goes right first, pushing against my guide's already leaning body. More than dynamic balance, a sense of imbalance is created.

D The path and energy of the eye is direct and dynamic.

is held in what would be his left hand (**B**). Cultural implications aside, the two photographs get read quite differently in terms of the path of the eye and the resulting balance.

In the original orientation, the gesture imbalances the frame. The eye moves across the top of the frame, gaining momentum, and by the time it hits the already leaning figure of the man, there is enough visual mass to knock the frame slightly off balance (**C**). But in the flipped version, the posture of the man aligns with the primary diagonal, a stronger diagonal because it matches the path of

our eye more closely and therefore channels the energy of that path. So instead of pushing against the diagonal, our eye simply follows a clear path from top of frame to the sharp focus on the eye, then to the kettle and down (**D**). On consequent passes, the eye will take in other details, going slower, perhaps following the lines and textures of the turban, before resuming the path to the hand and kettle. But that path is still in the direction of the primary diagonal and therefore feels very balanced—though still dynamically, because of his leaning posture.

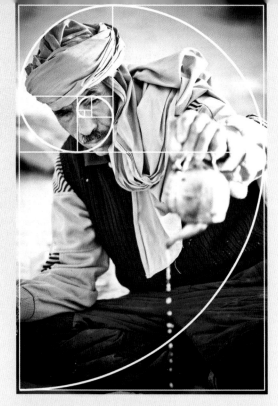

E The spiral shows the path of the eye, beginning at the face of the guide, then spiraling around. Eventually the eye will retrace that spiral in reverse, or simply go back to the beginning and do it again.

F Key elements on the thirds, or the intersection of the thirds, hint at centers of interest and potential balance. But remember that the rule of thirds is only descriptive, not prescriptive.

If we go back to compositional aids like the thirds or spiral grid, you'll see further hints about the balance in this photograph, though these would be the same for either the original or flipped image. Compliance to a grid of thirds or a spiral doesn't necessarily make a good photograph, but these tools do help us understand balance. Overlaying the spiral on this photograph (**E**) is interesting to me because it closely matches the path of the eye—if we allow that in any one image the eye can take several paths, some of them simple, others more complex, but we'll look at that in greater detail in a later photograph. Overlaying the grid of thirds gives clues about why the balance works as it does, placing key elements on thirds (**F**). But remember there is much more to balance than grids or spirals. If balance is about visual mass and what our eye is drawn to, then the dark black of the pants at

the bottom of the frame provides a strong, stable anchor, so even in the original, unflipped image, the man isn't so off-balance that we feel he's about to tip over. Reading the image left to right, the man's face balances against the rest of his body and the kettle. Going from top to bottom, the face and turban—light, textured, sharply focused—need the bottom two-thirds of the frame and the darker tones to balance them out.

The decision to render this photograph in black and white was an easy one. Our guide's turban, as you can see from the original color photograph (**G**), was a beautiful sand color, and—in someone's idea of desert fashion—it probably goes well with his baby blue shirt. But in terms of the photograph, the sleeves of his sweater exert enough visual pull that any mood I might have gained through some of the nicer colors is overpowered by the distraction of the blue. As so often happens when converting to black and white, the lines and the gesture of the photograph are allowed to take center stage. In this case, they tell the story more clearly and power-fully without the color. The conversion performs another function, too: it makes up for the bleaching effect on the sleeve of the guide. The light is hot on his pouring arm in either version, but in the color version it becomes more noticeable, and therefore distracting. In the black and white version, it simply adds contrast. In neither case is the sleeve burned out, or free from detail, but in the color version it feels much closer to being blown out, and to photographers at least, this signals a weakness in the image.

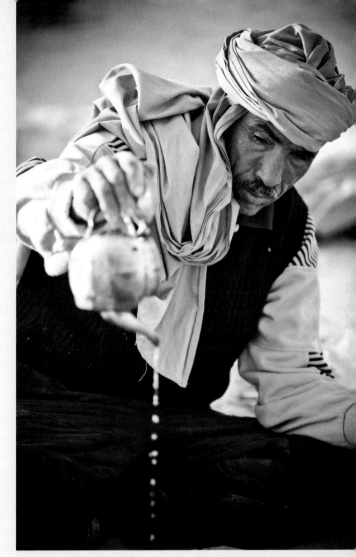

G

Burning Bush, Lake Naivasha, Kenya, 2010

I PHOTOGRAPHED "BURNING BUSH" ON Crescent Island on Lake Naivasha in Kenya. It was an astonishing day of clouds in formations I'd never seen, but it wasn't until this column of smoke began to form, elongate, and drift that I saw potential for something special. The title obviously implies a connection to the biblical story of Moses' encounter with God in a bush that burned yet wasn't consumed, but also reminded me of the eventual train of refugees that left Egypt in a hurry, and according to the narrative, followed God as He appeared in a column of fire by night and a pillar of smoke by day.

The most obvious framing for this was vertical, and while I say it's obvious, I know a full half of the photographers who might have shot a scene like this would've photographed it horizontally. We can be slaves to our horizon. If the horizon is part of the story but not the story itself, then it should get put way down the list of priorities. Here, the horizon and the band of ground beneath it is an anchor in the frame, but it doesn't add to the story, which is entirely about the relationship between the tree and the cloud. I've left the aspect ratio at 2:3 because it's more strongly vertical than 4:5, and

I'm still not a fan of vertical frames much thinner than a 2:3. 16:9 verticals give me vertigo and, in this case, wouldn't have given my eye room to move between the column of cloud and the edges of the photograph.

Aperture and shutter speed weren't key to the aesthetics of this image—the focal length was. At 350mm, there was enough compression effect to pull the cloud closer to the bush. The illusion isn't complete, but I wanted to pull the cloud and the tree together to establish a connection, as it is that perceived proximity that implies the cloud or smoke might in some way be coming from the tree. I say "implies" because we know it's not, yet there is a forced connection because of the flattening.

The longer lens wasn't the only thing that made this work. The timing was everything, in terms of both the shape of the cloud and its position. I've included a couple variations taken within a few seconds of each other, and within a minute of the final frame, which was my final select (**A**). Had I kept shooting, you'd see that cloud drift off from behind the tree, losing the forced relationship I was working to keep.

▶ Canon 5D MK II, 350mm, 1/160 @ f/8, ISO 100

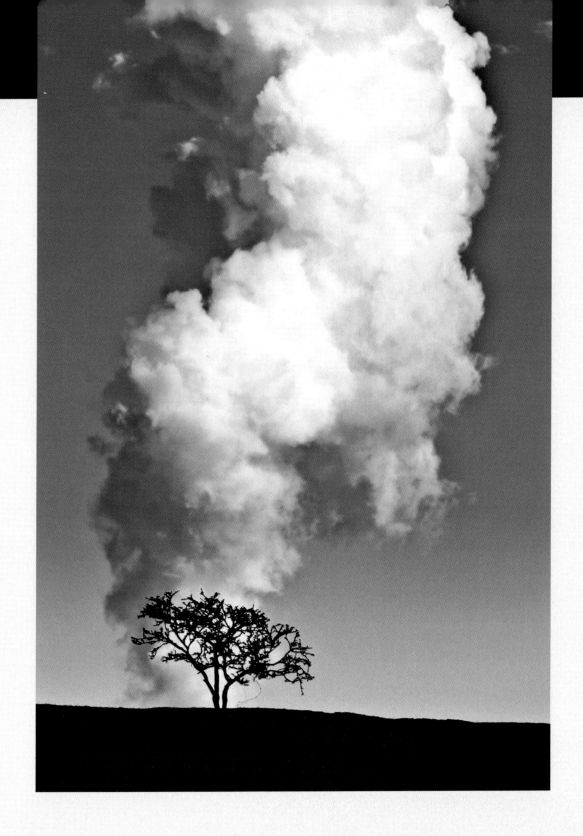

Burning Bush, Lake Naivasha, Kenya, 2010

A There were only two minutes between the first and third of these frames. And less than two minutes later, the cloud had passed its peak. The decisive moment in slow, slow motion.

Even as it was moving, I had to keep moving my own POV to keep the tree and cloud aligned. When choice of moment and the need to tweak your POV conflict, you have to work fast. The three images here, pulled from a sequence of about 20 frames, show the movement of that cloud, finally taking the form it took in its final presentation. It was also a battle against the people in the images, none of whom I cloned out later. I just waited and got lucky.

Bear in mind, I had no idea what was going to happen, but if you're observant and receptive, and you play the what-if game with some patience, interesting things happen. In this case I saw the cloud lengthening, and although what I was primarily interested in was a photograph that was as "burning bush-ish" as I could make, to my great delight the cloud formed a beautiful, subtle S-curve that gives the eye an elegant path to follow, up and down, but in slow, graceful curves (**B**).

Compositionally, I am showing you the final shot as a cropped image. While I photographed this, I was having a hard time keeping up with the cloud, so I made the tree central to the image. After the fact I cropped it (**C**), leaving the aspect ratio the same but cropping both to eliminate some of the wayward clouds (which I'd rather do than remove them in Photoshop) and to shift the tree left in the frame to better balance it against the leaning S-curve of the

cloud. In fact, cropping it as I have has pulled the tree from a static and symmetrical position in the frame and placed it on the leftmost third (**D**). That it falls on a third is only coincidental; I don't generally crop to my guidelines, but to a sense of balance. That it ended there at all shows the helpfulness— sometimes—of using the thirds grid to pursue options with your balance. You'll notice it's not per- fectly on the third; that would've pulled the cloud out of balance. That tree and cloud both exert a lot of visual mass, so balancing them is not hard, but it helps that the black and white conversion I did on this photograph rendered the ground (which was green grass) quite dark. Had I done it differently, lightening the grass, I'd have ended up with a weak anchor and the tree wouldn't have been enough to hold the elements in tension.

I've included one more illustration in the hopes of further exploring the balance in this image, because, as I wrote earlier, this stuff is hard to explain for me and sometimes needs a more oblique approach. In image **E**, I've split the frame vertically and horizontally, though the horizontal split isn't even. First look at the bottom of the image (1+2). This half of the frame is balanced; there is enough negative space and mass in 2 to balance 1, albeit dynamically. Now look at the top half of the photograph (3+4); these two sides also bal- ance each other. So tops and bottoms of the image are balanced. Where the dynamism comes from is setting 1 against 4, and to do this at all, I had to divide the frame asymmetrically. If you can divide the frame into four equal quadrants and they all

B Once in a while, you get lucky. As the cloud grew in height, it blew into a beautiful S-curve.

C This crop retains the original aspect ratio but rebalances the frame and cuts out some of the clutter.

D Although I don't shoot to conform with grids, I do use them later to suggest alternate crops and balances.

E

balance out, you've got a much more static balance. But here the visual mass, so strong on the bottom, anchors the image enough to support a much taller, more dynamic frame. But without the room on either side of the cloud or the negative space present in 2, the balance in this image would be static, like the uncropped version I started with. To me, that would be less interesting and have less pull on my attention to explore the whole photograph.

The contrast in this image, which is rich in tonal contrasts and textures (micro contrasts, if you will),

is more symbolic than anything. If you're familiar with the biblical narrative, then that contrast is immediately recognizable. Trees don't smoke unless they're on fire, and if they're on fire, they are meant to be consumed. This photograph will resonate that way for some. For others it will be more about the meeting place of earth and sky, solid versus gaseous. What is less easy to describe—or take any credit for, aside from being ready when the moment arrived—is the sense of wonder we feel when we see something this cool. It's a great juxtaposition, and the best we can do at times is use our

craft as well as we can to simply present something as it is, for what it is. There's much to be said about wonder, and the more we can get out of the way, the better.

Lastly, here is the original photograph, uncropped and in color (**F**). My decision to convert it to black and white was simply to focus on the lines, tones, and textures. Our imaginations are powerful, and allowing them to dictate how blue the sky might have been, or how green the grass was, is another form of inviting the reader of our photographs to participate in the experience. Of course, it's not always so cut and dried. The next photograph presents beautifully in both color and black and white; that's when it helps to know what you want the image to accomplish and be willing to go with your gut.

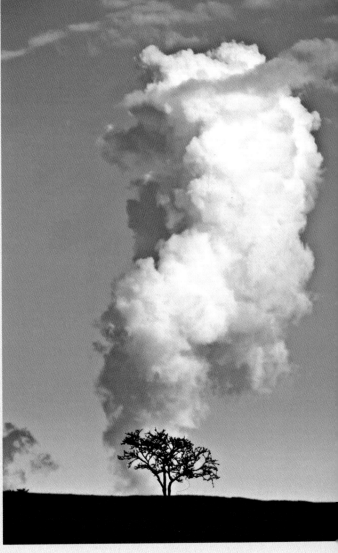

F

Burning Bush, Lake Naivasha, Kenya, 2010 **215**

Hope,
Sahara Desert, Tunisia, 2008

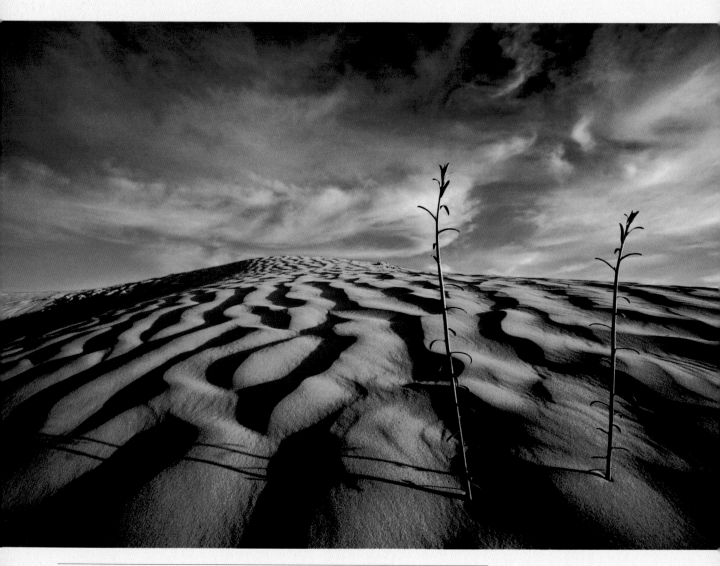

▲ Canon 5D, 17mm, 1/200 @ f/4, ISO 400

A, B

"HOPE" HAS A LOT GOING FOR IT, though I never quite accomplished what I wanted, which I'll explain at the end. It's been one of my best-selling images, and so in one sense I communicated something that resonates. However, sometimes we can do that unwittingly, even while failing to completely express the thing we wanted to.

"Hope" was framed horizontally but could, I think, have been framed vertically because the lines in this image are largely vertical. What kept me from doing so was the depth I achieved with both the horizontal frame and the ultra-wide angle lens. On top of that there are other lines than just the clouds and sand. The lines formed by the shadows of the plants would've been lost, and they were part of what I loved about the scene.

It's the lines that make this image for me—the color, too, although if I had to pick only one, now that I've looked at this for three years, I'd go with the lines over the color. The lines of the windswept dunes echo the lines of the clouds, providing a kind of visual rhyme or echo in the repeating elements, but also pulling the eye *through* the photograph toward the horizon, giving it a sense of depth (**A**).

The second set of lines—the two struggling grasses and their shadows—gives the eye something specific in the foreground to follow (**B**). Were they absent from the image, I suspect this would just be a boring photograph of a dune. The movement across the dunes and up the stalks, then back again, and the fact that this movement happens in tandem, generates even more interest. Like I

said, were the stalks not there, this would be about a dune. In their presence, it's about stalks in the dune, and there's the suggestion of story in that.

The story in this image comes, as it so often does, from contrast. Here it is the contrast of small plants surviving in an inhospitable environment. I named the image "Hope" not specifically because I saw in it a metaphor, but because I hoped they'd make it.

Compositionally, this photograph has very little to contribute if what you want to do is find support for

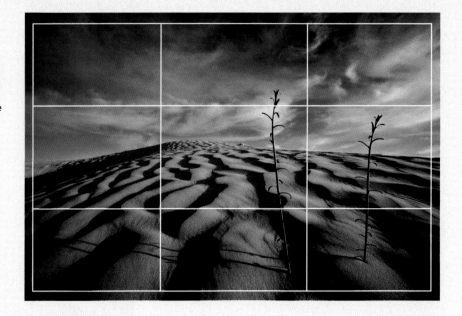

C The traditional thirds grid is only partly helpful here. If you're looking at it and thinking nothing really lines up to thirds, you're right. I don't think it harms the photograph at all. These principles are here to serve our photographs; our photographs are not here to serve the rules.

the notion that the rule of thirds is either a rule at all or applies in all circumstances (C). Yes, the plants are closer to a third than the center, but otherwise, all bets are off. The horizon is in the middle because to drop it or elevate it to a third would've lost the symmetry of the lines echoing between sand and sky. Consider compositional aids, by all means, but only as they serve your intent for the photograph. No spiral in the world would help me here. No grid would make it magically aligned. But looking at this thirds grid, it's still easy to see the balance and the tension that keeps it interesting.

The light in this photograph is everything. Low in the sky, this was photographed around 5 p.m. in January, so the sun was heading west quickly. The quality of light here—very warm and directional—is what gives the image its color and vibrance as well as its texture. Had I shot this at midday, the colors would be bleached, the sky boring, and worst of all, the shadows almost nonexistent. But it is the shadows that form the lines in this photograph, snaking along the dunes—the darker lines forming where the light can't reach, giving texture and depth, creating leading lines that give the image energy. The ability of light to make or break a photograph can never be underestimated. With different light, the mood, the tension, and the visual mass would all change, making a completely different photograph.

Where this image failed me—or rather, where I failed it—is that these stalks were so small, and

the sense of helplessness, the sense of "these little shoots haven't a hope in hell" is reduced for failure to provide some sense of scale. Getting so low and so close with my 17mm lens gave me the lines I wanted, but in the end I simply couldn't get that sense of scale. Am I still happy with this photograph? Very much. But there is something left unexpressed in it. I mention this because I think it's important to be open to the idea that our work lacks perfection, at times, if not always. I'm not even sure perfect photographs move hearts, at least not technically perfect images. Perhaps it is in a photograph's ability to move hearts and minds that, by virtue of that, it is perfect. But still I wish I'd found a solution to that.

Lastly, I wanted to place the image next to a black and white version to show you the effect of removing the color (**D**). Where they both have their merits, it's clear that one photograph is about the warmth and the color of the Sahara in the late day, whereas the other is a study in lines and textures. Which one you choose depends on your intent (vision) and what you aim to express. I see no reason why you can't present them as alternate versions. Musicians mix things up all the time, and it's probably high time, while this art is still young, to avoid the ruts formed by rules and conventions.

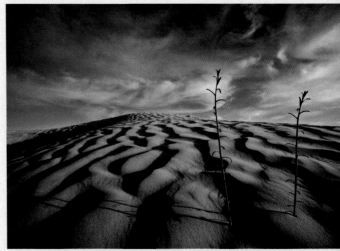

D

Sweeper Two, Agra, India, 2007

AS WE NEAR THE LAST FEW PHOTOGRAPHS, I want to point out something I think is important, and it has to do with being seduced by our subjects, particularly the exotic. So far we've looked at photographs I've made in Iceland, Jamaica, Italy, the United States, Haiti, India, Ethiopia, Nepal, Canada, Tunisia, and Kenya. Not once do I believe it would be fair to say that the light, the lines, the contrasts, the POV, the moment, or any of the other elements of the visual language were unimportant, trumped as they were because I made these photographs somewhere exotic. This is another photograph from India, and while some of the lines and shapes are what they are because of local and historical architecture, a photograph either works or it doesn't, and it is the elements and decisions that go into making that photograph that determines this; it is not because the photograph was made somewhere far from home. The reason I mention this is because it's inevitable that a reader, at some point, will point to the diverse locations where I've made these photographs, and discount them entirely because, "I live in New York, I can't go to India." There are lines and moments and light in every city in the world. Don't let that stand in your way.

Now. "Sweeper Two." As you'll see toward the end I photographed this scene from several angles. Before you keep reading, take a moment to look at this photograph yourself. Talk about it. Make notes. Why does this photograph work? Maybe it doesn't work for you. And that's fine, but it's not fine if you can't identify why.

For me, it works for a number of reasons, chief among them the lines, the repeated elements, the moment, and the depth. This photograph has such great gesture and has always been one of my favorites.

The lines in this photograph run in two primary directions, and they do so quite strongly. The first, and strongest, lines are the verticals (**A**), which determined my choice of framing, both as a vertical and as a 2:3 aspect ratio instead of cropping it down to 4:5. The gesture in this photograph comes so largely from these lines that to minimize them would be to minimize the impact of the photograph. The repeated lines of the columns give the photograph strong verticality—there's hardly a horizontal line in the frame, and those that are there are very small, mere details on the larger vertical lines.

▶ Canon 5D, 135mm, 1/400 @ f/10, ISO 800

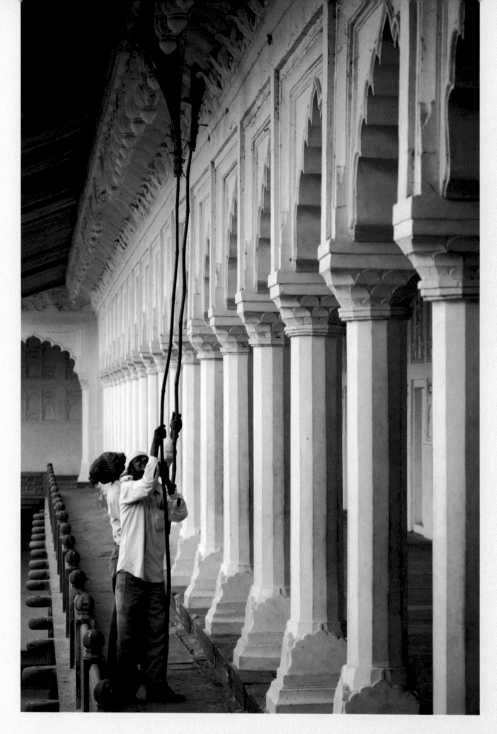

A

B

To me the strongest vertical lines are the darker, longer poles of the brooms themselves, echoing the repeated elements of the columns, but also contrasting with them. The columns are marble; the brooms are wood. The columns are thick and solid, the brooms so thin they look like they'll bend under their own weight. The columns are white; the brooms are dark. But the similarity—their verticality—exaggerates their dissimilarities and introduces the best contrast of the photograph.

The second set of lines would be horizontal if viewed from another angle. In the scene itself, there are plenty of horizontal lines. But now that I've permanently flattened the photograph, those lines are forced by the laws of perspective to recede to the vanishing point, which is the arched doorway, the only way out of this scene. These lines, now strong diagonals, pull the reader through the scene and to the doorway, giving the photograph depth (**B**). Using a longer lens, as I did here, tightened the scene, but these great receding lines give a depth you might not normally expect of a longer lens. Part of that was my own POV. Had I moved right, closer to the columns, the lines of perspective that would've been formed, and the spaces between the columns, would've flattened and disappeared.

The repeated elements here are, of course, the vertical lines; those include the columns, the brooms, and the twin sweepers. But they also include the beautiful scalloped arches, repeating visibly and

clearly in the foreground, then in the far doorway. Repeated elements give us that elegant rhythm and interest.

Capturing the moment took some patience. Synchronization wasn't a priority for these sweepers, and they were easily distracted. So finding a moment when the brooms were as close to parallel as possible, while the faces of the sweepers were looking in the same direction, therefore creating strong implied vertical lines, took some waiting. Patience is underrated as a photographic skill, but unless you believe the world just shows up and aligns itself according to your aesthetic will, you need to wait these moments out. Without this moment, the photograph wouldn't have the vertical interest that it does, nor for that matter would it imply what it does. This photograph is about harmony to me—harmony in the architecture as well as harmony in the work, which is what struck me about this scene, even from other angles. I love the way these two sweepers work together. Finding a moment when the two of them were as close to being one person was what I wanted.

In terms of placement, here is this photograph with both a thirds grid and a spiral overlay (C). Neither the grid nor the spiral is precise; I've had to squish the spiral a little to make it fit. But while the purists and the mathematicians will find this offensive, I'm not doing it to reinforce a mathematical principle, but to again illustrate the usefulness of these tools to demonstrate balance and the path of the eye. In terms of visual mass, the columns and repeated elements are really powerful, but they balance out

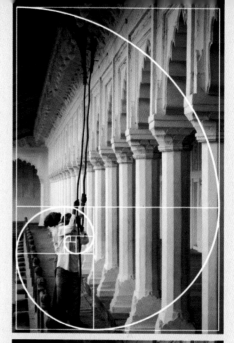

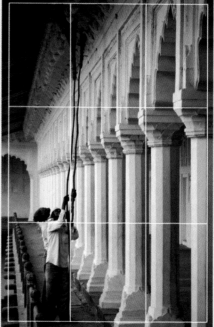

C

D

against the two human figures as well as the darker tones, which are all on the left side of the frame, balancing against the massive columns on the right.

Lastly, the light in this scene, soft and diffused, allows the tones and the lines to take center stage without harsh contrast, which is the same reason I rendered this into black and white. There is nothing wrong with the original color version (**D**), but there is also nothing to which the color contributes, and pulling the color, as it so often does, allows the lines and tones to take prominence.

Now it's your turn. I'm including two more photographs from this scene (**E**), and without comment from me, now's your chance to pick these apart. What works and why? What are the elements and decisions that contribute to each photograph? Do they say different things or similar things in different ways? Grab a piece of paper and see if you can fill it, but do your best to list everything. Describe the framing, the light, the POV, the lines, the moment, everything.

E

Matt Brandon, Ladakh, India, 2010

NOT EVERY PHOTOGRAPH has to be about a larger theme, nor does it have to be photographed somewhere exotic. I happened to make this photograph one morning on a rooftop in Ladakh, India, but it might just as easily have been on a cool evening in Denver. Still, the principles of visual language can be used to create stronger photographs, so I want to discuss a favorite portrait of a close friend.

This photograph is framed vertically, exaggerating the line of the story, which is a momentary one of a man lighting his pipe. That verticality creates a path for the eye that is, on first pass, strongly from face to match and back again, up the stem of the pipe (**A**). On subsequent passes the eye takes in other details: the *topi* Matt wears on his head, the details in the pipe, the matchbox, the down jacket. All of these visual clues begin to piece together a story. As with all photographs, all we have is what is within the frame. Here I've cropped very tight, wanting this to be about Matt himself. But we know he's somewhere cold. The hat gives a sense that he's not only in a cooler context, but likely in a place like Pakistan, Afghanistan, or Northern India.

My favorite element of this photograph is the light. It was early morning when I shot this, so the light of the struck match threw light to Matt's face, warming it and giving the sense of warmth and comfort in an otherwise cool moment. Take a moment to really look at that light, the way it not only warms Matt's face but also lights his cupped hands, through his fingers and under the matchbox itself.

This light, combined with the shape of the hands and the flame of the match, gives the bottom of the frame enough visual mass that it's not only interesting, but also serves to balance the bottom of the frame against the top of the frame, containing Matt's ruggedly handsome face. This is a statically balanced frame, appropriate for what is a serene moment, one—if you know a pipe smoker—that is usually contemplative, even a ritual.

There's a beautiful symmetry in this photograph, not only left to right, but in other elements. Look for example, at the round lines formed by the top of Matt's hat. The semi-circle is echoed in the lower brim a couple times, in the shape formed by his eyebrows, even the shape of his mouth and his

▶ Canon 1Ds Mk III, 85mm, 1/320 @ f/1.4, ISO 200

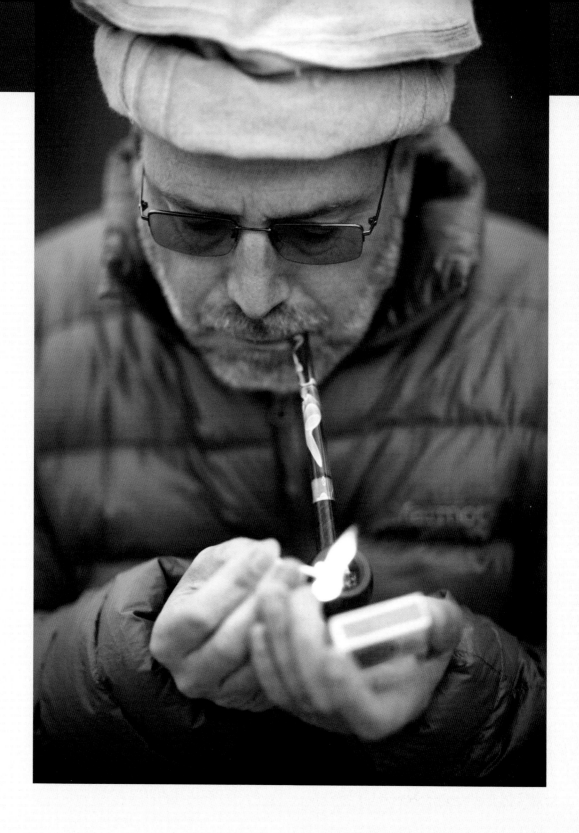

A, B

beard as it wraps his face (**B**). Not only do these repeated elements form a rhythm, but the circles are concentric. As they get smaller, like the lines of perspective, they draw our eye down to where Matt's eyes should already draw us, to the flame. My own POV was important here. I was low, facing Matt directly. Had I been higher, the line looking down would've had more energy, but I'd have lost much of Matt's face, and where now his hands appear in front of his torso, looking down would've created a space between them, a distance changing the relationship. I would also have introduced new elements into the scene, as well as lost the matching green background. The plane of focus would've changed, too, forcing me to use a larger aperture, or to be happy with different elements drifting into and out of that plane of focus. Don't ever dismiss the importance of where the camera is, and at what angle it shoots—it rearranges everything within the frame.

While we're talking symmetry, if you overlay a grid of thirds on the image, you find Matt's eyes aligned with the top third, and the flame of the match on, or near, the bottom third (**C**). It's neither here nor there, but interesting to note that the thirds grid can be used to create dynamic balances, but just as easily be used to create static and symmetrical balances; you just need to use the lines on both thirds, not just one.

Other decisions, too, make this image the intimate portrait it is. One is the crop. I shot this with an 85mm lens and kept quite tight, wanting this to

remain intimate and unaffected by the background. At the same time I used a shallow depth of field and focused on his face to create some depth with the various levels of focus. His hands in the immediate foreground are soft, but not so soft that it can't be inferred that they are hands lighting a match. That's not unimportant. Sometimes we allow ourselves such a narrow depth of field that we gain all kinds of softness but lose enough detail that no one except ourselves can make sense of what's going on. Matt's leaning over, so the plane of focus allows me to keep much of his face, the stem of the pipe, and the cuffs of his down jacket in focus, while allowing the rest of his body to go soft, creating a strong midground and clear background, which also blends into the green and out-of-focus trees. Had the space behind Matt been bright sky, it would've increased the visual mass in that area, pulled the eye, and not had the same kind of harmony that it does now.

Lastly, while I trust it by now seems self-evident, the moment makes this photograph. The moment provides the action, and it provides the light that gives this image its contrast and the warmth in an otherwise cool scene. Without the flame there'd be no clear point of action, and it wouldn't be a portrait of Matt doing something that is very much Matt. It would be a photograph of a guy looking down at his hands. That flame makes the photograph, and it doesn't last long, which gives the reader of the image a sense of being perpetually within a crucial moment, somewhere between the pipe being unlit and it being lit.

C

While I'm nearly fanatical about asking students to try images in black and white, there is no point in doing so with this photograph. This is not a photograph about lines and textures, although those are there; it's about the lighting of a pipe. The loss of the color, both in the greens of the jacket and background, and—most importantly—in the warmth of the flame, would rob this photograph of the mood that makes it what it is.

Smoke Break, Delhi, India, 2007

THIS IS ONE OF MY FAVORITE street photographs, both for the moment and the lines, which give the image its spatial depth. Horizontally framed and kept in its original 2:3 aspect ratio, the image is a long one, which allows the lines to play long and pull the reader in and through the photograph. The primary aesthetic decisions here were not related to shutter or aperture, or even the light, though the lack of bright light allows us to see further into the shadows, which we wouldn't be able to do if the light had been brighter and I had been forced to expose to keep this man's white shirt and hat from being overexposed. Like any of my images, and I hope yours too, I looked at this both in color and black and white, but the tonal contrasts and lines in this were too strong—and the original color palette too uninteresting—to even consider leaving it in color. Instead, the primary decisions here had more to do with the lines and the moment, both of which are important to tell the story. The lines, at least the ones connecting foreground to background, connect the character to his setting and imply that he's taking a break from something related to the bottles in the background. The moment defines the nature of that break, both in his posture and with the cigarette to his mouth.

The lines are exaggerated by two decisions. The first was the decision to use a wider focal length, in this case 42mm on a 24–70 zoom. The second was to stand obliquely to this man. Facing the shutter door from the street would've forced those lines into a horizontal pattern, and the pull of the diagonals would've been lost. Of course, so too would the angle on the man himself and the great line created simply by his posture. With that stance, the cigarette in his mouth, and the lines of the door, the gesture of this image is created. A different POV would've produced a very different photograph.

In terms of the lines, real or implied, there are a few different things here, and while I'm usually one for images where the eye takes only one or two paths, here I think there are at least three. In no particular order, the first is the path created by the implied line of his eyes (**A**). The eyes have such visual mass that they pull us to them and then push us to look where he looks. In this case, we have no idea where he's looking, but the resulting mystery gives the photograph the implication of a story beyond just the photograph.

The second set of lines has more to do with points of interest that form a triangular path for the eye.

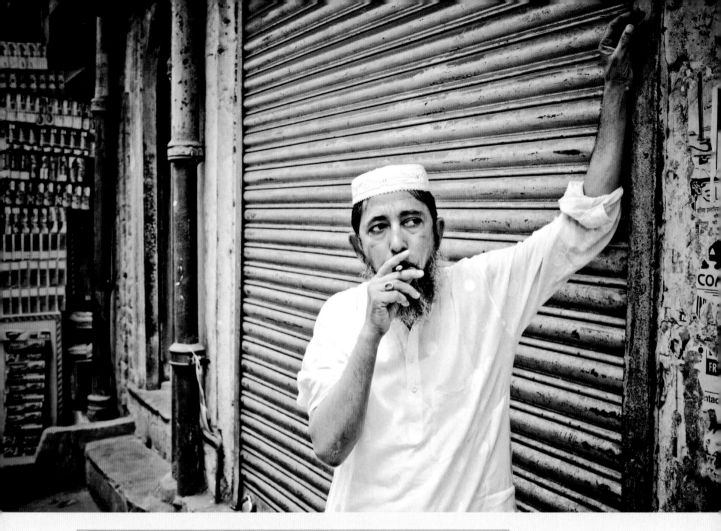

▲ Canon 5D, 42mm, 1/125 @ f/5, ISO 400

Beginning at the same place, the point of greatest visual mass, we look at the eyes and the hand with the cigarette, then upward to the hand on the post, down the length of the arm and to the other elbow, and finally back to the face and the hand with the cigarette (**B**). We may, of course, do the same path in reverse, but as the eyes are looking right and slightly up, I suspect most of us will follow the former path. Triangular paths like this one are experientially strong for the reader, as they keep the eye in a repeating path, but they depend on strong lines and points of interest to work well and keep the eye from going elsewhere to find something interesting to look at.

Graphically, the final set of lines is perhaps the strongest, formed by the effect of perspective on the lines of the shutter (**C**). Those lines lead to a

vanishing point well outside the photograph, but in this image the direction of the lines works against the way most of us naturally read a photograph (and again, that may be an entirely Western bias). As a result, the eye is pulled down the length of the shutter lines into the heart of the photograph, to the stack of what appear to be soft drink bottles. But our inclination to read the image from left to right pulls the eye back along those same shutters to the man taking his smoke break, creating a back-and-forth in the way we explore the image visually, producing a visual tension, and so keeping the reader engaged and "in" the photograph.

The moment after I took this, the man pulled his right hand down, dropping the cigarette to his side. He became self-conscious and the dynamic between us changed, altering the photograph. I'm including the other seven frames from the sequence I shot (D). In these images, not only did the moment change but the POV and the focal length did as well. That said, the moment itself changes enough that, all other decisions being equal, I'd have lost the so-called decisive moment if I had missed that first frame.

A, B, C

D

Maasai Warrior, Kenya, 2011

IF IT'S TEMPTING TO THINK that all this discussion about composition and lines and depth appeals only to some disciplines within photography and not, for example, to portraiture, then I want to dispel that notion as best I can here. This portrait of a Maasai warrior was made during a session with the Maasai on one of my safari tours. He patiently posed for us while I showed a couple of students what you can accomplish with a little indirect light and a total lack of gear.

I want to talk specifically about a couple things here, so I'm going to be brief on the other details. By now you should have a sense for the basics—for example, why I chose to orient this frame vertically, and why I chose a shallow aperture (f/2.8), allowing the eye to be undistracted by elements in the background that would've been distinct even at f/4. You should already have picked up on the close alignment to the grid of thirds to place elements like the spear or his eye (**A**). Thirds don't always work, but when they do they help bring balance and tension. Sure, it's a portrait, but we're still working with the same basic building blocks—the only ones any photographer has—lines and tones and light and moments. Everything matters.

The spear, for example, was placed intentionally to give a strong straight line where every other line is organic and textured. Could it be stronger? I think it could. If I could do it over I'd ask him to push the whole spear closer to me, creating a larger, more prominent foreground that increased the depth. I'd also prefer to see it slightly tilted to give it some energy and greater tension. Because of the laws of perspective, pushing the spear forward would also raise the point of the spear relative to the top of the frame and allow for a stronger implied diagonal line from the top of the spear through the warrior's foremost eye, and then through the rest of the frame (**B**). That implied line is there now; it's just not as strong as it could be, and I've never been accused of subtlety.

Ultimately I think the eye can take several paths through an image. In this case, there's the stronger diagonal path just mentioned, but earlier in the book I chose this photograph—with a slight alternate crop—to illustrate the golden spiral (page 106), and that's still the path my eye takes on this photograph: counterclockwise from the leading eye (his right eye), leading around the face, along the back of the head, down to the beads, and eventually it takes the reverse path only to do it again. I think this accounts for a sense of complexity in some

▶ Nikon D3s, 200mm, 1/40 @ f/2.8, ISO 800

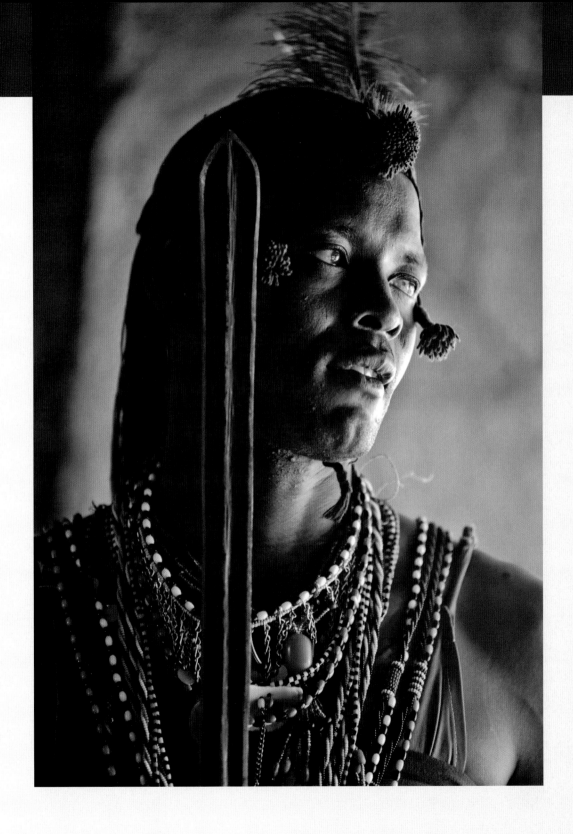

Maasai Warrior, Kenya, 2011 **235**

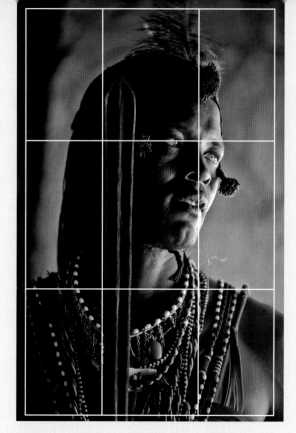

A The thirds grid gives clues to why the image feels balanced as it does. The strong lines at the leftmost vertical third counterbalance the pull our eye feels to the face. Likewise, horizontally, the lower third pulls heavily—dark and textured—to anchor the top two thirds.

to say about this warrior. Whether I said it well would depend on the choices I made about the elements I had to work with. So many photographs of people in fading cultures are made as a curiosity piece, often shot in bright light and making them—especially with the rise of tourism—a satire of their former glory and dignity. So I wanted to create a dignified, beautiful portrait. I didn't want a posed smile and I didn't want him dancing. I just wanted something human. And I wanted the beadwork, because I'm a fan of African beadwork and I worry that as these tribes slowly modernize we'll lose this beauty.

All of that led me to choose specific light. Before I go further, look at the light in this photograph. Describe it. Where is it coming from? Is it hard or soft? What is the effect of this light on the subject matter?

This is classic indirect sidelight, and it's creating classic chiaroscuro, that light that fades as it can no longer wrap around the three-dimensional object, producing a modeling effect. Look at the light and see where it falls, and how it feathers off. It gives depth to his face and a catchlight to his eyes, bringing life. It creates texture in the muscles of his neck and in the beads that contrast strongly with his skin. The same thing happens on the wall in the background, though sharply because of the angularity of the corner. Light just doesn't turn hard corners the way it fades gradually across a rounder object. The depth in this image comes from the light. Had I moved our subject two feet further under the roof, the light would've fallen off more dramatically and

photographs. When a photographer can create within one frame not one visual journey or path of exploration, but a couple of them—or even multiple paths—the experience of the reader increases exponentially.

To return to the basic premise of the book, I had something specific I wanted to point to, something

we'd have been in full shade. The chiaroscuro effect would be gone, and with it the depth and texture. The contrast would be lost, and with it some of the drama I wanted to maintain. After all, he's a warrior, so this drama is important. Remember this was photographed when the midday African sun was high and unforgiving, but there's so much we can do to craft the light, and those decisions will often make the image—or destroy the chance it had.

The moment here is important, too. Like I said, I didn't want him mugging at the camera. I didn't want a grin or a false show of strength. I wouldn't go so far as to say I wanted to show a young man contemplating the future of his fading culture, but that could certainly be inferred by readers. I did want this to be about him, not about me or our interaction. Eye contact or any sense of camera-awareness would've ruined that illusion. Instead, he's looking beyond. Beyond what? We don't know. And I think that ambiguity makes this a stronger portrait than much of my early work. Smiles and laughter are beautiful and human, but they are not our only emotions, nor are they necessarily the ones that connect the most with the readers of a photograph. We are glutted with "say cheese" photographs. We experience a gamut of emotions as humans, and although happiness is one of the pleasant ones, it is often the more difficult or complex emotions that many of us more often identify with in our day-to-day life.

A portrait is no different from a landscape photograph in terms of the need to compose, choose the moment, and understand the light. In fact, I think

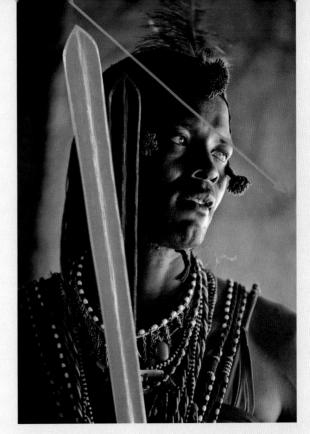

B If I could reshoot this, I'd place the spear closer to the camera, allowing a stronger foreground and more looming spear, and creating a stronger implied diagonal line.

landscape photographers could teach portrait photographers a great deal about form and light. They have no ability to ask the land to smile; they simply move about until the lines appear, and they wait for the light on the land to create its best expression, knowing that only the light and the lines can carry the image.

Candles & Prayers, Kathmandu, Nepal, 2010

AFTER LOOKING AT 19 PHOTOGRAPHS, and having what I hope has been a productive discussion about the visual language, I've been resisting giving a checklist because I strongly suspect that anytime we reduce things to formulas or checklists, we remove from our art the creative and unique stamp that makes it ours to begin with. I've also yet to give you the experience I inflict on the students who join me on the workshops I've led with friends like Matt Brandon and Jeffrey Chapman. If you'll remember, one of my first rules is that the photographer has to remain silent. I've been anything but. Barring the foolishness of artist statements, the photographer speaks through his photograph, and if the photograph isn't strong enough to say that thing the photographer wanted to say, then the solution is to go make a photograph that does, not to talk our way out of it.

So I want to leave you with a list of questions, the responses to which I will never see, so you are free to be honest and creative about your interaction here. They can also be used for your own photographs and critique sessions with friends, but in this case, regarding this photograph:

- What feelings and thoughts are you conscious of as a result of this photograph? Does it stir a memory or a desire? If so, how? If your first words are "I like it," please immediately follow it up with a reason. Why do you like it? Dig deep. And then answer the rest of the questions as mindfully as you can.

- How does the framing or aspect ratio affect this photograph?

- Is this photograph balanced? If so, is it dynamic or static? If not, how does that make you feel, and could it be corrected? How?

- Does the principle of thirds or the spiral suggest a path for the eye?

- Describe the light in this photograph. Is it direct, indirect? Does it fade quickly? From which direction does the light come, and what does that contribute to the photograph?

- Does the light add mood? Is it used as a compositional device? Does it reveal or isolate?

- Without looking at EXIF data, what choice of lens was made by the photographer? What makes you think that?

▲ Canon 1Ds Mk III, 85mm, 1/100 @ f/1.2, ISO 800

- How does the choice of optics make the photograph what it is?

- Did the choice of shutter speed or aperture affect the aesthetic of the photograph?

- What kinds of lines, or implied lines, are present in this photograph? Do they lead the eye, provide balance, or form relationships among elements?

- Are there elements that repeat themselves, providing a rhythm or theme in the photograph?

- Are there elements that simply pull your eye for one reason or another, giving them greater visual mass?

- What kind of color, or tonal, contrasts are in this photograph?

- What kind of conceptual contrasts are present that might more clearly tell a reader what the image is really about?

- What is the role of color in this image, and what would change—either weakening or strengthening it—if it were rendered in black and white?

- Describe the moment and how it contributes to the photograph. What might have happened if the photographer had waited a little longer or not waited as long? Would a change in moment change the heart of the photograph?

- Are there relationships or implied relationships between elements in the frame? Describe those relationships.

- What role does the POV (point of view) of the photographer contribute to this photograph? If the photographer were more to the right, to the left, lower, higher, or closer, how would that change the photograph?

- What is the theme of this photograph? What is this photograph *about*?

Conclusion

THERE ARE A FEW RISKS INHERENT in discussions like the ones we've undertaken in this book. The first is that, in simplifying things for the sake of education, an *over*simplification occurs. If at any point—particularly in the discussion of the 20 photographs at the end of book—I made any of this stuff seem easy, let me clarify: it is not. Like spoken language, there are times you do it effortlessly, without thinking. Other times you trip over your words, and you need to try to better express yourself a couple times before getting it right. With time and practice you speak or write with greater ease, accessing that conscious part of the brain less and less as you grapple for the words. Sometimes

These were photographed on my iPhone during the first half of the road trip around North America that I began in February 2011. I love the iPhone's ability to process the images, maximizing their mood, and even place borders around them—in this case, CameraBag's Instant filter applies a Polaroid border that gives the images a certain nostalgic feeling I associate with road trips. That they were created on the iPhone makes them no less among my favorite photographs from 2011.

you see all kinds of elements and make all the right decisions and there's a creative flow that, if you recognized it, would make you think you were a genius. Fortunately, the next photograph often disabuses you of that notion quickly. Learning a language, and then making it your own as you express things in a way unique to yourself, is a long journey. So settle in, and give yourself the grace to learn at your own pace.

"This is a young art, and the dictionaries and lexicons are still being written by photographers of all stripes."

A second risk is that in writing this from my own point of view, I may have mistakenly implied that this way is the only way. Nothing could be further from my intention. My photographs express my own vision in my own voice. I gravitate to certain styles, certain symmetry or balance in my work. My compositions are often on the simple side. But that's not the only way; it's just my way. What I wanted to do in this book was not convert a single soul to my way of making photographs, but to encourage awareness—simply, that the elements and decisions that go into the final photograph form the visual language with which we express ourselves. This is a young art, and the dictionaries and lexicons are still being written by photographers of all stripes. All language is organic; it evolves. The way we express ourselves photographically will change over the next 50 to 100 years, probably dramatically. What will not change is that people will continue to read meaning into photographs, and the more aware the photographer can be about how the photograph is read, the more able she'll be to create photographs that both express and communicate. Learn the language, then make it your own. The poets W.H. Auden and Gerard Manley Hopkins shared a language, but the two couldn't be more dissimilar in what they said and how they said it. The last thing we need is more homogeny in the world of art. Once you've found your vision, find your voice, but make sure it's your own. That takes courage.

The third risk is that, in my choice to present the visual language as being either elements or decisions, I have chosen a device to communicate something that is much more complicated. In the end, whether something is an element or a decision is totally irrelevant; they both have implications and they must both be manipulated or chosen mindfully and intentionally. So if the distinction is lost on you or feels at times like a contrivance, then let me join you and acknowledge that it is, and it doesn't really matter. Whether we understand what a noun or verb is, or can tell an adverb from an adjective—these distinctions are irrelevant.

Call them what you like; what matters is that you understand that our every decision changes the aesthetic of the photograph, and therefore changes what that photograph says.

Our photographs will be read by others, but even if our only audience is just ourselves, we will still find greater clarity and meaning in our expression as we understand more of the language, and can therefore find new ways to wield it. And if our hope is to communicate with others, then the stronger the use of that language, the greater the chance that we will, in fact, communicate, and when we are lucky, that language, like written prose or poetry, will engage people, bring them fresh perspectives, and move their hearts and minds in some new way.

Peace,

David duChemin
Ottawa, 2011

Index

DATE DUE

PRINTED IN U.S.A.